LATIN AMERICAN &
CARIBBEAN ART
MoMA at EL MUSEO

LATIN AMERICAN & CARIBBEAN ART
MoMA at EL MUSEO

Edited by
Miriam Basilio
Fatima Bercht
Deborah Cullen
Gary Garrels
Luis Enrique Pérez-Oramas

El Museo del Barrio and
The Museum of Modern Art
New York

This volume is produced by El Museo del Barrio in collaboration with The Museum of Modern Art

EDITORS
Fatima Bercht and Deborah Cullen,
El Museo del Barrio

Gary Garrels, Luis Enrique Pérez-Oramas, and Miriam Basilio,
The Museum of Modern Art

PUBLICATION MANAGER
Deborah Cullen
with the assistance of Margarita Aguilar and Melisa Lujan,
with editing support from Marion J. Kocot and
Michael Goodman, for El Museo del Barrio,
and David Frankel, for The Museum of Modern Art
and with translations of Luis Enrique Pérez-Oramas's and
José Roca's essays by R. Kelly Washbourne

DESIGN
Elvira Morán, elviradesigns.com

PRODUCTION
Marc Sapir and Elisa Frohlich, The Museum of Modern Art

Printed by
Turner, Madrid, Spain

Distributed by
D.A.P./Distributed Art Publishers, Inc., New York

Library of Congress Control Number: 2003116663
ISBN 0-87070-460-5

Printed in Spain

Frontispiece: Detail of Iran do Espírito Santo. *Butterfly Prussian Blue*. 1998.
Gouache on paper, sheet: 11 x 13 7/8" (27.9 x 35.2 cm)

FOREWORD

"MoMA at El Museo: Latin American and Caribbean Art from the Collection of The Museum of Modern Art" is the central exhibition in a triptych of shows with which El Museo del Barrio, New York's Latino center for arts and culture, celebrates its thirty-fifth anniversary. We initiated our yearlong commemoration with "Voces y Visiones: Highlights from El Museo del Barrio's Permanent Collection" (November 2003–February 2004); we now present "MoMA at El Museo" (March–July 2004), and later this year will witness the opening of "Retratos: 2,000 Years of Latin American Portraits." This series of landmark exhibitions marks the most ambitious undertaking in the history of El Museo.

The collaboration behind the exhibition brings to light the distinctive histories of two different institutions whose holdings are nonetheless complementary. Whereas the origins of El Museo lie in the vision of an enlightened group of Puerto Rican educators, artists, and parents during the civil rights movements of the 1960s, who sought to recognize the cultural achievements of this important community, MoMA's interest in Latin America can be traced to its early years, in the 1930s. The collections of both El Museo and the Modern have grown considerably over time and have become more comprehensive in their focus. By presenting exhibitions first of El Museo's Permanent Collection and then of MoMA's holdings in Latin American art, we wish to stress the different strategies underlying each collection and how today their juxtaposition enriches both while at the same pointing to their respective particularities. In short, the breadth of El Museo's mission within Latino culture provides context, history, and a sounding board for MoMA's holdings.

As an institution, MoMA may be said to have come to define and signify modernism. It is all the more relevant, then, that it has had close ties with Latin American art from its inception. Not surprisingly, MoMA is considered the first institution of international prominence to have devoted attention and resources to Latin America, sending representatives to travel extensively south of the U.S. border and adding these expeditions' discoveries to its collection. Yet the Latin American works that constitute this exhibition are not a separate collection within MoMA; within its larger holdings they serve to integrate the art-historical discourse of past and current centuries. That is precisely what marks this exhibition as a landmark, in that it brings together works hitherto overseen by different departments in the first attempt to gauge the breath of its Latin American holdings. MoMA's international scope and privileged vantage point make its Latin American art a reflection of the times in which that collection was created, and should be considered against the backdrop of an evolving notion of modernism. As the collection is constantly growing, we may consider it a work in progress, and this presentation as a milestone for its scholarly examination and understanding.

"MoMA at El Museo" marks the culmination of a very fruitful collaboration between two leading New York cultural institutions, a unique exchange of expertise and knowledge. The origins of this project date to conversations between my predecessor, Susana Toruella Leval, and Glenn D. Lowry, Director of The Museum of Modern Art. Recognizing that such a joint venture could generate both groundbreaking scholarship and pure pleasure for museum-goers, teams from El Museo and MoMA have worked tirelessly on all stages of the exhibition, producing a very fine publication and important education programs in the process.

It has been a gratifying experience to see these institutions come together and bring to fruition so ambitious an undertaking. During this exchange, the staffs of MoMA and El Museo del Barrio have built a deeper mutual appreciation and respect for the professional talent of participating

individuals. Their stewardship in producing this challenging exhibition and groundbreaking publication warrant acknowledgment: to curators Miriam Basilio, Fatima Bercht, Deborah Cullen, Gary Garrels, and Luis Enrique Pérez-Oramas goes my profound gratitude, not only for truly original research but also for the contribution this exhibition makes to the field of Latin American art and to the history of MoMA. I join the curators in acknowledging the seminal, insightful efforts toward this collaboration by Paulo Herkenhoff during his tenure as Adjunct Curator at the Modern. His enthusiasm, commitment, and remarkable collegiality inspired this project throughout.

It is equally important to acknowledge that for many visitors this exhibition will come to life through interpretative programs devised by the education departments of the collaborating institutions. MoMA's leadership in and El Museo's innovative approaches to arts education have resulted in unique programs that illuminate the visitor's experience of this exhibition.

In addition, I would like to extend my gratitude to those who have contributed so much to the organization and success of this project. In particular I would like to thank, from MoMA, Glenn Lowry, Director; Jennifer Russell, Deputy Director for Exhibitions and Collections Support; and Jay Levenson, Director of The International Program, for their continuing support and the engaging dialogue they brought to the realization of the project. I would also like to thank the staff and Board of Trustees of El Museo del Barrio for their early embrace of this initiative and for the passion, dedication, and personal commitment they have made to bring this exhibition to its full potential.

A major undertaking such as this would not have been possible without significant support from our sponsors and generous patrons. We are especially indebted to Bloomberg and Altria Group, Inc., for recognizing the importance of this exhibition early on.

We are also very honored to have received major support from the Jacques and Natasha Gelman Foundation, The International Council of The Museum of Modern Art, Estrellita and Daniel Brodsky, Agnes Gund and Daniel Shapiro, Joseph and Carmen Ana Unanue, and Nazca Saatchi & Saatchi. Additional funding was provided by Yolanda Santos Garza, GEICO, the LEF Foundation, Power Corporation of Canada, the Mex-Am Cultural Foundation, Inc., and Tony Bechara.

We are most grateful to Patricia Phelps de Cisneros and The Reed Foundation, Inc., for the support that made this publication possible.

Lastly, a very special thanks to The Board of Trustees and Advisory Board of El Museo del Barrio for their vision and support of this project.

In closing, we are very proud to present "MoMA at El Museo," a unique collaboration between two of New York's leading art institutions, brought together to share and complement our expertise to present this landmark exhibition in celebration of our thirty-fifth anniversary.

Julián Zugazagoitia
Director, El Museo del Barrio

FOREWORD

This exhibition is the culmination of more than four years of conversation and collaboration between The Museum of Modern Art and El Museo del Barrio. The project began when I approached Susana Torruella Leval, then the Director of El Museo, with the invitation to coorganize an exhibition, to be shown at El Museo, of works in the Museum's collection by artists from Latin America and the Caribbean. Paulo Herkenhoff, Adjunct Curator at The Museum of Modern Art from 1999 to 2002, undertook initial discussions with Susana and subsequently with El Museo's new Director, Julián Zugazagoitia, about such an exhibition. When Paulo decided to return to his home city of Rio de Janeiro, Gary Garrels, Chief Curator of Drawings and Curator of Painting and Sculpture at the Museum, assumed the role of leading a team of curators from both museums to formulate and organize the exhibition. The team included our new Adjunct Curator, Luis Enrique Pérez-Oramas, from Caracas, who joined the Museum in January 2003; Fatima Bercht, Chief Curator at El Museo; Deborah Cullen, Curator at El Museo; and Miriam Basilio, Curatorial Assistant at MoMA.

The Museum of Modern Art's long history of collecting art from throughout Latin America and the Caribbean began in the 1930s. This involvement, however, has been episodic, and one of my concerns upon becoming Director was how to reengage this history and more consciously and systematically renew the Museum's involvement with the art of Latin America. Many individuals at the Museum—trustees, curators, and other staff—have shared this commitment with me, and over the past five years it has coalesced into a number of new initiatives.

Rather than hiring a curator specifically for Latin American art, the Museum decided instead to invite an adjunct curator from Latin America to join the curatorial staff for a three-year appointment. Our goal was to encourage consideration of Latin American art within the collection and within programs as a whole, while adding the curatorial expertise that had been missing. In doing so we hoped to create a situation whereby the exchange of information and the development of relationships between the Museum and our colleagues in Latin America would deepen and widen. Paulo Herkenhoff and Luis Enrique Pérez-Oramas have filled this role admirably; their presence and influence have permeated the Museum and linked it with a rich network of associates in Latin America and around the globe.

With the support of the Cisneros Travel Fund, curators have been encouraged to make research trips throughout Latin America, sometimes with specific goals but often simply to view art otherwise little known in New York, to visit artists' studios, and to meet their peers at other museums. The results are already tangible, and the potential for further development in the future is equally important.

A crucial link between The Museum of Modern Art and institutions and individuals in Latin America has been the Museum's International Program, which was founded in 1952. Since Jay Levenson became the program's Director, in 1996, he has expanded its efforts. Among other initiatives, in 1998 he invited a group of twelve directors, curators, registrars, and other museum professionals from several Latin American countries for ten days of workshops at the Museum, enabling them to meet with curators and other staff.

Parallel to the development of the Museum's collection, the library has consistently acquired exhibition catalogues and other publications on Latin American art and artists. In 2001, with the support of the Cisneros Foundation, the museum hired a Latin American specialist, Donald

Woodward, who systematically reviewed the library's holdings, adding over 5,000 titles and launching an on-line bibliography of Latin American art.

With this exhibition, we are able to celebrate and bring to larger public awareness not only the history of The Museum of Modern Art, but also its renewed engagement with art and artists from Latin America and the Caribbean.

Glenn D. Lowry
Director, The Museum of Modern Art

1. **Beatriz Milhazes**. *Succulent Eggplants*. 1996. Synthetic polymer paint on canvas, 6' 2 3/4" x 8' 1/2" (189.9 x 245.1 cm)

ACKNOWLEDGMENTS

"MoMA at El Museo" would not have been possible without the enormous effort, support, and enthusiasm of our colleagues at The Museum of Modern Art and El Museo del Barrio. Glenn D. Lowry, Director of MoMA; Julián Zugazagoitia, Director of El Museo; and Susana Torruella Leval, former Director of El Museo, have provided sustained commitment and encouragement. We would also like to extend our deepest thanks to the departments that lent works to the exhibition: we are grateful to John Elderfield, Chief Curator, Department of Painting and Sculpture; Deborah Wye, Chief Curator, Department of Prints and Illustrated Books; and Milan R. Hughston, Chief of the Library, for so generously committing works to the exhibition. We would like to thank Paulo Herkenhoff, former Adjunct Curator in the Department of Painting and Sculpture, for his invaluable early support for this project, for his research on works by artists from Latin America in the Museum's collection, and for his many contributions that made possible key acquisitions.

A number of our colleagues have made invaluable contributions to the cataloguing, research, and conservation of these works, as well as to the organization of the exhibition itself. In the Department of Drawings we are especially grateful to Kathy Curry, Assistant Curator; David Moreno, Preparator; John Prochilo, Manager; and Maura Lynch, Admistrative Assistant. Our former Intern in the Department of Drawings, Geaninne Gutierrez-Guimaraes, assisted in the extensive research that preceded this exhibition and publication, and contributed to all aspects of the organization of the show. In the Department of Painting and Sculpture, we would like to thank: Cora Rosevear, Associate Curator; Lilian Tone, Assistant Curator; Avril Peck, Curatorial Assistant; Ann Umland, Curator; Sharon Dec, Assistant to the Chief Curator; and Mattias Herold, Manager. We would also like to acknowledge Ferestesh Daftari, Assistant Curator, and Lianor da Cunha, former Administrative Assistant, for their contributions to the research for the exhibition catalogue. In the Department of Prints and Illustrated Books, we are grateful to Harper Montgomery, former Assistant Curator, for her support of the exhibition and contribution to its catalogue, as well as to Jennifer Roberts, Curatorial Assistant, Research and Collections; Raymond Livasgani, Curatorial Assistant; and Jeff White, Preparator. In the Library we thank Donald L. Woodward, former Bibliographer, Latin American Specialist, and Jenny Tobias, Librarian, Collection Development.

The Department of Conservation, under the leadership of Jim Coddington, in addition to treating a number of works, made major contributions to our research in preparation for this exhibition, and we are grateful to Anny Aviram, Conservator, Scott Gerson, Assistant Conservator; Roger Griffith, Associate Sculpture Conservator; Karl D. Buchberg, Senior Conservator; Erika Mosier, Associate Conservator; and Lynda Zycherman, Conservator. The Department of the Registrar has played a key role in the coordination and research leading to the exhibition, and we thank Ramona Bronkar Bannayan, Director, Collections Management and Exhibition Registration; Sydney Briggs, Senior Assistant Registrar; Allison M. Needle, Senior Registrar Assistant; Sarah Freeman, former Senior Assistant Registrar; Steve West, Art Move Coordinator; Pete Omlor, Manager of Art Handling and Preparation; Rob Jung, Assistant Manager of Art Handling and Locations Manager; John Dooley and Mark Murchison, Preparators, and Chakira Santiago-Gracia, former Twelve-Month Registrar Intern. In the Department of Collection and Exhibition Technologies we thank Eliza Sparacino, Manager; Susanna Ivy, CEMS Assistant; and Gaël Anne LeLamer, Senior CEMS Assistant. We are also grateful to our colleagues in the Department of Exhibition Production and Design: Jerry Neuner, Hope Cullinan, and especially Peter Perez, who led the efforts for framing works in the exhibition.

2. **David Alfaro Siqueiros**. *Collective Suicide*. 1936. Enamel on wood with applied sections, 49" x 6' (124.5 x 182.9 cm)

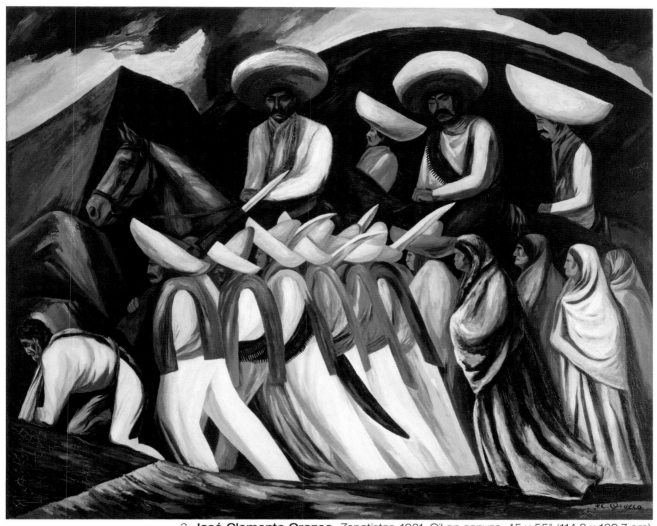

3. **José Clemente Orozco**. *Zapatistas*. 1931. Oil on canvas, 45 x 55" (114.3 x 139.7 cm)

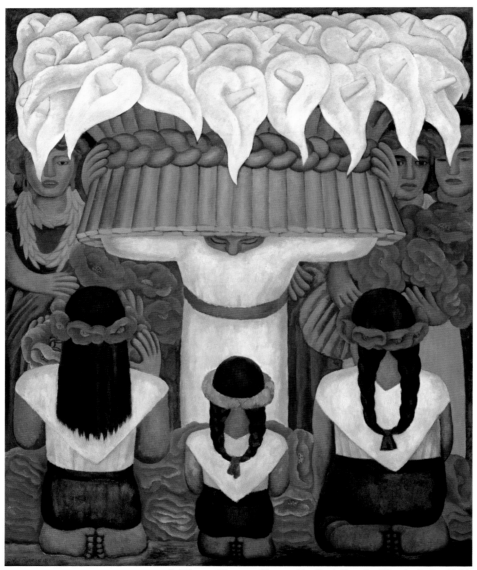

4. **Diego Rivera**. *Flower Festival: Feast of Santa Anita*. 1931.
Encaustic on canvas, 6' 6" 1/2 x 64" (199.3 x 162.5 cm)

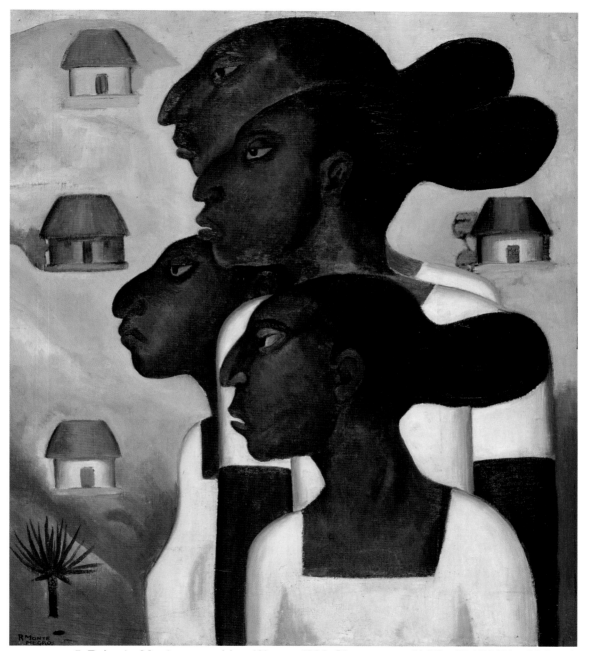

5. **Roberto Montenegro**. *Maya Women*. 1926. Oil on canvas, 31 1/2 x 27 1/2" (80 x 69.8 cm)

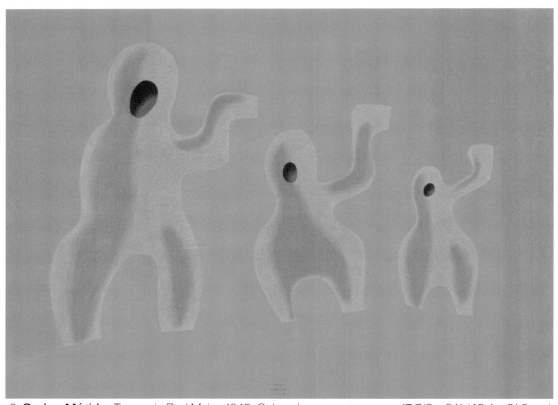

6. **Carlos Mérida**. *Tempo in Red Major*. 1942. Colored crayons on paper, 17 7/8 x 24" (45.4 x 61.0 cm)

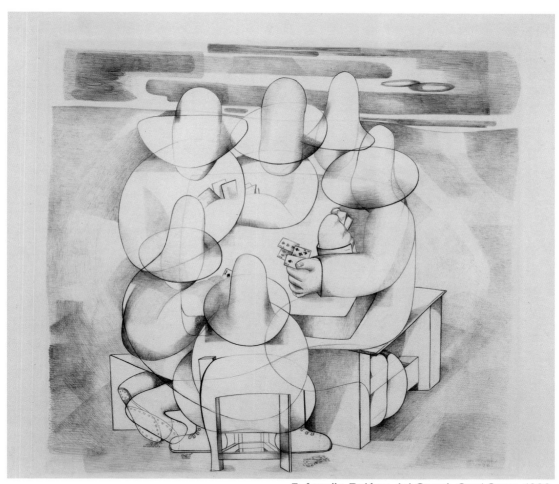

7. **Amelia Peláez del Casal**. *Card Game*. 1936.
Pencil on buff paper, 25 3/8 x 26 3/8" (64.4 x 67 cm)

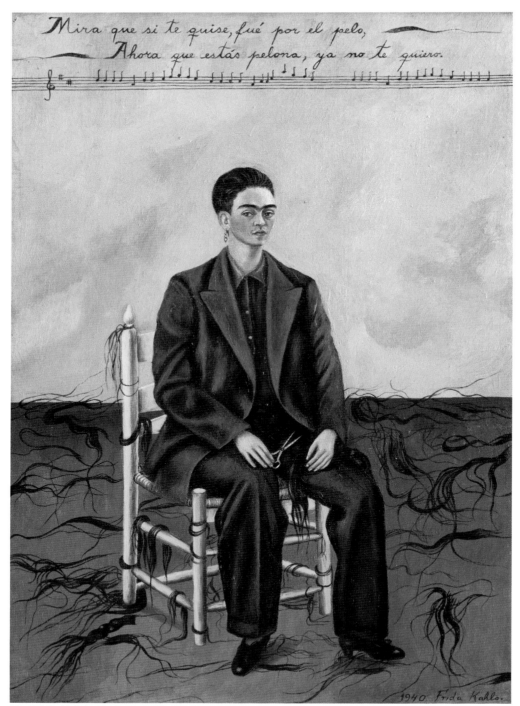

8. **Frida Kahlo**. *Self-Portrait with Cropped Hair*. 1940. Oil on canvas, 15 3/4 x 11" (40 x 27.9 cm)

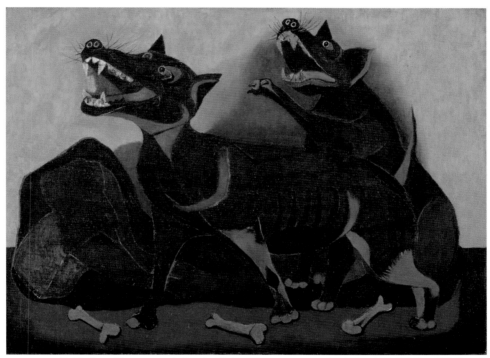

9. **Rufino Tamayo**. *Animals*. 1941. Oil on canvas, 30 1/8 x 40" (76.5 x 101.6 cm)

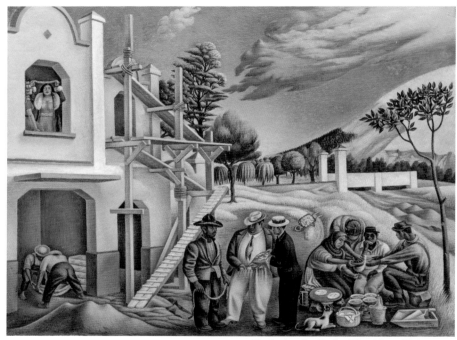

10. **Antonio Ruiz**. *The New Rich*, 1941.
Oil on canvas, 12 5/8 x 16 5/8" (32.1 x 42.2 cm)

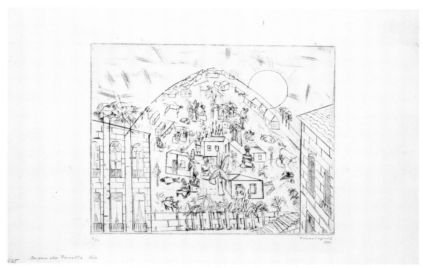

11. **Lasar Segall**. *Shantytown in Rio de Janeiro*. 1930.
Drypoint, printed in black, plate: 9 3/8 x 11 3/4" (23.8 x 29.8 cm),
sheet: 12 15/16 x 20 3/16" (32.9 x 51.3 cm)

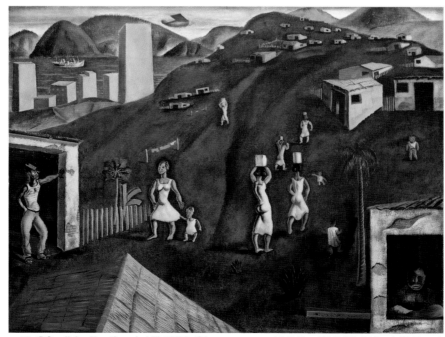

12. **Cândido Portinari**. *Hill*. 1933. Oil on canvas, 44 7/8 x 57 3/8" (114 x 145.7 cm)

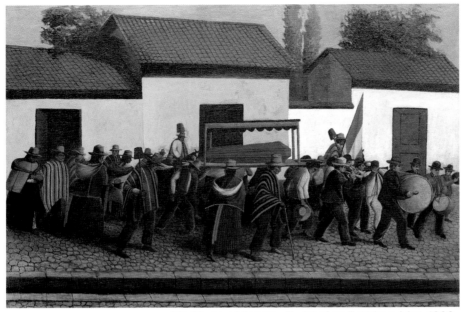

13. **Mario Urteaga**. *Burial of an Illustrious Man.* 1936.
Oil on canvas, 23 x 32 1/2" (58.4 x 82.5 cm)

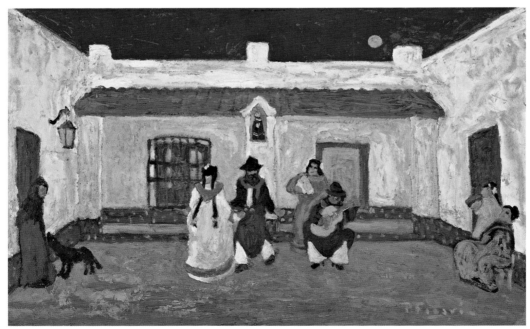

14. **Pedro Figari** *Creole Dance.* (c. 1925?). Oil on cardboard, 20 1/2 x 32" (52.1 x 81.3 cm)

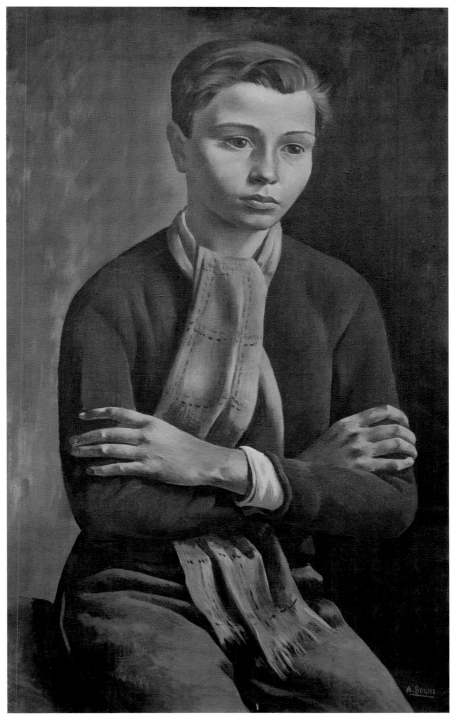

15. **Antonio Berni**. *Seated Boy*. 1942. Oil on canvas, 37 x 22 3/4" (94 x 57.8 cm)

LOOKING BACK/GOING FORWARD:
MoMA RECONSIDERS ART OF LATIN AMERICA AND THE CARIBBEAN

In considering an exhibition at El Museo del Barrio of works by Latin American and Caribbean artists from the collection of The Museum of Modern Art, the history of the formation of the collection emerged as a principal point of departure for consideration of the works themselves. The Modern has a very individual collection, one that richly represents the diversity of artists in these vast regions through the course of the twentieth century but makes no claim to be a comprehensive or representative overview. "MoMA at El Museo" is thus an effort to illuminate the history of The Museum of Modern Art's involvement with the art of Latin America and the Caribbean, and to share and celebrate these artists' achievements.

The structure of the exhibition is therefore complex, offering a narrative of the growth of the collection as well as insights into stylistic developments and thematic issues related to the works on view. Some of the works in the collection have become icons, inseparable from any contemplation of Latin American and Caribbean modern art, while others have not been exhibited since their acquisition. Our intent has been both to reveal and to deepen the understanding of the Museum's history and to stimulate renewed consideration of the works of art, both familiar and unknown.

The exhibition is divided into four primary sections that reflect the Museum's collecting activity. The first section focuses on the 1930s, the period of the first acquisitions, which were largely gifts made by Abby Aldrich Rockefeller of works by three Mexican artists: Diego Rivera, José Clemente Orozco, and David Alfaro Siqueiros. The second section, beginning in 1942 and continuing through the mid-1940s, highlights the Museum's active engagement in acquiring, largely through purchase, works by artists from throughout Latin America and the Caribbean. In this period, the collection added major works by Wifredo Lam, from Cuba; Matta, from Chile; Joaquín Torres-García and Pedro Figari, from Uruguay; Antonio Berni, from Argentina; Cândido Portinari, from Brazil; the Mexicans Frida Kahlo and Rufino Tamayo; and many others. The third section corresponds to a resurgence of collecting activity in the 1960s, again with many key artists of the period entering the collection for the first time: these included Jesús Rafael Soto, Gego, and Marisol, from Venezuela; Fernando Botero, from Colombia; Julio Le Parc and Jorge de la Vega, from Argentina; Antonio Frasconi, from Uruguay; Matthias Goeritz, from Mexico; and Rafael Montañez Ortiz, a Puerto Rican artist from New York. The final section presents works acquired since the 1990s and recognizes the renewed vitality of artists from Latin America, including Doris Salcedo, from Colombia; Arturo Herrera, from Venezuela; Fernando Bryce, from Peru; Guillermo Kuitca, from Argentina; Beatriz Milhazes, Vik Muniz, Iran do Espirito Santo, and Leonilson, from Brazil; Gabriel Orozco and Enrique Chagoya, from Mexico; Felix Gonzalez-Torres, Kcho, and Los Carpinteros, from Cuba, and many others. Not unusually in contemporary culture, a number of these artists have moved from one country to another.

Since it began to collect Latin American art in the 1930s, the Museum has generally acquired works shortly after they were made—in other words, as contemporary works of art. Only in recent years has it made more of a self-conscious effort to begin to fill in historical gaps. "MoMA at El Museo" integrates a number of such works into its respective chronological sections, notably including works by Hélio Oiticica, Lygia Pape, Mira Schendel, and Cildo Meireles, from Brazil; León Ferrari, from Argentina; Ana Mendieta, from Cuba; Eugenio Dittborn, from Chile; and others. A number of these, in addition to some recently acquired contemporary pieces, are here exhibited publicly for the first time since entering the museum's collection.

While the chronological development of the collection forms the backbone of the exhibition,

clusters of works have been organized around thematic and stylistic concerns, or to create a dialogue: groupings of works, for example, focus on portraiture, scenes of the city, and politically engaged work. Other cases highlight Op art, political Pop, and Conceptual tendencies. This publication similarly explores the development of the collection in depth, in the essay by Luis Enrique Pérez-Oramas and in the chronology prepared by Miriam Basilio—but just as we hope that in the exhibition itself the presence and experience of the works of art will be foremost, for this publication we have selected pairs or groups of works for extended focus, analysis, and appreciation by a range of authors. In some instances these choices reflect not only pivotal historical examples but also the authors' personal passions, indicating the range and richness of potential responses of which the works are capable. Among these, for example, works by Lam and Matta, Marisol and Botero, and Frasconi and Meireles are paired and contrasted.

To organize the exhibition itself, a team of curators was formed from The Museum of Modern Art and El Museo del Barrio. Our goal was to view every work of art by Latin American and Caribbean artists in the collection, and across several mediums, including painting and sculpture, drawings, prints, and artists' books. Since the artists often work in several disciplines, they may be represented in the collection in more than one of these departments. In thoroughly reviewing collection records, we discovered some cases of mistaken attribution and incomplete cataloguing.

Our curatorial team comes from diverse geographies and cultural backgrounds—a curator from Brazil, one from Venezuela, one from Puerto Rico, and two from the United States. Our respective curatorial experiences, art-historical training, and theoretical perspectives are equally varied. As we looked at artworks together, divergent points of view inevitably emerged. We learned from each other's perspectives and respected the knowledge, insight, and particular judgment each of us brought to our considerations. Remarkably, throughout the process, we reached consensus at every turn about the works to be included in the exhibition.

"MoMA at El Museo" also afforded the occasion to begin to research documents and archives so as the better to understand and reconstruct the Museum's history of acquisition, exhibition, and the use of the collection. It has allowed us to view the collection in a more analytic and rigorous framework, to recognize its strengths and shortcomings. The research and reconsideration of the collection are ongoing. Since initiating the planning for the exhibition, a number of works new to the collection have been acquired by purchase and gift. Some of these were sought out specifically to fill historical gaps. Works by contemporary artists continue to be acquired, continuing the practice the Museum initiated in the 1930s. This exhibition is thus not a conclusive summary but rather a jumping-off point for the future—for continuing to move forward, building the collection, and reaffirming our engagement with artists, institutions, and individuals throughout Latin America and the Caribbean. We hope the project will be as revelatory and exciting for others as it has been for us.

Gary Garrels
Chief Curator, Department of Drawings
Curator, Department of Painting and Sculpture
The Museum of Modern Art

FROM EL MUSEO DEL BARRIO:
A CURATOR'S NOTES ON "MoMA at EL MUSEO"

The impetus for "MoMA at El Museo: Latin American and Caribbean Art from The Collection of The Museum of Modern Art" came from MoMA. From the beginning, this effort was conceived as a collaboration involving the curatorial staff of both institutions. That invitation was extremely attractive in its potential to reveal and interpret for a broad public a selection from The Museum of Modern Art's holdings of works created by Mexican, Caribbean, Central and South American artists.

This collection—over 2,000 artworks, not including photographs, films, and industrial design—is comprehensive yet fragmentary, diverse yet limited: incongruities bespeaking a complex history of collecting, based partly on incidental knowledge and the use of parameters established prior to in-depth study and knowledge of the artworks themselves. In other words, institutional policies regarding the acquisition of works by Latin American and Caribbean artists have not been fully subject to the parameters applied in the acquisition of works created by European and American modern and contemporary artists.[1] At the same time, paradoxically, the Latin American and Caribbean collection is unique in size and content, as the works have been gathered according to an overarching geopolitical construct foreign to the acquisition policies of the great majority of museums, even in those regions. At the Modern, museological activities such as collecting, preserving, interpreting, and presenting, as applied to modern and contemporary Latin American art, have wavered in response to diverse forces exerted by, for example, U.S. foreign policy and economic interests, and collecting by the private sector (which, through its donations to museums, has become the core of most well-known Latin American "institutional" collections). Most recently, these activities have been affected by the desire to develop new categories of museum-goers. It should be noted that this analysis applies not only to The Museum of Modern Art but to most of the U.S. museums that have built collections under this geopolitical construct.[2]

Organizing a meaningful exhibition of a selection of these holdings presents a rare opportunity and a formidable challenge. On the one hand, only a small part of this collection has seen the light of day in the United States. The works that are well-known have been reproduced ad nauseam in many textbooks devoted to Latin American art, modern Mexican art, and, to a lesser degree, Surrealism. This handful of works—whether or not of historical importance—has come to symbolize the "essence" of Latin American art. There are many other works, however, that have rarely been exhibited or published and that remain unknown to scholars and the public at large. In a sense, the collaborative effort behind this exhibition provides the opportunity to bring to light the multifaceted achievements of many artists who made important contributions to the development of twentieth-century visual art, and of artists who are contributing to the art scene today, whether in their native countries or elsewhere.

The challenge of presenting a small selection of works from this particular collection, however, once again derives from the use of a geopolitical construct to frame the contents of an exhibition. Aggravating this challenge is the fact that the exhibition is presented under the auspices of El Museo, recognized today as one of the most vital Latino cultural institutions in New York and the nation, an entity that is part and parcel of the ethnic and class struggles that pertain to the history of the United States. Both the "Latino" and the "Latin American–Caribbean" labels homogenize what in reality are multiple histories, multiple cultures, multiple social stratifications. Intertwining (or not) in space and time, such factors affect the shaping of visual languages. In past decades, these comprehensive constructions have been applied in the organization of exhibitions,

publications, and conferences in a manner detrimental to the study of both the histories of art and the specific visual languages created in these broad territories, real and imaginary.

Keeping in mind these formidable constraints, we sought to create a curatorial strategy that could foster understanding of the history of the collection (in terms of our present knowledge) and at the same time provoke consideration of the works themselves. The specific selection of works included and studied here has been made in an attempt to promote different views, values, and questions implicit in the artworks themselves. It is our hope that this allows us to transcend the constraints implicit in the nature of this collaboration.[3]

For El Museo, this exhibition is in keeping with its mission. The museum was founded in New York City in 1969 by Puerto Ricans whose goal was to create educational resources and to preserve and promote their artistic and cultural heritage. In 1994, the Board of Trustees edited the mission statement so that it would include the presentation, preservation, and study of the artistic and cultural heritage of not only Puerto Ricans but all Latin Americans in the United States. Almost from the date of its inception, El Museo regarded its collection as a repository of artistic and cultural meaning for Puerto Ricans; the objects comprised by the collection served to foster the preservation of the community's collective memory. Today, the collection includes more than six thousand objects, and is extremely diverse in terms of cultures, media, and periods represented. Its strongest holdings are in Taíno objects, created by a culture that emerged in the Caribbean around 1200 C.E.; Puerto Rican *santos de palo*—devotional sculptures carved in wood and painted, dating from the nineteenth century but also made in present-day Puerto Rico; and graphic arts by Puerto Rican artists, which exemplify an outstanding school of printmaking on the island, formed in the 1950s. El Museo's

Permanent Collection also includes paintings, sculptures, and installation works by contemporary artists. As much as 85 percent of the works in the collection have been created by Puerto Rican artists working on the Island or in the continental United States, mostly in New York City. The museum recently completed a six-year project of study, conservation, and publication of a representative selection of works. This project has culminated in a national traveling exhibition and an accompanying five-volume publication, both entitled "Voces y Visiones: Highlights from El Museo del Barrio's Permanent Collection." This presentation fortuitously coincides with the museum's thirty-fifth anniversary, and preceded the development of "MoMA at El Museo."[4]

In retrospect, since the founding of El Museo del Barrio in 1969, its existence and activities have paralleled those of The Museum of Modern Art in the same city. These institutions' missions have defined their histories—including that of collecting and presentation. In fact, a motivating force behind the foundation of El Museo was the need to create suitable spaces for the presentation of the artistic and cultural manifestations, both past and present, of Puerto Ricans, in lieu of the lack of interest shown by mainstream museums. Thus, convergences in the holdings of these institutions are few and far between. Two of the extremely rare overlaps between El Museo and the Modern appear in the presentation of the work of Rafael Ferrer and Rafael Montañez Ortiz (who actually founded El Museo). These remarkable artists are represented in both collections, along with works—all in the medium of printmaking—by a handful of Puerto Rican artists, such as Adál, Rafael Tufiño, Lorenzo Homar, Carlos Irrizarry, and Antonio Martorell. Another imbrication was the early but crucial museum training of Susana Torruella Leval in The Museum of Modern Art's Department of Drawings, led by William Lieberman, in the late 1970s. She would become the Chief Curator of El Museo in 1990, and in

1993 its Director. In fact, it was during her tenure that El Museo received the invitation from Glenn D. Lowry, the Director of The Museum of Modern Art, to undertake this project. Under her leadership, "MoMA at El Museo" was embraced by the trustees and initial work on the collaboration was begun. A collaborative effort of this magnitude—between two very different institutions—is possible, I believe, thanks greatly to a shift in how the Modern now perceives its "Latin American" collections, and in the evolution of El Museo del Barrio. It is a special moment, as two institutions, each vitally important to the cultural life of New York, join their resources to the benefit of a heterogenous audience. One hopes that this collaboration will help strengthen the Museum's commitment to the study of works by Latin American and Caribbean artists and promote the acquisition of works by artists from the region informed by expertise and scholarship, as initiated in recent years. A deeply ingrained commitment on the part of The Museum of Modern Art to open itself to the production of artists in all continents bodes well for a future of richer and more complex experience of human creativity.

Fatima Bercht
Chief Curator, El Museo del Barrio

1 See Luis Enrique Pérez-Oramas's essay in the present publication, "The Art of Babel in the Americas." Pérez-Oramas, Adjunct Curator in the Department of Drawings at The Museum of Modern Art, addresses the values implicit in the Museum's mission and the way they foster an on-and-off relationship with the visual arts of Mexico, the Caribbean, and South and Central America. His essay also highlights some of the most salient characteristics of twentieth-century art in that region, and connects them to the history of simultaneous inclusion and exclusion in the formation of the Latin American collections. The in-depth archival and bibliographical research of Miriam Basilio, Curatorial Assistant in the Museum's Department of Drawings, The Museum of Modern Art, by no means exhaustive, has brought to light important information on the history of the Museum's initiatives in Latin America and the Caribbean. A summary of this research is published in this volume, under the title "Reflecting on a History of Collecting and Exhibiting Work by Artists from Latin America."

2 For a critical discussion of the complex motivations shaping the inclusion of artworks by artists from Latin America and the Caribbean in U.S. cultural circles from the 1940s onward, see Mari Carmen Ramírez, "Brokering Identities: Art Curators and the Politics of Cultural Representation," in Reesa Greenberg, Bruce W. Ferguson, and Sandy Nairne, eds., Thinking about Exhibitions (London: Routledge, 1996), pp. 21–36.

3 Gary Garrels, Chief Curator of the Department of Drawings and Curator of Painting and Sculpture at The Museum of Modern Art, describes the conceptual framework of the exhibition in the preceding essay in this volume. It is further discussed by Pérez-Oramas. This publication seeks to clarify the points of view developed in the course of the collaboration between the two museums, as well as to create a space for other scholars to address specific artworks in the collection. Public programs are also scheduled for the duration of the exhibition; these are designed to provide a forum for scholars working with exhibition materials and to inform the broader public. In addition, a teachers' resource book is available: Latin American and Caribbean Modern and Contemporary Art: A Guide for Educators, written by María del Carmen González, edited by Sarah Ganz, in English and Spanish, the Teacher Information Center at The Museum of Modern Art.

4 For the most complete history of El Museo del Barrio, see Deborah Cullen, "Institutional Timeline and Exhibition Chronology," as well as the essays by Rafael Montañez Ortiz, Gladys Peña Acosta, Petra Barreras del Río, and Susana Torruella Leval, all in El Museo del Barrio 1969–2004, vol. 1 of Fatima Bercht and Cullen, eds., Voces y Visiones: Highlights from El Museo del Barrio's Permanent Collection (New York: El Museo del Barrio, 2003).

5 The artist and educator Montañez Ortiz eloquently refers to this perception in an article published in 1971: "The cultural disenfranchisement I experience as a Puerto Rican [in New York] has prompted me to seek a practical alternative to the orthodox museum, which fails to meet my needs for an authentic ethnic experience. To afford me and others the opportunity to establish living connections with our own culture, I founded El Museo del Barrio." Remarkably, Montañez Ortiz envisioned El Museo as collectionless. "The museum as a treasure house of objects is a distortion of the cultural process; culture is embalmed and made inaccessible to people." The alternatives were multisensory presentations, portable, adjustable, and financially feasible, utilizing all sorts of media (audio- and videotape, film, and television for example) available at the time. These presentations were designed to create an experience "relevant to the people's needs." Ralph Ortiz, "Culture and the People," Art in America, May–June 1971, p. 27.

THE ART OF BABEL IN THE AMERICAS

I

Consider the following statements:

The Museum of Modern Art began to acquire work by European artists right from the time of its founding, in 1929.

The Museum of Modern Art began to acquire work by North American artists right from the time of its founding, in 1929.

The Museum of Modern Art began to acquire work by artists from Latin America and the Caribbean in the early 1930s, virtually from the time of its founding.

These statements seem banal. However, since we could not insert Asian, African, or Oceanic artists into the last sentence, this one, indeed, becomes quite striking.

In April 2001, in a report on the Museum's "Non-Western Holdings" submitted to the Museum's Curatorial Forum (a periodic gathering of staff from every curatorial department), Fereshteh Daftari, Assistant Curator in the Department of Painting and Sculpture, argued that the case of Latin American artists should be considered in the context of art produced in the Western Hemisphere. Despite this acknowledgment, the problem the report addresses is still relevant. "We all know that today universalism has been replaced with a sensitivity toward difference. The question is, how can we incorporate this new sensibility into our operations here at The Museum of Modern Art?"[1]

Through the scope of its holdings, the ambition of its aspiration to the "modern," and its international reputation, The Museum of Modern Art is a museum with a universal vocation. It must inscribe itself, in other words, in the history of the "universal museum," of which it is one avatar, and as such must draw on "enlightened" or

"humanistic" roots, and on a utopian aspiration to contain—as in a *ficción* by Borges—a fragment of every fragment that makes up the world of art.[2]

Yet given that the object of the collection is modern art at a time when the concept of modernity is fading into the past, the Museum confronts a paradoxical challenge in attempting to continue to be a universal museum. It cannot help but integrate into the parameters of its future operations a certain notion of the modern and of modernity in general, with its myriad international styles and local schools— whether the School of Paris or the New York School—that through the contingencies of artistic reception have become global models of aesthetic legitimization. According to that notion, the modern was perhaps the final period of a utopia of universality that emerged in the West with the French Encyclopedists and the Enlightenment: namely, the aspiration to identify a cultural lingua franca in which, like the image that takes shape in a kaleidoscope, the differences, striations, boundaries, and breaks in time and space that make up the world in its entirety would have no effect as such.

The Museum of Modern Art, then, cannot help but try to continue to be a universal museum. At the same time, as a bearer of the legacy of modernity, it cannot help but try to subject the very idea of universality that modernity demands to a thorough critique. In Gianni Vattimo's words, "Even should a perfecting of the tools of conservation and information transmission allow a 'world history' to be recorded, the very idea of a 'world history' is impossible."[3]

Consequently, to state that The Museum of Modern Art has collected Latin American art does not seem so trivial. In a museum whose collections are clearly identified by their formal mediums—painting, sculpture, drawings, film, video, architecture, design, photography, prints— and by these mediums' ability to express a "generic universality," the mention of a Latin

American collection appears to relegate it to a remote geographical outpost, a territory apart. The nomenclature acts like a symptom of these works' resistance to the universality of a modern lingua franca—precisely when the Museum seeks to represent the modern in its totality. This may have great significance in the self-critique in which the Museum is constantly engaged. Many works in the Museum's holdings do not fit easily into the reading of modernity that the institution has proposed through its displays of its collection and its exhibitions: some appear "modern despite modernism," to borrow the title of Robert Storr's well-known book;[4] others, while overlooked and unknown to most curators and historians, are assimilated surprisingly easily; some works simply defy integration.

This trait is not of course unique to twentieth-century Latin American art. The Museum of Modern Art holds many works by artists of different nationalities and origins that are unlikely to fit into the canonical idea of modernity. The Museum's power to legitimize and popularize notwithstanding, and regardless how basic it may seem, we must state an obvious truth: no one can legitimately use the idea of these works as "outposts of resistance against the modern canon" as a critical matrix for dismissing their quality. Nor, by the same token, can anyone use the works as a pretext for stigmatizing the idea of a modern artistic canon—relative though that idea is—that over time The Museum of Modern Art has come to embody.

The problem is different. It is, first, a problem of the policies of The Museum of Modern Art, and of the Museum as a political entity: to what point has the Museum's interest in South American art been regulated by logics outside its strict collecting strategy? Second, it is a problem in philosophy, and specifically in epistemology: is it perhaps possible to establish a precept for the modern? Is it legitimate to turn the features of major European and North American modernist works into signifiers of "distinction,"[5] aesthetic criteria with universal meaning? Then the problem is also academic: if historians, and to a certain degree curators, are necessarily the interpreters of a particular community, how can they then resonate with what a community outside their area of expertise has produced? What are the means by which works produced outside the United States enter the academic arenas where Museum of Modern Art curators are trained? Finally, the problem is also anthropological, and banal: on the broad boulevards of the First World, who cares what is happening in La Paz or Caracas?

II

"MoMA at El Museo" demonstrates the history of a geographically oriented collection within a museum marked by a formal tradition, a museum that divides and differentiates its collection by a taxonomy of art form or genre. It is the history, or one chapter of the history, of a generous interest. It is also, at times, an account of a strategy to be faulted for omissions and exclusions. It is a history of a utopian image: that of a "torpedo" advancing through the art world, carrying in its "tail" the oldest works of art and in its "nose" the avant-garde art of "the United States and Mexico," as Alfred H. Barr, Jr., the Museum's first director, imagined in 1933.[6] The show is a history of several shared shining moments in art both north and south of the "border," whose proper names—Diego Rivera, David Alfaro Siqueiros, Matta, Wifredo Lam—form part of the world heritage of the modern. It is a history of the belated recognition of a few artists—Joaquín Torres-García, Frida Kahlo, Hélio Oiticica, Gego (Gertrude Goldschmidt); and it is a history of many omissions and vast misunderstandings.

"MoMA at El Museo" is not an exhibition of The Museum of Modern Art's entire Latin American

collection, nor is it an exhibition about the art of Latin America, like exhibitions previously organized by the Museum. It is an exhibition that reflects on and historicizes the Museum's Latin American and Caribbean collection by taking a series of cross-sections of it, and then by arranging those works so that they engage each other in dialogue, illuminate each other, and even contradict each other, thereby redefining themselves.

The works are displayed chronologically, partly for reasons of clarity, partly because the history of Latin American acquisitions at the Museum begins at a specific point and continues to this day. The curatorial premise of the exhibition calls for two kinds of grouping: the first comprises four sections of emblematic, interrelated works belonging to key acquisition periods; the second contains works chosen independently of their dates of acquisition to form currents of meaning, like small archipelagos or "transformation groups"[7] in which stylistic or thematic similarities and differences function as drivers of meaning.

The four central, emblematic groupings are defined chronologically by decade: the 1930s, '40s, '60s, and the '90s to the present. These are periods in which the Museum's collecting of Latin American and Caribbean art had a special intensity. It was in the 1930s that the Museum received its first gifts of Latin American art—primarily works by the three great Mexicans, Rivera, Siqueiros, and José Clemente Orozco. Then, in the early 1940s, the U.S. government's participation in World War II unquestionably helped strengthen ties with Latin American countries. In fact the Museum began a deliberate program of seeking out art from South America and Cuba, as evidenced by Lincoln Kirstein's travels in Argentina, Brazil, Chile, Colombia, Ecuador, and Uruguay. Barr himself journeyed to Cuba and Mexico; he was interested in acquiring work to complete the representation of Latin American art in the collection. What had been an exclusively Mexican perspective rapidly broadened to include artists from Argentina, Bolivia, Brazil, Chile, Cuba, Peru, and Uruguay. But the 1940s were more complex than this cursory overview of their geopolitical traits suggests: these years would establish not only the political and military axes that would govern the global balance of power until the end of the twentieth century, but also the critical and aesthetic alignments that, after 1945, would divide the future visual arts of the American continents into north and south.

On the one hand, different parts of the South American continent produced a powerful reaction against the figurative and social modes of the Mexican muralist tradition, leading to the formation of groups and schools of abstract and nonobjective art, principally in Argentina, Brazil, Uruguay, and Venezuela. Yet since the major polemics over Latin American abstraction did not take place until after 1945 and the end of World War II, when the interest in acquiring South American art waned, the fruits of this development were not assimilated into the Museum's collection.

On the other hand, the crystallization of a powerful critical theory to accompany the emergence of new tendencies in abstract painting in New York after 1940—principally under the influence of Clement Greenberg—would make it impossible to fit much Latin American art, including its abstract modes, into the formalist criteria. These same criteria would lead to the prevalence of self-reflective art forms whose ambition lay in being identified with the purity of their medium.[8] The emergence of this basic formalist thought in the mid-1940s was certainly a factor in the epistemological rift within the visual arts of the Americas. At that point, artists who had communicated with one another in three languages—English, Spanish, and Portuguese—and had shared a single expressive universe began to "speak" numerous, often mutually untranslatable "languages" in their work.

It was only in the mid-1950s and in the 1960s, another period of geopolitical convergence between North and South America, that the Museum began to acquire artistic styles produced in Latin America since the 1940s. During the era of the Kennedy administration's Alliance for Progress, and with renewed purchases through the Inter-American Fund, works that had not been made a part of the Museum collections, such as some lyrical and geometric abstractions, were acquired. Between 1954 and 1956, for example, the Museum purchased the first Latin American abstract geometric works since it acquired Torres-García's 1932 *Composition*, in 1942. These were works by the Colombians Edgar Negret and Eduardo Ramírez Villamizar and the Cuban Luis Martínez-Pedro, and they mark a renewed aesthetic dynamic for Latin American acquisitions that would continue throughout the 1960s.[9]

During the 1960s, Pop art emerged as an international style, even while it was often stigmatized as a veiled mode of academicism or a kitsch form of artistic expression.[10] Although not reflected in the Museum collection, artistic consonances among the arts in the Americas existed during this period as they had not since the 1940s: between the Argentine Jorge de la Vega and Andy Warhol, for example, or the Venezuelan Marisol Escobar and the Argentines León Ferrari and Antonio Berni. It seemed that the arts on these continents began to suture the stylistic and aesthetic fissures that had followed the imposition of the New York canon in the late 1940s and the 1950s. Artists were once again "speaking" in a similar language: sarcastic, ironic, often cynical, always political. Once again, however, the principal beneficiary was North American, as the dynamic, consuming force of U.S. Pop imposed a hegemonic model that left many questions unanswered. Not only did many Latin American works remain out of circulation or without viewers outside their respective countries, but also, and above all, a noticeable ideological difference between Latin American and North American styles of Pop art—one that would also be a characteristic of Conceptual art on both sides of the border—was suspended.

III

At the beginning of the 1990s, and perhaps for the first time in the Museum's history, a series of institutional, historical, and strategic developments contributed to an awareness within the Museum of the existence of a specific history of Latin American art—and of the difference inherent in that history.[11] Among those developments were the renewal of democratic forms of government in a number of Latin nations; a perceptible shift in U.S. foreign policy in the region; the growing internationalization of the art world; the emergence of collections of Latin American art with international profiles both within and beyond the Americas; and, finally, the resurgence of efforts by Museum curators and trustees to support the collecting and exhibiting of works by artists from Latin America.

For the first time since the Museum began to collect Latin American art, its acquisitions were dictated by the necessity of filling in certain lacunae, making up certain deficits. Major figures in twentieth-century art had gone unrepresented in the collection. A series of external factors helped to nurture this change in strategy: the growth in North American and European academic programs for the study of Latin American art, for example. The inclusion of work by Latin American artists—until recently ignored by hegemonic curatorial practices—in global exhibitions organized by curators with high international profiles was another factor. Decisive initiatives from benefactors and patrons played a major role. Finally, public debate—often skewed by resentment and politics—on the Museum's historical role in shaping the international visibility of twentieth-century Latin American art played its part as well.

The Museum's Latin American collection contains many major works, works that are legendary for their iconic value and plastic force. Some of these are already enshrined in the collective Western imaginary. But alongside them are many artworks that are rarely if ever shown to museum-goers and are accordingly little-known, yet that evidence seminal moments in the researches of major artists and shed light on others who are rarely studied or discussed. We have tried to establish ensembles of meaning among these works and to ensure they are seen in proximity to the acknowledged masterworks, because we believe that modern art is not solely a history of prominent figures and individual names, a sum of geniuses. On the contrary, if anything distinguishes the modern interpretation of meaning, it is the formation of structural synchronies: the idea that signs, icons, symbols, styles, texts, visual forms, and works of art are dynamic elements subject to constant transformation and only make sense through comparison, analogy, repetition, and differentiation among themselves.

From the iconographic point of view, it is interesting to note that the crucial works in the Latin American collection include visual testimonies of the first political revolutions of the twentieth century: the Mexican Revolution and the Russian Revolution. The former, which began in 1910, had as its "official" artists the three great muralists Rivera, Orozco, and Siqueiros. Rivera also traveled to Russia and brought back startling images of the 1928 May Day procession in Moscow. That date, incidentally, coincides with the institutionalization of both revolutions within a repressive state apparatus identified with a single party. By 1931, the year Orozco painted his emblematic *Zapatistas,* the end of *Carrancismo*[12] and the dawn of the autocratic governments of Alvaro Obregón and Plutarco Elías Calles had dashed the Zapatista dream and thwarted its assimilation into the fledgling apparatus of the

Mexican state. Similarly, the consolidation of Joseph Stalin's regime in 1920s Russia would bring with it the death of both the revolutionary dream and, with the implementation of a Socialist Realist orthodoxy, the hopes of the avant-garde for a social and aesthetic role.

The entire body of figurative Latin American art from the first half of the twentieth century has been judged erroneously by the criteria of this realist canon, which disparages the fantastic creative motifs and enduring interest in the surreal that many Latin American figurative artists share. It also prevents an accurate understanding of the complex constellation of figurative work that, to a greater or lesser extent, shared twentieth-century creativity with vanguard modes. In Latin America or anywhere else, one cannot speak of a "return" to figuration in the 1920s unless one deems that at some point progress was made toward another mode.[13] The nonobjective modes of avant-garde art—even the most radical of them, such as Suprematism—never ceased to be inscribed within the logic of representation. Similarly, in the Americas, Asia, and Africa, relatively mimetic forms of visual representation were always practiced without this quality being a detriment to the artworks' historical relevance for the communities in which they were produced.

It is my concern here to argue for the diversity of figuration in the modern period without falling into anachronistic stigmatizations or historicist exclusions. The breadth of this art's role in modernity remains to be fully explored. Rivera and Orozco's "political" images, which bear witness to the institutionalization of the Mexican and Russian revolutions, may be set against the "tragic" images of Siqueiros, which manifest the iconographic weight of art history—in the guise of a pre-Columbian mask in *Echo of a Scream* (1937), for example, or in the more complex legacy of classical images, as in the reiteration of Uccello's fifteenth-century battle scenes

metaphysical references; of concepts of writing and existential trace, in the work of Schendel; and in Gego's work, of the intuition of a dense, striated, centerless field that evolves from the margins without a master plan, particularizing space with its irregularities.

It is important to understand that to either side of the rift that came about in the art of the Americas in the 1940s lie different models of the modern, informing the transition from modernity to the contemporary scene differently on both continents. Perhaps the obsession with the concept of "presence" that arose in North American art after Abstract Expressionism explains the triumph of theatrical Minimalism[20] and post-Conceptual art, broadly informed by the Pop legacy. In Latin America, meanwhile, the concern with articulating a modern expressive grammar of existential concepts such as "writing," "symbolic narrative," and "time" informed another modernity and thus another contemporary scene. Here Conceptual art did not do battle with materiality but held fast, with paradoxical richness, to the idea of the object.[21] Moreover, the idea of that object's ideological circulation, particularly exemplified in the work of Cildo Meireles, prevailed over the perceptual and tautological experiments that marked North American conceptualism.

The two scenes, North and South America, are not distinguished, as in an all-too-common simplification, by figuration south of the border and abstraction north of it. A complex interrogation of the human organism—the body—as a metaphor for the world informs practically all the Latin American political art that might be associated with Pop, such as the work of de la Vega, Marisol, Antonio Dias, and Ferrari. The contributions of these artists to "MoMA at El Museo" suggest interrogations that go beyond a purely stylistic historiography. It is not surprising, then, that one possible explanation for the recent growth of interest in

contemporary Latin American art is the exhaustion of the formalist criteria that for so long held sway in the model of hegemonic modernity. Perhaps a world recognized as ever more complex politically and socially is rediscovering the virtues of allegory and narrative in locating the fragmented possibilities of representation. The often scorned idea of an art linked to real communities then comes to seem like an attainable goal.

It is too soon to determine whether the aesthetic borders between the two continents have been permanently transformed—whether love and death (Ana Mendieta, Felix Gonzalez-Torres, Doris Salcedo), space and place (Guillermo Kuitca, Fernando Bryce), body and fame (Leonilson, Gabriel Orozco, Enrique Chagoya), representation, reproduction, and anamorphosis (Jean-Michel Basquiat, Beatriz Milhazes, Vik Muniz, Arturo Herrera, Kcho), and opacity and transparency (Meireles, Waltércio Caldas) can once again meet in a common language in the arts of the Americas. Perhaps it is naive to seek to elude the fate of Babel. In any event, the curatorial premise of "MoMA at El Museo" demonstrates that for the past seventy years a major art institution in the "north" has embraced the arts of the "south," proving that borders may have always been fictions—as elusive as are, for us, the four cardinal points.

Luis Enrique Pérez-Oramas
Adjunct Curator, Department of Drawings,
The Museum of Modern Art

1 Fereshteh Daftari, "Report on the Non-Western Holdings at MoMA," April 18, 2001.

2 For the "encyclopedic" foundation of the "Universal Museum," and the early polemics to which it gave rise, see Antoine de Quatremère de Quincy, Lettres à Miranda sur les déplacements des monuments de l'art de l'Italie (n.p., 1796). See also Jean-Louis Déotte, Le Musée, l'origine de l'esthétique (Paris: L'Harmattan, 1993), and Douglas Crimp, On the Museum's Ruins (Cambridge, Mass.: The MIT Press, 1993).

3 Gianni Vattimo, "La Fin de la modernité," *Nihilisme et hermenéutique dans la culture post-moderne* (Paris: Editions du Seuil, 1987), p. 15. The bibliography on the critique of modernity is overwhelmingly vast. For a brief history of the concept see Hans Robert Jauss, *Pour une esthétique de la reception* (Paris: Editions Gallimard, 1978). Other works include those of Michel Foucault, Jean-François Lyotard, Giorgio Agamben, Antoine Compagnon, Niklas Luhmann, T. J. Clark, and Edward Said. More recently, on modernity as an ideological aesthetic acting in the schools of the Western intellectual marketplace, see Fredric Jameson, *A Singular Modernity: Essay on the Ontology of the Present* (London: Verso, 2002). For a recent critique of the concept of universality, see Alain Badiou, *Saint Paul: La Fondation de l'universalisme* (Paris: Presses Universitaires de France, 1997).

4 Robert Storr, *Modern Art Despite Modernism*, exh. cat. (New York: The Museum of Modern Art, 2000).

5 See Pierre Bourdieu, *La Distinction: Critique sociale du jugement* (Paris: Minuit, 1979), Eng. trans. as *Distinction: A Social Critique of the Judgement of Taste*, trans. Richard Nice (Cambridge, Mass.: Harvard University Press, 1984).

6 In this early comparison of the structure of the Museum's collection to the shape of a torpedo, Alfred H. Barr, Jr., included a selection of ancient works ("a Fayum portrait, a Byzantine panel, Romanesque miniatures, Gothic woodcuts, a Giotto school piece, . . . Coptic textiles, . . . African and pre-Columbian objects") in the torpedo's tail while modern works by Europeans, Americans, and Mexicans were grouped in its nose. See Kirk Varnedoe, "The Evolving Torpedo: Changing Ideas of the Collection of Painting and Sculpture of The Museum of Modern Art," in *The Museum of Modern Art at Mid-Century: Continuity and Change*, Studies in Modern Art no. 5 (New York: The Museum of Modern Art, 1995), pp. 20–21. Barr's torpedo metaphor has been widely quoted but still deserves more reflection in terms of the fundamental economy of the Museum and its relationship to an image of conquest: "The Permanent Collection may be thought of graphically as a torpedo moving through time, its nose the ever advancing present, its tail the ever receding past of fifty to a hundred years ago." See Barr, *Painting and Sculpture in the Museum of Modern Art 1929–1967* (New York: The Museum of Modern Art, 1977), p. 622.

7 Taking his cue from Claude Lévi-Strauss, Hubert Damisch has developed the idea that a work of art, like a symbol, has no intrinsic, invariable meaning. Instead, its meaning varies with its position in relation to other works. Following the vocabulary of structural anthropology, the group of works being compared is called a "transformation group." See Damisch, *L'Origine de la perspective* (Paris: Flammarion, 1987), pp. 256–62, and Lévi-Strauss, *Mythologiques I: Le Cru et le cuit* (Paris: Plon, 1964), pp. 59–64.

8 "The arts, then, have been hunted back to their mediums, and there they have been isolated, concentrated and defined. It is by virtue of its medium that each art is unique and strictly itself. To restore the identity of an art the opacity of its medium must be emphasized. For the visual arts the medium is discovered to be physical; hence pure painting and pure sculpture seek above all else to affect the spectator physically." Clement Greenberg, "Toward a Newer Laocoön," *Partisan Review* 7, no. 4 (July–August 1940): 307. Also: "It follows that a modernist work of art must try, in principle, to avoid dependence upon any order of experience not given in the most essentially construed nature of its medium." Greenberg, "The New Sculpture," in *Art and Culture: Critical Essays* (Boston: Beacon Press, 1961), p. 139. For a brilliant, conclusive critique of Greenberg's modernism, see Storr, "No Joy in Mudville: Greenberg's Modernism Then and Now," in *Modern Art and Popular Culture: Readings in High & Low* (New York: The Museum of Modern Art, 1990), pp. 161–90.

9 In understanding this moment one cannot underestimate the weight of another geopolitical coordinate: the triumph of the Cuban Revolution and the attempt to export it to Latin America, as well as the United States' attempt to oppose that effort by establishing some kind of cultural strategy promoting ideas of democratic freedom and an open society.

10 See, e.g., Greenberg, *Clement Greenberg, Late Writings*, ed. Robert C. Morgan (Minneapolis: University of Minnesota Press, 2003), pp. 10–11.

11 This assertion was made, virtually verbatim, at the first preparatory curatorial meetings for "MoMA at El Museo" by Paulo Herkenhoff, Adjunct Curator in the Department of Painting and Sculpture from 1999 to 2002, and the first curator of Latin American origin invited to join the Museum's staff.

12 *Carrancismo* refers to the unstable government of Venustiano Carranza (1859–1920), which lasted from 1915 to 1920, a period that saw the assassination of Emiliano Zapata (1883–1919).

13 "The concept of the historical progress of mankind cannot be sundered from the concept of its progression through a homogeneous, empty time. A critique of the concept of such a progression must be the basis of any criticism of the concept of progress itself." Walter Benjamin, "Theses on the Philosophy of History," *Illuminations. Essays and Reflections,* edited and with an introduction by Hannah Arendt, trans. Harry Zohn (Schocken Books, New York, 1969), p. 261. No one can deny the avant-garde's contribution in the renewal of the arts in the West, but whether or not this contribution can legitimately be considered in terms of "progress" is open to debate. See Benjamin H. D. Buchloch, "Figures of Authority, Ciphers of Regression," in *October* 16 (Spring 1981), pp. 39–68. Reprinted in Brian Wallis, ed., *Art after Modernism* (New York: New Museum of Contemporary Art, 1984) and Jean Clair,

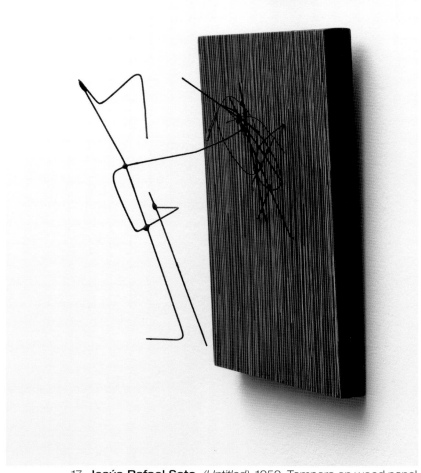

17. **Jesús Rafael Soto**. *(Untitled)*. 1959. Tempera on wood panel
with painted wire, 9 1/2 x 7 1/2 x 5 5/8" (24 x 19 x 14.1 cm)

18. **Ernesto Deira**. *Untitled*. (1963). Ink on paper, 12 5/8 x 18 7/8" (32 x 47.9 cm)

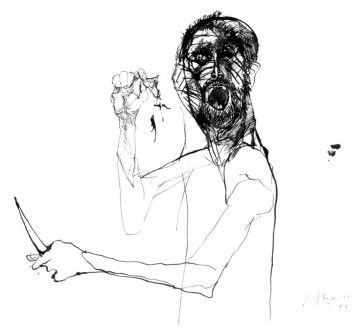

19. **Carlos Alonso**. *Van Gogh*. 1966. Pen and ink on paper, 13 3/4 x 19 5/8" (34.8 x 49.8 cm)

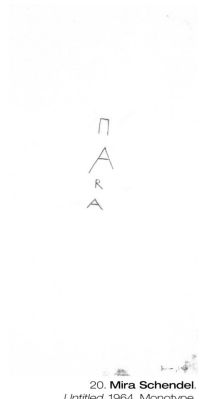

20. **Mira Schendel**.
Untitled. 1964. Monotype,
sheet: 18 1/4 x 9" (46.4 x 22.9 cm).

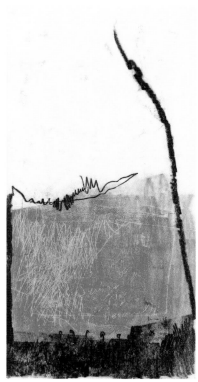

21. **Mira Schendel**.
Untitled (red). (1964). Monotype,
sheet: 18 1/2 x 9" (47 x 22.9 cm)

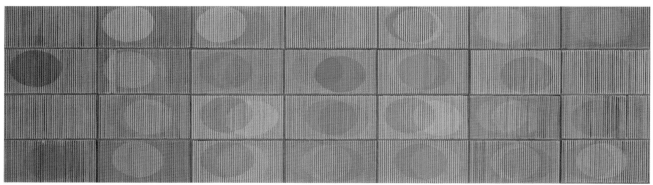

22. **Carlos Cruz-Diez**. *Physichromie, 114*. 1964. Synthetic polymer paint on wood panel and on parallel cardboard strips interleaved with projecting plastic strips (or blades), 28 x 56 1/4" (71.1 x 142.8 cm)

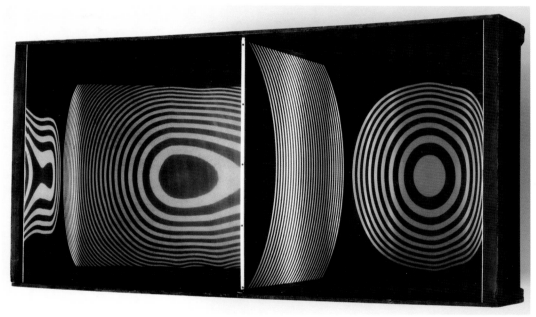

23. **Julio Le Parc**. *Instability Through Movement of the Spectator*. 1962. Synthetic polymer paint on wood and polished aluminum in painted wood box, 28 5/8 x 57 1/8 x 36 1/2" (72.6 x 145 x 92.8 cm)

24. **Anna Maria Maiolino**. *Black Hole* from the series *Holes/Drawing Objects*. 1974. Paper and Styrofoam in wooden box, sheet: 27 x 27" (68.6 x 68.6 cm)

25. **Willys de Castro**.
Abstract. 1957/58.
Ink on buff paper,
2 1/4 x 1 1/8"
(5.8 x 2.9 cm)

26. **Hércules Barsotti**. *Untitled*. 1960.
Folded photolithograph in Plexiglas mount,
comp. overall: 10 1/2 x 10 1/2 x 2 1/2" (26.7 x 26.6 x 6.4 cm)

REFLECTING ON A HISTORY OF COLLECTING AND EXHIBITING
WORK BY ARTISTS FROM LATIN AMERICA

The Museum of Modern Art, New York, is widely recognized as the first institution outside Latin America to collect art from those regions, an objective that has been intrinsic to the institution since its founding. The Museum opened to the public on November 8, 1929, with the "purpose . . . to acquire, from time to time, either by gift or by purchase, the best modern works of art,"[1] and eventually to include not only painting, sculpture, prints, and drawings but also photography, design objects, architecture, film, and graphic design. This intention is noted in *A New Art Museum*, a brochure issued in 1929 that further stated the new museum's aim to exhibit and to collect the works of "the most important living masters, especially those of France and the United States, though eventually there should be representative groups from England, Germany, Italy, Mexico, and other countries."[2] Alfred H. Barr, Jr.'s specific inclusion of Mexico was as pioneering as the goal of including various media within the scope of the collection.

Through its collection, exhibitions, and organization of related educational events and publications, the Museum has played an important role in shaping the reception of Latin American art in the United States. Yet despite the early acquisition of works by Latin American artists, only two exhibitions—in 1943 and 1967—focusing on what the Museum has called its "Latin American collection" have been held at the Museum. The present exhibition, "MoMA at El Museo: Latin American and Caribbean Art from the Collection of The Museum of Modern Art," jointly organized by a team of curators from The Museum of Modern Art and El Museo del Barrio, is the first time since 1967 that a selection of works in various media from this part of the Modern's collection is on view in a New York City museum.[3] "MoMA at El Museo" is a reflection on the history of the Modern's collection of art by artists from Latin American and Caribbean countries and presents a cross-section of notable acquisitions

from key periods in its formation (the 1930s, the 1940s, the 1960s, and recent acquisitions); it draws from the departments of Painting and Sculpture, Drawings, and Prints and Illustrated Books, and includes artists' books from the Museum Library as well.[4]

This part of The Museum of Modern Art's collecting history has generated much controversy for two reasons. In more than one instance the Museum's ties to Latin American artists coincided with broader political and economic circumstances that affected relations between the United States and Latin America. This issue has been the subject of a number of studies.[5] It cannot be claimed, however, that these circumstances were the sole determining factors behind the formation of this collection. Further research is also needed to understand how exhibitions and publications interpreted the work by Latin American artists that the Museum acquired. Despite its early interest in collecting art from Mexico and later from other countries in the region, the inclusion of Latin American artists in the Museum's collection galleries has been episodic and even negligible. For students of Latin American art, The Museum of Modern Art's "Latin American collection" has been an intriguing mystery. More heard about than seen, it has been rarely presented and is known largely through old exhibition catalogues, newspaper articles, and archival research.

This essay will present an overview of tendencies in the collection and exhibition of works by Latin American artists at the Museum, focusing on the three departments represented in "MoMA at El Museo."[6] The pivotal role of the Museum's curators—most notably Barr, from 1929 until his retirement in 1967—and the generosity of donors who have contributed to the formation of this diverse group of works will be noted. The one-person or group exhibitions specifically devoted to artists from the region are always mentioned when the history of the Museum's interest in Latin American art is

discussed. This is obviously important, since a number of those exhibitions led to acquisitions or donations of works for the collection, and many introduced the artists to North American audiences. However, by limiting the discussion to exhibitions focusing *only* on Latin America, part of the history is obscured. Besides being shown in region-specific contexts, Latin American artists have been included in a number of Museum exhibitions that helped to define key movements in modern art.[7] They also have been included as key figures in the shaping of international tendencies, and not simply as artists from a particular country or region. However, although these artists were included in such canonical exhibitions and some of their works later entered the collection, with notable exceptions they were rarely exhibited again. The presence of Latin American artists within the Museum's influential exhibitions surveying tendencies in modern art points the way to a possible means of incorporating these works into the collection galleries today. Also relevant here is the record of initiatives intended to promote the study and exhibition of Latin American artists, which for diverse reasons never advanced. Along with the objects now in various Museum departments, and the records of exhibitions organized over the years, these proposals testify to a recurring interest in the work of artists from this region on the part of Museum staff members, Trustees, and donors, and suggest paths that might be followed toward the future integration of these works into the main body of the museum collection. Today, the record of the Museum's earlier initiatives serves as a useful instrument as it reconsiders its approach to collecting and exhibiting work by artists from Latin America.

FIRST GIFTS: THE 1930s
In 1935, Abby Aldrich Rockefeller,[8] one of the founders of the Museum, donated to it a number of paintings and works on paper by Diego Rivera and José Clemente Orozco, inaugurating what has come to be known as its "Latin American collection." In fact initial interest focused on a particular tendency within specifically Mexican modern art: the work produced by the three leaders of the Mexican mural movement, Rivera, Orozco, and David Alfaro Siqueiros.[9] Rivera had been the subject of what today would be called a "blockbuster" solo show. Held at the Museum in 1931, it was only the second such show devoted to a living artist.[10] Notable acquisitions from the 1930s include major works donated by Rockefeller, among them Orozco's *The Subway* (1928); Rivera's *May Day, Moscow* (1928), a group of forty-five watercolors; and his *Flower Festival: Feast of Santa Anita* (1931).

In 1930, "An Exhibition of Work of 46 Painters and Sculptors under 35 Years of Age" included works on loan from private collectors by the Mexican artist Miguel Covarrubias, as well as by Fides Elizando and Jean Charlot, both of whom had resided in Mexico.[11] "American Sources of Modern Art (Aztec, Mayan, Incan)" was shown at the Museum in 1933, and color reproductions of Mexican frescoes by Rivera were part of the traveling exhibition "A Brief Survey of Modern Painting in Color Reproductions." Neither Wifredo Lam nor Matta (Roberto Sebastián Antonio Matta Echaurren) were included in the groundbreaking 1936 exhibition "Fantastic Art, Dada and Surrealism," but Siqueiros's *Collective Suicide* (1936), which later entered the Museum collection, was shown.

In 1939, work began to be acquired by artists from countries other than Mexico. The painting *Hill* (1933), by Cândido Portinari, and *Mother and Child*, a 1939 drawing by Lam, were the first works acquired by artists from Brazil and Cuba respectively. The following year, the exhibitions "Twenty Centuries of Mexican Art" and "Portinari of Brazil" were held. For the Mexican exhibition, which included pre-Columbian, colonial, folk art, and modern art,

Orozco was commissioned to paint the portable fresco panels *Dive Bomber and Tank*. Thanks to the Abby Aldrich Rockefeller Fund this work entered the collection in 1940, along with Rivera's portable fresco *Agrarian Leader Zapata* (1931), which had been commissioned from the artist for his 1931 exhibition. Following the Portinari exhibition the Museum acquired several prints and drawings by that artist, as well as his mural *Festival, St. John's Eve* (1938–39). The mural was among a handful of works that were destroyed in the fire that struck the Museum on April 15, 1958.

THE 1940s AND THE INTER-AMERICAN FUND

The most active period of the Museum's acquisition of Latin American art began with the endowment of the Inter-American Fund in 1942. Nelson Rockefeller, President of the Museum's Board of Trustees from 1939 to 1941,[12] anonymously endowed this fund, which was designated for the acquisition of works from Latin America. Lincoln Kirstein was appointed Consultant on Latin-American Art and assigned to travel to Argentina, Brazil, Chile, Colombia, Ecuador, Peru, and Uruguay to purchase works for the Museum.[13] By 1943 there were almost 300 works by artists from Latin America in the Museum collection. It has been argued that Rockefeller believed that Kirstein's cultural contacts and purchases could be used to create "good will" in South America toward the Allies and the U.S. government. During 1942–43, the years when he was employed as a museum consultant, Kirstein also made reports to U.S. State Department representatives in the countries he visited regarding the political attitudes of, among others, local intellectuals and artists toward the Axis powers.[14]

From an art-historical perspective, it is clear that Kirstein missed opportunities to purchase works for the Museum by major modern artists working in the countries he visited, such as Tarsila do Amaral, whose work he saw in Brazil.[15] However, it should be noted that when Kirstein was traveling, art-historical university courses or surveys devoted to the countries he was to visit were not available in English. (Courses devoted to the art and culture of Mexico were the exception to this situation.[16]) At the time the Museum did not accept a number of Kirstein's purchases for the collection; among those that were acquired were several works by self-taught or amateur artists that have not stood the test of time. Despite the fact that Kirstein's motives were more often diplomatic than art-historical, he did acquire works by important artists, including Antonio Berni's *New Chicago Athletic Club* (1937) and Joaquín Torres-García's *The Port* (1942). Kirstein's approach was at odds with Barr's.[17] In his published and private statements, Barr drew a distinction between curatorial criteria for acquiring works of art of the highest quality and the potential collateral benefit of cultural exchanges, that is, greater sympathy for the values of the Allies and the U.S. government.

In 1942, Barr himself traveled to Mexico for two weeks, and also spent eight days in Cuba accompanied by Edgar G. Kaufmann, a curator in what was then the Museum's Department of Industrial Design.[18] During his trip to Mexico, Barr acquired paintings, drawings, and prints by Raúl Angiano, José Chávez Morado, Antonio Ruiz, and Rufino Tamayo, as well as prints by Leopoldo Méndez and others produced by the Taller de Gráfica Popular. In 1943 Kaufmann donated *Self-Portrait with Cropped Hair* (1940), the first work by Frida Kahlo to enter the collection. This illustrates how Mexican artists such as Kahlo, whose work ran counter to the predominant mural movement, entered the collection at a time when they were not prominent in their own country.[19]

In anticipation of the 1944 exhibition "Modern Cuban Painters," organized by Barr and the

Cuban curator José Gómez Sicre, Barr acquired works by Amelia Peláez, Mariano Rodríguez, Fidelio Ponce de León, Cundo Bermúdez, and Mario Carreño, among others.[20] The Cuban exhibition was the first survey of contemporary art from the island held in an American museum and included works on loan as well as from the Museum collection. From January 13 to February 15, 1942, works purchased in various Latin American countries were exhibited for the first time at the Museum in "New Acquisitions: Latin American Art".[21] Among the works shown were *Christ* (1941) by the artist Maria (Maria Martins), a gift from Nelson Rockefeller, and Siqueiros's *Echo of a Scream* (1937), a gift from Edward M. M. Warburg. Other works in various media by Lam, Rivera, Siqueiros, and Portinari were acquired through the Mrs. John D. Rockefeller, Jr., Purchase Fund. The exhibitions "Mexican Children's Art and Mexican Costumes by Carlos Mérida" were also held that year.

More than 200 works purchased by Kirstein and Barr, as well as gifts and several loans from collectors and artists, were shown in "The Latin American Collection of the Museum of Modern Art," from March 31 to June 6, 1943. The 1943 catalogue by the same name, with an essay by Kirstein and an introduction by Barr, remains today the only illustrated reference to the first two decades of the Museum's Latin American acquisitions.[22] Other exhibitions held at the Museum in 1943 were "Recent Acquisitions: May-Day Sketchbook of Diego Rivera," and "Brazil Builds", which ran from January 13 to February 28. Barr's correspondence attests to his continuing interest in a number of artists other than the Mexican muralists, including Roberto Berdecio, Pedro Figari, and Torres-García, and to his efforts to acquire and exhibit their work.

In 1939, Museum Trustee Sidney Janis proposed a group show of contemporary South American artists. A member of the Exhibitions Committee identified in Museum records only as Mrs. Russell suggested Torres-García for inclusion in that exhibition.[23] Had such an exhibition taken place in 1939, it would be viewed today as a remarkable early instance of the recognition of Torres-García's work in the United States. Between 1942 and 1946, Barr and members of the Museum's Exhibitions Committee proposed solo exhibitions of Ruiz[24] and Siqueiros,[25] as well projects that would pair Ruiz with Siqueiros, or with Carlos Mérida. Barr faced opposition among members of the board that led to difficulties in the approval of a number of exhibitions of the work of artists from Latin America during the 1940s. Although the Exhibitions Committee accepted the group show and the solo exhibitions of Ruiz and Siqueiros, objections were raised and the shows were never held.

In particular, Andrew Conger Goodyear, a Trustee and one of the Museum's founders, felt that too many exhibitions had already been devoted to the region.[26] Goodyear may have also been reacting to the number of exhibitions sent to venues in the United States and Latin America by the Museum's Department of Circulating Exhibitions, which had been founded in 1933. The first of these was "Three Mexican Artists" (Rivera, Orozco, and Siqueiros) in 1938–39; this was followed by twelve more Latin American exhibitions over the next eight years.[27] In their meeting of October 7, 1943, the Exhibitions Committee debated mounting "Modern Cuban Painters," citing the issue of the large number of Latin American exhibitions that had taken place. Barr argued that wartime conditions made loan exhibitions from Europe impossible to organize, and that the works proposed for display were, for the most part, of good quality. According to the minutes, Goodyear accepted Barr's assertion that this show was "good in quality and can be judged on its own merits," but added "that the Museum should clarify its policy in regard to good neighbor exhibitions."[28] It should be noted that these reservations were made

within the context of staff and Trustee discussions about the merits of several exhibitions organized by the Museum as part of its contracts with the U.S. government.[29] Those projects focused on propaganda posters, prints, and other materials explicitly related to the Allied war effort.

In 1945, the year in which this intense period of travel and of the collection and exhibition of Latin American art peaked, a pioneering conference on the subject was held at the Museum. "Studies in Latin American Art" took place from May 28 to 31;[30] speakers addressed the study of pre-Columbian, colonial, modern, and folk art and the state of the field within the United States. Most discussed the need to offer academic courses in their fields in U.S. universities, and the need for English-language reference materials. In his lecture, Barr acknowledged that he was not an expert in the field and that politics in part had motivated the American interest in the region during World War II. This, according to Barr, led to "a good many errors, both of policy and taste." Barr noted the dual difficulty posed on the one hand by suspicions held in Latin America about the political motives behind U.S. cultural initiatives, and on the other by the "cynicism in [the United States] where even exhibitions, publications, and acquisitions of superior material were often discounted because they were Latin American, and, supposedly, must have been undertaken for political reasons." He concluded by reiterating his commitment to collecting and exhibiting work by Latin American artists: "We have a serious responsibility to justify what we did then in a state of emergency by our continuing interest now that the emergency is past."[31]

That same year, Barr prepared the first general installation of the Museum's collection of painting and sculpture, which included one-third of the collection—almost 300 paintings and 75 sculptures.[32] His preliminary plan and the final checklist indicate that he viewed much of the work by Latin American artists that had been acquired since 1935 within the context of the Museum collection as a whole, and as relevant to international tendencies in modern art. For instance, within the section referred to as "Cubist Tradition" in the preliminary checklist, Peláez's 1938 painting *Still-Life in Red* was to be shown alongside works by Stuart Davis, Lionel Feininger, and Charles Demuth. In the "Abstract Painting—Out of Cubism" gallery, Berdecio's *The Cube and the Perspective* (1935) would be seen with works by El Lissitzky, Kasimir Malevich, Piet Mondrian, and Jean Hélion. A gallery of realist works included Bermúdez's *Barber Shop* (1942), Carreño's *Tornado* (1941), Figari's *Creole Dance* (c. 1925?), Kahlo's *Self-Portrait with Cropped Hair*, and Juan O'Gorman's *Sand Mines of Tetelpa* (1942) among works by Thomas Hart Benton, Edward Hopper, and Charles Burchfield. Works by Tamayo and Ponce de Léon were shown in a gallery of romanticist work. Not surprisingly, given both the number of works by Rivera, Orozco, and Siqueiros within the initial gift by Abby Aldrich Rockefeller, and Kirstein's preference for figurative work with local or political references, quite a few works by Mexican artists were included in a section titled "Social Comment." Among them were: Orozco's *Zapatistas* (1931), Ruiz's *The New Rich* (1941), Rivera's *Agrarian Leader Zapata* (1931), and Orozco's *Dive Bomber and Tank*. A series of galleries were devoted to fantastic art, and here Siqueiros's *Collective Suicide*, Mérida's *Tempo in Red Major* (1942), and Matta's *Listen to Living* (1941) were shown with works by artists such as Wassily Kandinsky, André Masson, Joan Miró, and Jackson Pollock. A section on allegory included Siqueiros's *Echo of a Scream*, Lam's *The Jungle* (1943), and Matta's *The Vertigo of Eros* (1944). Barr's presentation of a global view of modern and contemporary art tendencies—including the work of Latin American artists—in many ways anticipated the current, broadly international state of contemporary art.

and to acquire both contemporary and historical works. She advocated regular trips to meet artists and view local collections, and emphasized the importance of dialogue with scholars from the region and the need to acquire research materials for the Museum. In other words, her efforts were geared toward integrating the study and acquisition of Latin American art within the research and administrative procedures already in place for the rest of the Museum's collection. Between 1966 and 1968, Johnson traveled to Argentina, Bolivia, Brazil, Chile, Colombia, Costa Rica, Ecuador, El Salvador, Guatemala, Honduras, Mexico, Nicaragua, Panama, Peru, Uruguay, and Venezuela. Her journeys, which were sponsored by the Museum's International Council, led to the acquisition of drawings, prints, and artists' books. In 1968, she began to submit proposals intended to further the study, exhibition, and collection of Latin American art at the Museum.[51]

In 1969, Bates Lowry (the Museum's Director for less than a year, from 1968 to 1969) announced that Johnson would be conducting a study of the Museum's activities related to Latin American art, including works in the collections of the departments of Painting and Sculpture and of Drawings and Prints.[52] This was the first time such a role had been assigned within the Museum since Kirstein's tenure as consultant. Later that year, Trustee Walter Bareiss (who led the Museum on Lowry's departure from 1969 to 1970, along with Counsel Richard Koch and Director of Exhibitions Wilder Green) informed Johnson that no funds were available to implement her proposals. Bareiss cited David Rockefeller's involvement with the Center for Inter-American Relations, an organization Rockefeller had founded in 1965 to promote political, economic, and cultural ties between Canada, the United States, and Latin America. Staff and resources would be devoted to facilitating collaboration between the Museum and the Center, but the Latin American exhibitions that would result were to be held at

the Center, not at the Museum.[53] From 1969 through 1971, Johnson was an associate curator in the Department of Painting and Sculpture. In 1970 she proposed a solo exhibition of Kahlo to be accompanied by a catalogue and planned for 1972; in 1971 she proposed "Foreign Observers: The Sketchbooks of Diego Rivera in Moscow," "Jules Pascin in Cuba," "Jean Dubuffet and Nancy Graves in Morocco" and "Contemporary Drawings from Canada and Latin America." None of these exhibitions took place.[54]

1970–1989

Although the number of works by Latin American artists that entered the collection in the 1970s declined in comparison to the previous decade, there were important gifts, such as the gift by Kleiner, Bell & Co. of 3,000 prints produced between 1960 and 1970 at the Tamarind Lithography workshop in Los Angeles.[55] Paintings and drawings by Matta came into the collection from the James Thrall Soby Bequest.[56] Through the David Rockefeller Latin American Fund, drawings by Juan Downey and Antonio Seguí entered the collection, as did prints by Soto.

The Museum's early interest in Mexican art was rekindled in a number of exhibitions around this period: in 1971, an exhibition of photography by Manuel Alvarez Bravo was held, and five years later "The Architecture of Luis Barragán" was on view at the Museum. In 1978, "Mexican Art," jointly organized by Lieberman and Alexandra Schwartz, was shown at the Museum[57]; it included over eighty drawings, prints, and paintings from the collection. "Latin American Prints from the Museum of Modern Art" was organized by Castleman and shown at the Center for Inter-American Relations in 1974. This exhibition is the only one to date to focus on one of the strengths of the Museum's holdings of art by Latin American artists: prints and illustrated books.

A number of exhibitions held at the Museum between 1970 and 1989 included Latin American artists. "Information," organized in 1970 by Kynaston McShine, then an Associate Curator in the Department of Painting and Sculpture, played a major role in the recognition of Conceptual art and included the work of Cildo Meireles, Hélio Oiticica, and the New York Graphic Workshop (Camnitzer, José Guillermo Castillo, and Porter). "The Artist as Adversary: Works from the Museum Collection," organized in 1971 by Betsy Jones, drew from aspects of socially committed art—including prints—produced by artists from Latin America. This was also the case in the 1988 exhibition "Committed to Print: Social and Political Themes in Recent American Printed Art," organized by Deborah Wye, Chief Curator of the Department of Prints and Illustrated Books. In 1980, Rasmussen proposed "Modern Art from Latin America," for showing at the Museum and international venues; it would have included loans and works from the collection, but was not held due to difficulties in fundraising and securing loans and venues.[58] Finally, in 1971, the "Projects" shows began, a series of exhibitions of work commissioned from contemporary artists; this program has featured a number of artists from Latin America over the years. The work of most of these artists, among them Felix Gonzalez-Torres, Guillermo Kuitca, Meireles, Leonilson, and Gabriel Orozco, are now represented in the Museum's collection.

RECENT DEVELOPMENTS

The 1990s marked a renewal of interest in exhibiting and collecting Latin American art at The Museum of Modern Art. This was due in part to broad forces such as the development of international exhibition networks—biennials, for example—including artists from all over the world; a number of major traveling exhibitions[59] organized in the United States and abroad; the rise in the number of academic departments

offering art-history courses in Latin American art; and the creation of a market for Latin American modern and contemporary art. No doubt the ease of air travel and the emergence of the Internet have also greatly facilitated the exchange of information and the development of personal ties. In addition, the increase in the Latino and Latin American population in the United States has encouraged awareness and appreciation of these cultures. Most importantly, as more exhibitions devoted to pre- and postwar artistic tendencies incorporate Latin American artists into their art-historical narratives, the possibility of recognizing the relevance of works in the Museum's collection widens.

The most recent exhibition of modern and contemporary Latin American art held at the Museum, "Latin American Artists of the Twentieth Century," shown in the summer of 1993, was a survey organized by Rasmussen that included works from the Museum as well as many more on loan from public and private collections.[60] A variation of the exhibition originally proposed by Rasmussen in 1980, the show included over 400 works and was one of the largest traveling exhibitions of art by Latin Americans. Versions of the exhibition, which traveled in 1992–93, were presented at the Estación Plaza de Armas, Seville; the Musée national d'art moderne, Centre Georges Pompidou, and the Hôtel des Arts, Paris; and the Museum Ludwig at Josef-Haubrich-Kunsthalle, Cologne, before the tour concluded at the Modern. By presenting rarely seen works from the Museum collection alongside loans from other museums and private collections all over the world, Rasmussen contributed to a greater awareness of the importance of the works in the collection.

A number of recent exhibitions have borrowed Latin American works from the Modern that have not been exhibited at the Museum itself for decades. These include "The Latin American Spirit: Art and Artists in the United

States, 1920–1970," which traveled between 1988 and 1990; "Art in Latin America: The Modern Era, 1820–1980," presented in 1989 at the South Bank Centre in London; and the 1992 exhibition "Wifredo Lam and His Contemporaries, 1938–1952," at the Studio Museum in Harlem, which included a number of works the Museum acquired in Cuba during the early 1940s.[61] Within the Museum, several exhibitions since the late 1990s have featured works by artists from Latin America and the Caribbean.[62]

A crucial aspect of this renewed interest in modern and contemporary art from Latin America within the Museum is the creation of a position for an adjunct curator with expertise in the field. Paulo Herkenhoff—the first adjunct curator from Latin America, in the Department of Painting and Sculpture (1999–2002)—fostered discussions across departments about the representation of artists from Latin America in the collection. In 2002, Luis Enrique Pérez-Oramas joined the Department of Drawings as the second adjunct curator from Latin America. Both have worked with the Museum's curators, studying the holdings in their respective departments and identifying possible acquisitions of work by modern and contemporary artists. The research undertaken in preparation for the present exhibition has also contributed to this ongoing and twofold process: to identify gaps in the representation of artists and movements, as well as in the relationship between Latin American work and the Museum collection as a whole.

For the most part, the works acquired from the 1930s through the 1980s, either as gifts or purchases, entered the collection shortly after they were created. It is no accident that the greatest number of works representing the widest range of countries entered the collection between 1942 and 1943 and again in the 1960s, periods when curators working for the Museum proposed purchases following travel to Latin America, Cuba, and Puerto Rico. This means, however, that many important artists and tendencies are not represented in the collection at all, or that artists are represented by works that are "snapshots" of particular moments in their careers, rather than by work from their maturity. It also means that some artists who work in more than one medium may be represented by work in only one technique. Notable exceptions to this include Gego, Lam, Marisol, Matta, Meireles, Gabriel Orozco, Rivera, Siqueiros, Soto, and Torres-García, who are now represented in various media and therefore several Museum departments. From the 1930s through the '80s, the emphasis on collecting generally focused on acquiring contemporary works; over the last decade, greater attention has been paid to collecting works in order to remedy historical gaps, while at the same time continuing to acquire contemporary works.

This new approach to collecting both historical and contemporary work is now possible because of the acquisitions of the Museum's curators and the generosity of Trustees, collectors, and family members of several artists. Notable in this regard are the gifts from Museum Trustee and International Council member Patricia Phelps de Cisneros, a Venezuelan collector who has also lent her support to initiatives fostering the study of Latin American art within the Museum, in locations including the International Program, the Museum Library, and the Department of Education.[63] Among her gifts to the Museum are works by Kuitca, Meireles, Lygia Pape, Gego, Oiticica, and Gabriel Orozco. Agnes Gund, a collector of contemporary art, Museum Trustee, and President Emerita of the Board, has made a number of gifts to the Museum, including works by Ana Mendieta, Beatriz Milhazes, and, with Museum Trustee Lewis Cullman, Gabriel Orozco. Brazilian collector and International Council member Gilberto Chateaubriand has also donated work by Waltércio Caldas and Oiticica to the Museum,

the latter given with Manuel Francisco do Nascimento Brito. The Oiticica family has also presented the Museum with a number of gifts of the artist's work, as has the Estate of Leonilson.

Both Herkenhoff and Pérez-Oramas have also been involved with various research, educational, and editorial initiatives that have furthered collaborations with scholars, museum professionals, and institutions in Latin America while fostering interest in the field within The Museum of Modern Art. In the fall of 2002, the symposium "Traveling, Exhibiting, Collecting," made possible by the International Council, was organized by Herkenhoff and Jay Levenson, Director of the International Program.[64] Levenson and Herkenhoff also initiated a series of anthologies of Latin American art criticism that are now being prepared by the International Program. The first of these, *Listen, Here, Now! Argentine Art in the 1960s: Writings of the Avant-Garde*, is forthcoming.[65]

A number of other programs have furthered research, acquisitions, and professional exchange with colleagues in the region. The International Program administers the Cisneros Travel Fund, which enables members of curatorial departments to travel to Latin America. Museum staff in various departments have taught courses or led workshops in a number of Latin American countries, and in 1998 a workshop for Latin American museum professionals was held at the Museum. Milan Hughston, Chief of Library and Museum Archives, recognized the potential of the Museum's important holdings in Latin American publications of different kinds and created the position of Latin American Specialist, greatly expanding the Library's holdings in this area, which now total over 15,000 items, including books, periodicals, and exhibition catalogues as well as artists' ephemera and press clippings.[66] The Museum's Department of Education has initiated a number of programs in collaboration with Latin American institutions,

such as the Visual Thinking Curriculum, currently implemented in schools in Argentina and Venezuela. In 2004 the Department of Education will produce its first teachers' guide to works by artists from Latin America in the collection, which will be available to educators internationally and will be published in English and Spanish editions.

CONCLUSION

As Pérez-Oramas has observed, what is informally referred to as the Museum's "Latin American collection" is the only portion of its collection that is identified according to a geographic region rather than by media within a department, indicating a lack of integration with the narratives about modern art that are elaborated within the Museum.[67] Works categorized geographically rather than according to art-historical context are clearly not seen through the same critical lens as those in the rest of the Museum. A number of contemporary artists represented in the Museum collection, such as Vik Muniz, Gabriel Orozco, or Gonzalez-Torres, are largely regarded not as "Latin American" artists but as important artists exhibiting within an international context. Paradoxically, this means that only those artists whose work has not been incorporated into international exhibition circuits are still primarily regarded as "Latin American" modern or contemporary artists. The classification of North American– or European-born artists who have lived or live and work in Latin America, such as Goeritz or, more recently, Francis Alÿs, is another complex issue.

Just as these works suffer by being grouped according to a regional framework that denies their individual artistic, aesthetic, and historic specificity, the framing of this history according to geographic criteria poses difficulties for the historian. Not surprisingly, given the amount of work by Mexican artists in the collection,

numerous studies have focused on the reception of Mexican artists in the United States and on the role of the Museum as collector and organizer of exhibitions of Mexican art. Another area of the Museum's history that has attracted scholars is the role of the Rockefeller family, particularly the period when Nelson Rockefeller served as coordinator of the U.S. Department of State's Office of Inter-American Affairs. The study of the Museum's ties to Latin America poses several challenges, among them the danger of characterizing specific relationships among members of the Museum's staff, artists, and collectors according to generalized motives that may be relevant only to one country, or to a specific moment in time. The many events and motivations leading to particular exhibitions and acquisitions should not be viewed as static or monolithic, nor should past motives be projected into the present. What is more, a particular issue, such as the political context for cultural relations between the Museum and a given country or region, should not be viewed as the sole determining factor behind an exhibition or acquisition.

Since the Museum has not yet produced a full catalogue of this aspect of the collection, and since most of this work has not been on view for decades, it is easy for many to forget that it is thanks to the generosity of the Rockefeller family, beginning with Abby Aldrich Rockefeller and continuing through the present day, that the Museum has acquired works of major historical importance, including work commissioned by the Museum (such as the portable frescoes by José Clemente Orozco and Rivera). It would be difficult to acquire many of the works included in "MoMA at El Museo" today, or to find other work of similar quality.

Analysis of the relationships between works in the Museum's so-called Latin American collection and the Museum collection as a whole are useful in formulating new ways of interpreting and presenting works in the collection by artists from Latin America. Several questions should be considered, such as: How were works by Latin American artists exhibited, whether in collection galleries or in temporary exhibitions? How were Latin American artists represented in the Museum's seminal exhibitions defining important movements in modern art? Furthermore, if these artists were regarded by their contemporaries as key participants in movements such as Surrealism, Op art, or Conceptual art, how should this be taken into account in the understanding and presentation of the collection? It is now possible to reconsider the importance of historical modern works by Latin American artists in the collection, as well as to recognize institutional precedents, such as Barr's 1945 presentation of the collection. Recent developments—curatorial initiatives to fill historical gaps in this area, for example, as well as the continued support by Trustees and collectors of art from these countries—make possible a full integration of historical and contemporary work by Latin American artists into all aspects of the Museum's curatorial and educational activities.

Miriam Basilio
Curatorial Assistant, Department of Drawing,
The Museum of Modern Art

1 Alfred H. Barr, Jr., *A New Art Museum*, 1929, quoted in "Chronicle of the Collection of Painting and Sculpture," in *Painting and Sculpture in the Museum of Modern Art 1929–1967* (New York: The Museum of Modern Art, 1977), p. 620

2 Ibid., p. 620. Barr also explicitly mentioned Mexico in "Report on the Permanent Collection," prepared in 1933. See Kirk Varnedoe, "The Evolving Torpedo: Changing Ideas of the Collection of Painting and Sculpture of The Museum of Modern Art," in *The Museum of Modern Art at Mid-Century: Continuity and Change, Studies in Modern Art* No. 5 (New York: The Museum of Modern Art, 1995), pp. 13–73.

3 El Museo del Barrio was founded in 1969 and collects and exhibits Caribbean and Latin American art. The exhibition team is, from MoMA: Gary Garrels, Chief Curator, Department of Drawings, and Curator,

Department of Painting and Sculpture; Luis Enrique Pérez-Oramas, Adjunct Curator, Department of Drawings; and the present author, Miriam Basilio, Curatorial Assistant, Department of Drawings. From El Museo: Fatima Bercht, Chief Curator, and Deborah Cullen, Curator.

4 The Museum's important collection of artists' books, many of them acquired by former Library Director Clive Philpot in 1994 as part of the Franklin Furnace Archive, includes the work of Augusto de Campos, Eugenio Dittborn, León Ferrari, Alfredo Jaar, and Claudio Perna, among other artists from Latin America. Although the Museum has an extensive history of presenting and collecting film, video, and photography, funding and space constraints made it impossible to present these works in "MoMA at El Museo."

5 A number of these studies will be cited in the text below. In preparation for this exhibition and its accompanying publication, research was conducted on works by Latin American artists in the three departments represented in the exhibition, as well as on artists' books in the Museum's Library. Sources include files in departmental Museum collection archives, the Department of the Registrar, and the Museum Archive, as well as museum exhibition catalogues and other publications. Further research will surely shed more light on the Museum's exhibiting and collecting of works by artists from Latin American countries.

6 See also Waldo Rasmussen, "Introduction to an Exhibition," in *Latin American Artists of the Twentieth Century* (New York: The Museum of Modern Art, 1993), pp. 11–17, for an introduction to MoMA's ties to Latin America. Rasmussen joined the Department of Circulating Exhibitions in 1954; he was Director of the International Program from 1962 to 1993, when he became the program's Director Emeritus.

7 Most of these exhibitions have accompanying publications, and the references may be consulted in the Museum of Modern Art Library; see the online catalogue at http://library.moma.org. The checklists and in most cases press releases for those exhibitions that did not have accompanying publications are held in the files of the Department of the Registrar at the Museum, and are noted below.

8 See Sam Hunter, "Introduction," in *The Museum of Modern Art: The History and the Collection*, 1984 (reprint ed. New York: The Museum of Modern Art, 1993), pp. 9–24; Riva Castleman, "Prints and Illustrated Books," in ibid., pp. 327–28; and Deborah Wye, *Abby Aldrich Rockefeller and Print Collecting: An Early Mission for MoMA*, exh. brochure (New York: The Museum of Modern Art, 1999).

9 Writings that shed light on the reception of Mexican art in the United States include Laurance Hurlburt, *The Mexican Muralists in the United States* (Albuquerque: University of New Mexico Press, 1989); Alejandro

Anreus, *Orozco in Gringoland: The Years in New York* (Albuquerque: University of New Mexico Press, 2001); Jacinto Quirarte, "Mexican and Mexican-American Artists in the United States: 1920–1970," in *The Latin American Spirit: Art and Artists in the United States, 1920–1970* (New York: The Bronx Museum of the Arts and Harry N. Abrams, Inc., 1988); Shifra M. Goldman, *Dimensions of the Americas: Art and Social Change in Latin America and the United* States (Chicago and London: The University of Chicago Press, 1994); and Dawn Ades, Renato González Mello, and Diane Miliotes, eds., *José Clemente Orozco in the United States, 1927–1934* (Hanover: Hood Museum of Art, and New York: W.W. Norton, 2002). There are also a number of unpublished studies: Holly Barnet Sánchez, "The Necessity of Pre-Columbian Art: United States Museums and the Role of Foreign Policy in the Appropriation and Transformation of Mexican Heritage, 1933–1944" (Ph.D. diss., University of California, Los Angeles, 1993); Cathleen M. Paquette, "Public Duties, Private Interests: Mexican Art at New York's Museum of Modern Art, 1929–1954" (Ph.D. diss., University of California, Santa Barbara, 2002); and Anna Indych, "Mexican Muralism without Walls: The Critical Reception of Portable Work by Orozco, Rivera and Siqueiros in the United States" (Ph.D. diss., Institute of Fine Arts, New York University, 2003).

10 See Rasmussen, "Introduction to an Exhibition," p. 11. According to Rasmussen, almost 57,000 people, a "record-breaking number," attended the exhibition.

11 See Eva Cockcroft, "The United States and Socially Concerned Latin American Art: 1920–1970," in *The Latin American Spirit*.

12 On Nelson Rockefeller and the Museum see Hunter, Introduction, pp. 14, 20–21, 31, and 35.

13 Stephen C. Clark, Chairman of the Board, The Museum of Modern Art, letter to Lincoln Kirstein, October 26, 1942. Kirstein, File 7-A, The Museum of Modern Art Archives, New York. Clark writes, "We have no provisions in our budget for setting up a Latin-American Department."

14 Gustavo Buntinx has conducted extensive research on Kirstein's activities and his ties to Rockefeller and the State Department, which he is preparing for publication. Cathleen Paquette also discusses this aspect of Kirstein's activities. See Paquette, "Public Duties," 216–218.

15 Lincoln Kirstein Papers, "Latin American Notes," The Museum of Modern Art Archives, New York.

16 See Elizabeth Wilder, "Call for Pioneers," *Art Journal* 1, no. 1 (November 1941): 6–9 for the state of the field as of 1940. See also Quirarte, "Mexican and Mexican American Artists in the United States," pp. 14–71; and Ades, González Mello, and Miliotes, eds., *Orozco in the United States.*

17 Barr and Kirstein had a falling-out after Kirstein's article "The State of Modern Painting" was published in the October 1948 issue of *Harper's*, critiquing modernism, abstract art, and The Museum of Modern Art. See Sybil Gordon Kantor, *Alfred H. Barr, Jr. and the Intellectual Origins of The Museum of Modern Art* (Cambridge, Mass., and London: The MIT Press, 2002), p. 233.

18 Edgar G. Kaufmann had joined the Museum in 1940 as curator. In 1946, after serving in World War II, he was named Director of the Industrial Design Department, a post he held until 1948. Following the creation of the Department of Architecture and Design, he acted as Research Associate and Consultant in Industrial Design until 1955. From 1950 to 1955 he organized the Good Design program at the Museum. He was also an adjunct professor of art history and architecture at Columbia University from 1963 to 1986.

19 See *Modernidad y Modernización en el Arte Mexicano, 1920–1960* (Mexico City: Instituto Nacional de Bellas Artes, 1991).

20 Barr's essay "Modern Cuban Painters" and a checklist published in *The Museum of Modern Art Bulletin* XI, no. 5 (April 1944), served as the exhibition's catalogue; José Gómez Sicre's book *Cuban Painting of Today* (Havana: María Luisa Gómez Mena, 1944) was published to coincide with the exhibition. Gómez Sicre was a Cuban art historian Barr met while on the island. Wifredo Lam denied permission for the Museum to show his work in the exhibition owing to disagreements with Gómez Sicre, who was the Cuban organizer, and with the sponsor Maria Luisa Gómez Mena, the wife of painter Mario Carreño, who was included in the exhibition.

21 See the press release "Museum of Modern Art Acquires Heroic Statue of Christ Sculptured in Wood by Brazilian Artist," and checklist of the exhibition.

22 Kirstein, *The Latin American Collection of The Museum of Modern Art* (New York: The Museum of Modern Art, 1943).

23 "Exhibitions Proposed by the Exhibition Committee of The Advisory Committee of The Museum of Modern Art," EMH I.12.a, The Museum of Modern Art Archives, New York.

24 The Antonio Ruiz show was proposed by Monroe Wheeler, then Director of Exhibitions and Publications, at the Exhibitions Committee Meeting of November 30, 1943, and was supported by Barr and René d'Harnoncourt, then serving in the Museum's Administrative Council as Vice President in Charge of Foreign Affairs, who suggested a pairing with Carlos Mérida. A member of the committee identified only as Mrs. Levy proposed that the Ruíz exhibition should be put on the calendar, and Barr seconded; the proposal was approved on April 24, 1944. Committee Minutes 20 a-b, The Museum of Modern Art Archives, New York. For more on Wheeler's tenure at MoMA, see Barr, "Chronicle of the Collection of Painting and Sculpture," p. 650; and Hunter, "Introduction," p. 19.

25 The Siqueiros exhibition was proposed at an Exhibitions Committee meeting in November 1942. At an October 1948 meeting, Wheeler proposed that approved exhibitions be scheduled; among them was an exhibition pairing Siqueiros and Rufino Tamayo. Committee Minutes 20 a-b, The Museum of Modern Art Archives, New York.

26 A number of combinations and dates were proposed but none of the exhibitions was held. Other exhibitions proposed and rejected during this period were "Art of the Twenty-One American Republics," proposed in 1941; exhibitions of Mexican artists José Guadalupe Posada and José Maria Velasco, both proposed in 1943; exhibitions of the Cuban artist Rafael Moreno, who had been recommended by Pierre Loeb, and of the painter German Novoa, both proposed in November 1944; a solo exhibition of Figari, proposed in December 1945; and a retrospective of José Clemente Orozco, proposed in April 1946. See Committee Minutes 20 a-b (Minutes of meetings of the Exhibitions Committee of The Museum of Modern Art, 1939–1948), The Museum of Modern Art Archives, New York. Goodyear, a collector and former Director of the Albright Knox Gallery in Buffalo, was the Museum's first President and served in a number of capacities until 1939. According to Kantor, he and Barr had disagreements about a number of acquisitions, among them works by Surrealist artists and Mark Rothko. See Kantor, *Alfred H. Barr, Jr*, pp. 356–59, 371–72.

27 See Rasmussen, "Introduction to an Exhibition," p. 12.

28 Committee Minutes 20 a-b (Minutes of the Exhibitions Committee Meeting, October 7, 1943), The Museum of Modern Art Archives, New York. This was a reference to Franklin Delano Roosevelt's Good Neighbor Policy, an effort to foster closer political and economic ties with Latin America during World War II in the hopes of gaining support for the Allied war effort.

29 According to Barr, "In connection with World War II, the Museum executed thirty-eight contracts . . . for various governmental agencies, including the Office of War Information, the Library of Congress, and the Office of the Coordinator of Inter-American Affairs; nineteen exhibitions were sent abroad and twenty-nine were shown in the Museum, all related to the War." See Barr, "Chronicle of the Collection of Painting and Sculpture," p. 627; and Hunter, "Introduction," pp. 20–21, 24. See also EMH I.12.h. (Advisory Committee Report on the Exhibition Policy of The Museum of Modern Art, April 1944), The Museum of Modern Art Archives, New York.

30 See Wilder, ed., *Studies in Latin American Art: Proceedings of a Conference Held in The Museum of Modern Art, New York, 28–31 May 1945* (Washington, D.C.: The American Council of Learned Societies, 1949).

31 See Alfred H Barr, "Problems of Research and Documentation in Contemporary Latin American Art," in Wilder, ibid. 37–48; 38, 42.

32 See the press release "Museum of Modern Art Opens Large Exhibition of Its Own Painting and Sculpture," and checklist of the exhibition. In his preliminary plan for this installation, Barr included Torres-García's *Composition* (1932) in a section he called "Post-Cubist (American)." See "Museum Collection: Categories made by A.H.B. Jr. for tentative plan of arrangement of galleries for Museum Collection exhibition June 1945," DCM VII. ADD B.E.1., The Museum of Modern Art Archives, New York.

33 See Paquette, "Public Duties," pp. 287–335.

34 See Varnedoe, "The Evolving Torpedo," 12-73.

35 D'Harnoncourt (1901–68) left his native Vienna in 1925 for Mexico, where he sold Mexican pre-Columbian and folk art and organized exhibitions for the Mexican government. Exhibitions he organized at the Museum included *Indian Art of the United States* (1941) and *Ancient Art of the Andes* (1954). For more on d'Harnoncourt see Hunter, "Introduction," p. 386; Barr, "Chronicle of the Collection of Painting and Sculpture," p. 650; and Rasmussen, "Introduction to an Exhibition," p. 12.

36 The International Program was directed by Porter McCray from 1952 to 1962. See Helen M. Franc, "The Early Years of the International Program and Council," in *The Museum of Modern Art at Mid-Century: At Home and Abroad*, Studies in Modern Art No. 4 (New York: The Museum of Modern Art, 1994), pp. 109–49. See also Rasmussen, "Introduction to an Exhibition," p. 13.

37 See Franc, "The Early Years of the International Program and Council," and Michael Kimmelman, "Revisiting the Revisionists: The Modern, Its Critics, and the Cold War," both in *The Museum of Modern Art at Mid-Century: At Home and Abroad*, pp. 39–55.

38 Rasmussen, "Introduction to an Exhibition," p. 14. Rasmussen traveled to São Paulo to coordinate the U.S. representation at the Bienal: the MoMA exhibition *Jackson Pollock: 1912–1956*.

39 Ibid., p. 13. The hanging of *The Jungle* has aroused controversy. See John Yau, "Please Wait by the Coatroom," *Arts Magazine* 63 (December 1988): 56–59.

40 Rubin was curator in the Department of Painting and Sculpture in 1967, chief curator from 1968 to 1973, then director from 1973 to 1990. See Hunter, "Introduction", pp. 34–36.

41 See Andrea Giunta, *Vanguardia, internacionalismo y política: Arte argentino en los años sesenta* (Buenos Aires: Paidós, 2001). For a discussion of the Alliance for Progress and exhibitions of Latin American art in the United States, see esp. pp. 241, 244–42, 266–67, 275–80, and 305–31.

42 These acquisitions coincided with investments by the Rockefeller family in Central and South America; see ibid., pp. 263–66. See also Frances Stonor Saunders, *Who Paid the Piper? The CIA and the World of Arts and Letters* (New York: New Press, 2000).

43 See Rasmussen, "Introduction to an Exhibition," p. 15, and Giunta, *Vanguardia, internacionalismo y política*, pp. 284–94.

44 Jesús Rafael Soto was originally to be included in "The Responsive Eye," but decided not to participate because of disagreements about the context in which it was shown. See Teresa Grandas, "Chronology," in Guy Brett, ed., *Force Fields: Phases of the Kinetic* (Barcelona: Museu d'Art Contemporani de Barcelona, and London: Hayward Gallery, 2000), pp. 213–14. I am grateful to Valerie Hillings for this information.

45 Philip Johnson was the first Director of the Department of Architecture, and served in this capacity in 1932–34 and 1945–54. He joined the Museum's Board of Trustees in 1957.

46 The Sidney and Harriet Janis Collection comprises 103 paintings and sculptures and has been described as "the greatest single gift of modern and contemporary art in the Museum's history." See Hunter, "Introduction", and Barr, "Chronicle of the Collection of Painting and Sculpture," pp. 645, 648.

47 The works in Gallery 19 were on view from March 17 to April 30, those in Gallery 20 from March 28 to June 4. See the press release and checklist. Barr's catalogue of the collection includes extensive and comprehensive illustrations of works by artists from Latin America. See Barr, *Painting and Sculpture in the Museum of Modern Art*, pp. 204–17, 284, 287–90, 306–7, 311, 313, 341, 352, 368, 371, 373–75, 389, 394, 438, 442, 445, 458, 467, 480, 488, 502–5, and 509. Mentions of acquisitions are also found in Barr's "Chronicle of the Collection of Painting and Sculpture," pp. 625, 627, 629, 633–35, 639, 641–43, and 646–49.

48 See Hunter, "Introduction," pp. 27–28, 34, 36. William Lieberman had joined the Museum in 1945 as Barr's assistant. He became Curator of the Department of Drawings and Prints in 1960 and its Director in 1966. In 1967 he was named a curator in the Department of Painting and Sculpture, and was Director in that department from 1969 to 1971. He became the first Director of the newly formed Department of Drawings in 1971 and held that position until 1979. He is currently chairman of the Modern Art Department of the Metropolitan Museum of Art, New York.

49 Elaine L. Johnson was Assistant Curator from 1961 to 1963, and Associate Curator of Drawings from 1963 to 1969.

50 Castleman joined the Museum in 1969, was appointed Curator in 1971, and Director of the Department of Prints and Illustrated Books in 1972. Castleman was later Deputy Director for Curatorial Affairs, from 1986–1992.

51 These proposed initiatives included an in-depth study of the Museum's holdings in order to identify gaps in the collection; a survey of 100 years of printmaking in Latin America; a historical overview of the Latin American collection to update the 1943 exhibition and publication; collaboration with universities offering courses in Latin American art; invitations to scholars from various countries to lecture to Museum staff, Trustees, and members of acquisition committees; exchanges of publications between the Museum and cultural institutions in Latin America; and the hiring of Latin American staff and interns in order to foster diversity. See Elaine Johnson, unprocessed records from The International Program (Latin America), The Museum of Modern Art Archives, New York.

52 Works on paper were included in the Department of Painting and Sculpture until 1960, when the Department of Drawings and Prints was formed. In 1971, departments of Drawings and of Prints and Illustrated Books were established as separate entities. See Hunter, "Introduction," 27–28, 34, 327.

53 See Memo from Walter Bareiss to Elaine Johnson, May 15, 1969, unprocessed Elaine Johnson files from the Department of Drawings and Prints; memo from Bareiss to Lieberman, August 11, 1969, W. S. Lieberman Papers, I A. 1. 50 a, The Museum of Modern Art Archives, New York. For more information on the Center for Inter-American Relations (now the Americas Society), see A Hemispheric Venture: Thirty-Five Years of Culture at the Americas Society, 1965–2000 (New York: Americas Society, 2000).

54 Memo from Elaine Johnson to Virginia Allen and Bernice Rose, March 1, 1971, unprocessed Elaine Johnson records from the Department of Drawings and Prints, now in the Department of Drawings.

55 See Castleman, "Prints and Illustrated Books," in The Museum of Modern Art: The History and the Collection, pp. 327–30.

56 James Thrall Soby was Director of the Department of Painting and Sculpture from November 1943 through January 1945, a Trustee beginning in 1942, and Chair of the Acquisitions Committee from 1941 to 1943. See Barr, "Chronicle of the Collection of Painting and Sculpture," pp. 640, 650.

57 See the press release and checklist.

58 Rasmussen, "Introduction to an Exhibition," p. 16. The essays commissioned for the planned catalogue were later published in Damian Bayón, ed., Arte moderna en América Latina (Madrid: Taurus Ediciones, 1985).

59 See the discussion of these recent exhibitions in the essay that follows by Deborah Cullen.

60 Waldo Rasmussen with Fatima Bercht and Elizabeth Ferrer, eds., Latin American Artists of the Twentieth Century (New York: The Museum of Modern Art, 1993). Although currently out of print, this publication remains an important English-language reference book for the field.

61 See The Latin American Spirit: Art and Artists in the United States, 1920–1970 (New York: The Bronx Museum of the Arts and Harry N. Abrams, Inc., 1988) and Wifredo Lam and His Contemporaries, 1938–1952 (New York: The Studio Museum in Harlem, 1992). Art in Latin America: The Modern Era, 1820-1980 (New Haven: Yale University Press, 1989).

62 In 1997, the Museum mounted a retrospective of the work of the Mexican photographer Manuel Alvarez Bravo. "Arte Latinoamericano, 1920–1945," organized by Wendy Weitman for travel to Mexico City's Museo de Arte Moderno in 1998, included works from the collections of the Museum's departments of Painting and Sculpture, Drawings, and Prints and Illustrated Books. That same year, "Latin American Drawings" organized by Kathy Cumy and Mary Chan was exhibited in the Museum's drawings-collection galleries. "New to the Modern: Recent Acquisitions from the Department of Drawings," organized in 2001 by Gary Garrels, included a number of important new acquisitions of work by Gego, José Toirac, and Los Carpinteros. Other recent collection exhibitions, among them "Art of the Forties," 1991, organized by Castleman in 1991; "Mapping," organized by Robert Storr in 1994; "To Be Looked At," at MoMA QNS from July 2001 and continuing at the time of this publication; and "Stranger in the Village" organized by Jordan Kantor and Elizabeth Mangini (2002) have all included modern and contemporary works by artists from Latin America and the Caribbean. The same is true of "Tempo," curated by Paulo Herkenhoff, assisted by Miriam Basilio and Roxana Marcoci and "Drawing Now: 8 Propositions," curated by Laura Hoptman, both from 2002, which included works from the collection, loans, and commissioned pieces.

63 Patricia Phelps de Cisneros has been a member of the Board of Trustees since 1992 and a member of the International Council since 1981.

64 The symposium was coordinated by José Roca, Director of Temporary Exhibitions, Biblioteca Luis Ángel Arango, Bogotá. The speakers were Holly Barnet Sánchez, Buntinx, Andrea Fraser, Giunta, Roca, Mari Carmen Ramírez, and Mary Anne Staniszewski. The proceedings have not been published, but audio recordings of the event may be consulted at the MoMA Archive.

65 Two further publications in the series will be devoted to the writings of the Venezuelan art historian Alfredo Boulton and to the Brazilian curator Adriano Pedrosa.

66 Donald Woodward, Latin American Specialist from 2001 to 2003, brought in over 5,000 titles and launched an online bibliography of Latin American art, to be found at http://momaapps.moma.org/shtmlpgs/lab/Home.html. A new Latin American specialist has recently been hired by the Library. James A. Findlay was the first bibliographer of Latin American art at the Museum, working there from 1979 to 1983. See his *Modern Latin American Art: A Bibliography* (Westport, Conn., and London: Greenwood Press, 1983).

67 A number of similar issues arise in relation to the exhibition and documentation of the Museum's "non-Western" holdings; I am grateful here to Fereshteh Daftari for sharing her unpublished "Report on the Non-Western Holdings at MoMA," April 18, 2001.

TOWARD A HORIZON

*Artists have successfully crossed
borders that politicians have not.*
Shifra Goldman, *Caribbean Visions:
Contemporary Painting and Sculpture*, 1995

In 1991, Robin Cembalest wrote in *Artnews*, "Once upon a time, schoolchildren were taught that Columbus discovered America. . . . The textbooks are being rewritten, and the story has gotten more complicated. The word 'discovery' is gone."[1] In a case of déjà vu, however, the June 2003 *Artnews* carried the feature story "Rediscovering Latin America," by Roger Atwood. Twelve years later, the public is still cast as explorers penetrating the mysteries of the dark terrain quaintly known as "Latin America." In one of the slowest-echoing "booms" in twentieth-century art, the Latin American craze has been rhythmically reverberating every few years for the past several decades—a persistent fad that just won't quit.

After the uncertain political conditions that were widespread in Latin America in the 1960s and through the mid-1970s, the early 1980s saw a renewed stability that generated economic reinvestment.[2] At the same time, as Paulo Herkenhoff and Geri Smith have argued succinctly, Latin American art, earlier positioned for U.S. audiences as "exotic," "surreal," or "magical," developed into "postdictatorship" art, leaning on centuries of artistic achievement to address the ecological, political, and social challenges faced by rapidly developing economies.[3] Latin American art was suddenly once again of great interest in the United States, in both the critical arena (museums, symposia, books) and the market (gallery, auction, collection).

At the same time, a broader interest in Latino culture was brewing. Certainly the multicultural 1980s fed this ethnic fever. By 1992, and the quincentenary of Columbus's "discovery" of the Americas, the notion of the hyphenated American, or of the hybridization of U.S. culture,

was common currency. The 500th-anniversary celebrations, many of them fostering a corrective spirit and focusing on Latin American artistic and cultural traditions, helped breed interest. Over the last twenty years, demographics outlining the major marketing constituencies constituted by Latin American populations in New York, Chicago, Miami, Houston, Los Angeles, and other cities have also received attention. This past year, in fact, Latinos, when counted as a homogenous group, have for the first time attained the dubious honor of the title "majority minority"—the largest minority population—in New York City, destined to be the largest demographic in the country. These groups have inscribed well-traveled "cultural corridors," living networks that link U.S. sites with far points on the map, maintaining valid and vibrant Latin American and Caribbean "spaces" outside their geographic boundaries.[4] In the final analysis, the myriad, faceted, mestizo mélange that can be understood by the broad term "Latin American" has been part and parcel of the mongrel culture of the United States since the beginning.

The idea of "Latin American art," then, is in itself a problematic construct: the term implies a group of related works from fraternal but distant regions, yet also often includes work by artists of Latino descent living here in the United States. At the same time, as an isolated grouping, it seems to pose a separate but singular history, discourse, or framework. This troubled construct, as many have noted, may have been created in the United States under the auspices of The Museum of Modern Art.

Felix Gonzalez-Torres was born in Cuba and schooled in Puerto Rico, and he arrived in the United States at the age of twenty-two. The Museum of Modern Art collections management database classifies him as "American," a nomenclature determined by his passport. Had we relied on that database more completely than we did in organizing "MoMA at El Museo," he could have slipped through into the ether,

cast out by the computer's nationality field. I am reminded of the "passport" Adal created for his work *El Spirit Republic de Puerto Rico*, an artistic liferaft thrown to Puerto Rican artists who are always, miserably, classified as "American." Created for citizens of one of the world's last colonies, *El Puerto Rican Passport* (1995) reminds us that this is not yet a truly postcolonial era.[5] Over time the nuances of this type of classification will only grow. And we would do well to remember that Gonzalez-Torres and Adál, in their complexities and divergencies, are in fact the epitome of "American," which at heart, usually means "from elsewhere."

Over these last decades, serious efforts have been made to look at the extensive production of so-called Latin American and Latino artists— be they from the northern or the southern continent, from the Caribbean islands, or smack in the middle of the United States. In doing so, some have served up sweeping surveys that lump indigenous and colonial languages, religions, and traditions into one grand narrative, while others have taken more precise, scholarly, critical, and focused stances, contributing greatly to the scholarship in the field.[6] There is, however, a dilemma that must be acknowledged. While the need to move beyond "the use of geographical sites . . . as artistic categories," or to "go beyond reductive geopolitical parameters,"[7] is strong, there continue to be lacunae within the information that is widely available on what is meant by "Latin American/Latino art." Histories are not well elucidated, art is not visible. While many works are scattered through various public collections, few are placed on permanent display to become part of a broadly understood visual vocabulary. The available critical work, serious research, and well-developed scholarship is still fairly limited. Both texts and images are difficult to access, let alone analyze and synthesize.

And so, in distinction from the sweeping purview of museums like the Modern, more specifically oriented institutions began to spring up. The hard-fought struggles for equal rights and representation that began in the 1960s, welled in the '70s, and exploded during the multicultural inclusiveness of the 1980s brought into being a family of ethnically and racially specific organizations to address the needs and histories of different communities.

El Museo del Barrio, for example, was born in June 1969, when Martin W. Frey, Superintendent of School District 4 in New York City, under pressure from parents and community activists to implement cultural-enrichment programs for Puerto Rican children, appointed artist/educator Rafael Montañez Ortiz to create educational materials for District 4 schools on Puerto Rican history, culture, folklore, and art. At the time, this educational district covered parts of Central Harlem and East Harlem. Montañez Ortiz was primarily hired to serve the population of East Harlem, known as "El Barrio," where the majority of the Puerto Rican population lived.

As an artist, activist, and teacher at the High School of Music and Art, Montañez Ortiz was aware of the urgent need to create cultural resources for Puerto Ricans of all ages. Reconceiving his mandate from Frey, he created a community museum dedicated to the Puerto Rican diaspora in the United States, and he served as the Director of that museum from June 1969 to the spring of 1971.[8] The mission of El Museo is to present and preserve the art and culture of Puerto Ricans and all Latin Americans; the permanent collection comprises approximately 6,500 objects, ranging from pre-Columbian Taíno materials through popular visual traditions (such as *santos* and masks) and graphics to modern and contemporary art.

The early history of El Museo del Barrio was complex, intertwined with struggles over the control of educational and cultural resources in New York City and with the national civil rights

movement. Between 1966 and 1969, through public demonstrations, strikes, boycotts, and sit-ins, African American and Puerto Rican parents, teachers, and community activists in Central and East Harlem had demanded that their children—who, by 1967, composed the majority of the city's public school population—receive an education reflecting their diverse cultural heritages. In 1969, these activists obtained their goal of decentralizing the Board of Education, won for themselves community participation in structuring the school curriculum, and directed financial resources toward ethnicity-specific cultural programs that enriched their children's education. The energy and dedication to social justice of East Harlem's Puerto Rican community prepared the way for the founding of El Museo del Barrio.

Of course, the creation of El Museo was inspired by previous and concurrent efforts in the greater metropolitan region that sought both to nurture the unique contributions of Puerto Ricans and to broaden the mainstream's familiarity with, interest in, and appreciation of those contributions. Most notably, Friends of Puerto Rico, founded in the late 1950s, provided studio space for Puerto Rican artists and presented exhibitions of their work.[9] By 1969, the year El Museo was founded, two other organizations sought to serve Puerto Rican and Latino artists: OLA and El Taller Alma Boricua.[10] By the mid-1970s, several offshoots of Friends of Puerto Rico were available to promote the work of Latin American artists. The Cayman Gallery in SoHo was an influential venture that highlighted Puerto Rican and Latin American art. The Museum of Contemporary Hispanic Art (MoCHA) presented solo and group exhibitions in a prestigious venue.[11] In 1975, the Association of Hispanic Arts, Inc. (AHA), was created as a nonprofit umbrella organization dedicated to the advancement of Latino arts, artists, and art organizations.

For Puerto Rican and Latino artists, these organizations and institutions emerged as forums or spaces providing information and presentation opportunities that were otherwise lacking. But while institutions such as El Museo del Barrio still have important work of this kind to do, complex issues face us as we move forward. Luis Camnitzer, a thinker who has noted the pioneering importance of ethnicity-specific institutions, has also reflected on their contradictory purpose, noting an inherent conflict and paradoxical burden in validating those excluded by tacitly reinforcing the notion of a (broadened) canon. He has also argued that traditional methodologies of circulation, to the extent that they depend on class-based vertical ascension (via gallery representation, sales, auctions, museum collections, and so on), may not allow what he terms "coherent communities" to develop.[12] Then again, there is the idea that we might be developing strongholds of tokenism.

What options then are available to us? While staff members of El Museo and MoMA were in contact with each other interestingly early on, it has taken us over thirty years to undertake this single collaboration;[13] and if we imagine a bright future, El Museo and the Museum, in seeking to enrich their respective collections of Latin American art, may logically end up competing with each other. Certainly the vertical channels that worry Camnitzer are not threatening El Museo's communities just yet, and MoMA, meanwhile, is pursuing materials quite different from what we at El Museo can dream of. But where are we heading? Is the work of Diego Rivera, say, better suited to adding to MoMA's well-developed narrative or to helping us construct our developing one? There are only finite quantities of such works out there in the world.

It saddens me to think of all the city's institutions vying to create and defend separate stories: El Museo del Barrio, The Studio Museum in Harlem, the Asia Society, the Museum for African Art, The Jewish Museum, the Museum

of Tibetan Art, the Whitney Museum of American Art, the National Museum of the American Indian How can any of us seek to create historical collections that only tell one story, never another? We might consider ridding ourselves of the concepts of ownership and collection and creating instead a grand pool, a centralized, many-tentacled grouping of objects, from which we could all pick and choose—an object-oriented version of Internet hypertext. That may sound impossible as a museological structure—yet is it so different from Alfred Barr's unrealized scheme of the "evolving torpedo," his plan to pass MoMA's works on to the Metropolitan Museum once they reached a certain age, and to replace them with the young and new? Somewhere between the real and the visionary, if we are lucky, lie both our museums' futures.

Deborah Cullen
Curator, El Museo del Barrio

1 Robin Cembalest, "Goodbye, Columbus?" *Artnews* 90, no. 8 (October 1991): 104–9. In this essay, for ease of discussion, I have conflated all more nuanced terms under the shorthand "Latin America" and "Latino."

2 Brazil, Argentina, Chile, Uruguay, and Paraguay were ruled by dictatorships during these years, and in Mexico, Panama, El Salvador, and Nicaragua, the economies were unsteady.

3 Paulo Herkenhoff and Geri Smith, "Latin American Art: Global Outreach," *Artnews*, October 1991, pp. 88–93.

4 See Tomás Ybarra-Frausto "Latin American Culture and the United States in the New Millenium," *Collecting Latin American Art for the 21st Century*, ed. Mari Carmen Ramírez with Theresa Papanikolas (Houston: Museum of Fine Arts, 2002), pp. 31–59. While the idea of "cultural corridors" is Néstor García Canclini's, I am indebted to Rafael Emilio Yunén, the Director of Centro Cultural Eduardo León Jimenes, Santiago, Republica Dominicana, for the idea of borderless "spaces," which I embrace to describe these U.S. enclaves.

5 For this term see Taína Caragol, "Intersecting Circles: Prints and Drawings of Transnational Latin America and the Caribbean," at www.prdream.com/galeria/index.html.

6 Watershed Latin American survey exhibitions include "Art of the Fantastic: Latin America 1920–1987," organized by Holliday T. Day and Hollister Sturges (Indianapolis Museum of Art, Indiana, 1987); "Hispanic Art in the United States: Thirty Contemporary Painters and Sculptors," organized by John Beardsley and Jane Livingston (Museum of Fine Arts, Houston, 1988); "The Latin American Spirit: Art and Artists in the United States, 1920–1970," organized by Luis R. Cancel (The Bronx Museum of the Arts, New York, 1988); "Art in Latin America: The Modern Era, 1820–1980," organized by Dawn Ades (Hayward Gallery, London, England, 1989); "Transcontinental: An Investigation of Reality. Nine Latin American Artists," organized by Guy Brett (Ikon Gallery, Birmingham, and Cornerhouse, Manchester, England, 1990); "Chicano Art: Resistance and Affirmations 1965–1985," National Executive Committee Alicia Gonzalez, Teresa McKenna, Victor Alejandro Sorell, and Tomás Ybarra-Frausto (Wight Art Gallery, University of California, Los Angeles, 1990); "The Decade Show: Frameworks of Identity in the 1980s," organized by Julia Herzberg, Sharon Patton, Gary Sangster, and Laura Trippi (Museum of Contemporary Hispanic Art, The New Museum of Contemporary Art, and The Studio Museum in Harlem, New York, 1990); "Circa 1492: Art in the Age of Exploration," organized by Jay Levenson (National Gallery of Art, Washington, D.C., 1991); "The Hybrid State: A Project of the Parallel History Series," curated by Papo Colo and Jeanette Ingberman (Exit Art, New York, 1992); "Ante America = Regarding America," curated by Gerardo Mosquera, Carolina Ponce de León, and Rachel Weiss (Biblioteca Luis Angel Arango, Bogotá, Colombia, 1992); "Latin American Artists of the Twentieth Century," organized by Waldo Rasmusseum (Comisaría de la Ciudad de Sevilla para 1992, Sevilla, Spain, 1992); and "Cartographies", curated by Ivo Mesquita (Royal Gallery, Ottawa, Canada, 1994).

7 Monica Amor, "Cartographies," in Gerardo Mosquera, ed., *Beyond the Fantastic: Contemporary Art Criticism from Latin America* (Cambridge, Mass.: The MIT Press, 1996), pp. 247, 251, 252.

8 For the complex history of El Museo del Barrio, see Fatima Bercht and Deborah Cullen, eds., *El Museo del Barrio 1969–2004*, vol. 1 of *Voces y Visiones: Highlights from El Museo del Barrio's Permanent Collection* (New York: El Museo del Barrio, 2003).

9 Ably headed by Amalia Guerrero with support from the Office of Puerto Rico in New York, Friends of Puerto Rico maintained a building on Third Avenue and 30th Street. Its participants included Rafael Colon-Morales, Carlos Irizarry, Victor Linares, Domingo Lopez, Carlos Osorio, and Rafael Tufiño, among others. For an excellent overview of Puerto Rican art activities both on the Island and in the United States, see Marimar Benítez, "The Special Case of Puerto Rico," *The Latin American Spirit: Art and Artists in the United States, 1920–1970* (New York: The Bronx Museum of the Arts, in association with Harry N. Abrams, 1988), pp. 72–105.

10 OLA was led by Petra Cintrón. Founding members of Taller Boricua were Marcos Dimas, Adrian García, Manuel (Neco) Otero, Armando Soto, and Martín Rubio, who were given space to gather in El Barrio by the Real Great Society, an organization of architects and community activists. The founding Taller Boricua artists were also active in the Art Worker's Coalition, an arts advocacy group that championed the decentralization of art institutions, the development of programs within museums that would relate to local communities, and the inclusion of African Americans, Asians, Latinos, and women in mainstream museum exhibitions. Taller Boricua membership quickly expanded in the early 1970s to include Sandra María Esteves, Gilberto Hernández, Martín "Tito" Pérez, Fernando Salicrup, Jorge Soto, Sammy Tanco and Nitza Tufiño, with Rafael Tufiño and Carlos Osorio as the group's senior mentors. The early members were active in the nascent El Museo del Barrio. Taller Boricua continues to contribute to the cultural vibrancy of El Barrio. Dimas and Salicrup currently co-direct Taller Boricua.

11 Located on West Broadway in Soho, and succeeding Friends of Puerto Rico, the Cayman Gallery was directed by Jack Agueros and Nilda Perraza. While Agueros became director of El Museo del Barrio in 1977, Perraza went on to found MoCHA. Susana Torruella Leval, MoCHA's curator for three years, went on to become Chief Curator (1990–93) and then Executive Director (1993–2002) of El Museo del Barrio.

12 See Luis Camnitzer, "Cultural Identities: Before and after the Exit of Bureau-Communism," in *The Hybrid State,* eds. Jeanette Ingberman and Papo Colo (New York: Exit Art, 1991).

13 During 1969 and 1970, members of staff at the Modern, including William Lieberman and Elaine Johnson, met with El Museo founder Rafael Montañez Ortiz after he requested assistance in fundraising and contacting artists and potential lenders for the new museum. In 1973, Marta Vega, then director of El Museo del Barrio, wrote to Richard Oldenburg, then the director of the Modern, seeking assistance in the organization of an exhibition of contemporary Puerto Rican art; the collaboration did not take place. See Ralph Ortiz (Montañez Ortiz), letter to Johnson, October 3, 1969, and Johnson, memo to Lieberman and Arthur Drexler, November 18, 1969, unprocessed Elaine Johnson files in the Department of Drawings; and Vega, letter to Oldenburg, July 13, 1973, and memos dated 1973 to October 1974, Unprocessed/Unavailable Materials. II.3.4 (7), "El Museo del Barrio Project" 1974, The Museum of Modern Art Archives, New York. I am grateful to Miriam Basilio for this information.

27. **Marisol** (Marisol Escobar). *Love*. 1962. Plaster and glass (Coca-Cola bottle), 6 1/4 x 4 1/8 x 8 1/8" (15.8 x 10.5 x 20.6 cm)

28. **Gabriel Orozco**. *Horses Running Endlessly*. 1995. Wood, 3 3/8 x 34 3/8 x 34 3/8"(8.7 x 87.5 x 87.5 cm)

29. **Jorge de La Vega**. *Documentary*. 1966.
Pen, brush, and ink on paper, 14 x 16 3/4" (35.5 x 42.5 cm)

30. **Antonio Dias**. *Untitled*. 1967.
Brush, pen and colored ink on paper,
18 1/2 x 12 5/8" (47 x 31.9 cm)

31. **Antonio Dias**. *Untitled*. 1967.
Brush, pen and colored ink on paper,
18 1/2 x 12 5/8" (46.9 x 31.9 cm)

Ñame en la plaza,
ñame en el monte.
Pan para todos
de sur a norte.

ñapa

ñoco

ñaqui

32. **Antonio Martorell**. *ABC of Puerto Rico* by Rubén del Rosario and Isabel Freire de Matos. 1968. Illustrated book with thirty-six photolithographic reproductions after woodcuts, printed in color and in black, page: 9 1/2 x 8 5/16" (24.1 x 21.1 cm)

33. **José R. Alicea**. *Collar and Zemi*. (c. 1962-66). Woodcut printed in color, comp.: 12 11/16 x 18 5/16" (32.2 x 46.6 cm) (irreg.), sheet: 17 7/16 x 25 15/16" (44.3 x 66 cm)

34. **Gonzalo Díaz**. *Untitled*. 1991. Screenprint printed in color,
comp.: 42 1/8 x 29 15/16" (107 x 76 cm), sheet: 43 5/16 x 30 3/8" (110 x 77.2 cm)

35. **Iran do Espírito Santo**. *Butterfly Prussian Blue*. 1998. Gouache on paper, sheet: 11 x 13 7/8" (27.9 x 35.2 cm)

36. **Arturo Herrera**. *A Knock*. 2000. Cut-and-pasted printed papers, 70 x 60" (177.8 x 152.4 cm)

DIEGO RIVERA'S *May Day, Moscow* sketchbook

Diego Rivera's 1928 *May Day, Moscow* sketchbook consists of forty-five small drawings in pencil, ink, and watercolor "portraying a Russian worker and his family from the time they prepared to attend this event until its close, including the march into Red Square."[1] The series, acquired from Rivera by Abby Aldrich Rockefeller shortly before his enormously popular 1931–32 retrospective at The Museum of Modern Art, begins with domestic scenes. One shows the Russian worker dressing his son; between father and child a bust of Lenin, like a third family member, completes the setting. Most of the other works in the album document Moscow's elaborate parade to commemorate the international workers' holiday, a celebration also described by the Russian newspaper *Pravda* that year:

> Columns of demonstrators slowly moved along Tverskaya Street, filling the whole width. Banners, posters, and caricature figures floated above their heads. . . . Here there was a "green snake" crawling out of a huge bottle and winding itself round a group of workers with its annulated body. . . . The columns were interspersed with divisions of armed working lads carefully keeping in step with a march played by the factory orchestra.[2]

Rivera paid keen attention to these agitprop banners, posters, and floats, noting their forms and colors with swift gestures. For instance, one sketch depicts large figurative caricatures and, in the distance, what seems to be a red, Constructivist factory facade. In another view, the choking snake of alcohol abuse mentioned in the *Pravda* account appears as a wavy, abstract green band. It is rendered more recognizable in the oil painting *Red Square*, for which this work served as a study.[3] The appeal of these monumental parade floats to Rivera is not surprising considering his interest in Mexican popular arts, such as the papier-mâché Judas figures that were detonated and burned during the Holy Week preceding Easter, and the *calaveras* (animated skeletons) associated with the Day of the Dead. However, beyond their superficial similarity, traditional craft-making and state-sponsored revolutionary propaganda in truth represent divergent impulses. Rivera recognized this distinction when he encouraged Soviet artists to "look at your icon painters, and at the wonderful embroideries and lacquer boxes and wood carvings and leatherwork and toys."[4] To Rivera and the other Mexican muralists, revolutionary art was most effective when rooted in the traditions of the common people. Indeed, the movement's greatest strength came from the artists' passionate connection to Mexico's long history of anticolonialism, which involved not only armed insurrection but also the insinuation of indigenous customs into Catholic rituals. Although the most successful examples remain on Mexican walls, artists did produce easel paintings and prints for exhibition and sale, especially after mural commissions began to dwindle in the late 1920s; José Clemente Orozco's *Zapatistas* (1931) and Rivera's *Flower Festival: Feast of Santa Anita* of the same year are among the best examples of these easel paintings.

Because Rivera did not have a comparably intimate familiarity with Russian culture, for the execution of *May Day, Moscow* he relied on a strategy that was influenced, understandably, by contemporary Soviet ideas. At the time of his visit to Moscow, critics, artists, and curators began to use the Marxist term "dialectical materialism" to describe a particular form of visual activism that was gaining currency in certain circles. Essentially, the expression of point-counterpoint relationships—new versus old, proletarian versus bourgeois, participant versus bystander—was meant to radicalize the viewer, whose conclusions, ideally, would reinforce Communist ideology. Arguably the most successful examples of this technique are the jarring montage sequences in Sergei Eisenstein's films, which Rivera greatly admired.

37. **Diego Rivera**. *May Day, Moscow*. 1928.
Watercolor and pencil on graph paper,
6 3/8 x 4 1/8" (16.2 x 10.5 cm)

In *May Day, Moscow* Rivera initially introduces the procession from a spectator's point of view. From his vantage point, perhaps on a reviewing stand on the corner of Nikolskaya Street, he faithfully recorded the colorful passing display against the backdrop of Red Square's famous architectural landmarks, such as the GUM department store, the Kremlin towers, and the Senate building's neoclassical cupola flying the Bolshevik red flag. The bit of empty street in the lower left functions as a literal and metaphorical boundary that separates the viewer from the event. However, in the final sketches of the cycle Rivera moves into the square with the celebrating crowd, thus becoming a participant in the demonstration rather than a mere bystander. Because of this new perspective, those who view the drawing share Rivera's politicized gaze and thus become complicit in the celebration. Moreover, in one of these Red Square scenes a child (presumably the Russian worker's son from the beginning of the series) waves a red banner in front of the distinctive onion domes of St. Basil's Cathedral. During the 1920s it was common for artists to draw a parallel between childhood and the new workers' state, which was also in the early stage of its existence.

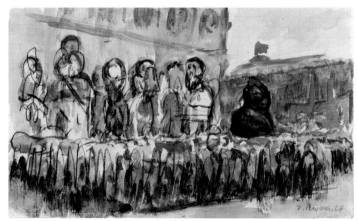

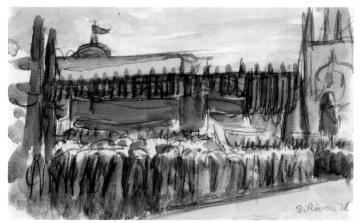

38. **Diego Rivera.** *May Day, Moscow.* 1928. Top: watercolor
and pencil on graph paper; middle and bottom: watercolor and
crayon on graph paper, each 4 1/8 x 6 3/8" (10.5 x 16.2 cm)

Literally supported by the shoulders of the proletariat, Rivera's Communist youth partially obstructs the cathedral from view, symbolically replacing the Tsarist artifact with young revolutionary zeal.

Rivera's connection to Russian art and politics can be traced back to his bohemian years in Paris, from 1909 to 1921. For most of that period he lived with the Russian painter Angelina Belova, through whom he established relationships with other Russian émigré artists and intellectuals. Among this circle were the writers Maximilian Voloshin and Ilya Ehrenberg (whose 1921 novel *Julio Jurenito* is based in part on Rivera's memories of his Guanajuato childhood); the sculptors Jacques Lipchitz, Aleksandr Archipenko, and Ossip Zadkine; the graphic artist Jean Lebedeff; and the painters Mykhailo Boichuk, David Shterenberg, Natalie Gontcharova, and Gontcharova's companion Mikhail Larionov. "With Angelina, [Rivera] would visit them or meet them in the café," explained the artist's biographer, Bertram Wolfe. "Diego claimed to have absorbed the intricacies of Slavic speech sufficiently to expound his views on their favorite theme: the coming revolution and its relation to the coming art."[5]

While this claim certainly exemplifies the artist's renowned tendency towards self-aggrandizement, the fact remains that by the time he returned to Mexico, in 1921, Rivera was a leading authority on Russian revolutionary culture. After joining the Mexican Communist Party in 1922, he became the unofficial cultural liaison between Mexico and Soviet Russia, and when the Russian Futurist poet Vladimir Mayakovsky visited Mexico City, in July 1925, naturally it was Rivera who acted as his guide. Rivera escorted the poet on tours of the city, including the anthropological museum, Chapultepec Park, the bullring, and Rivera's own, ever expanding fresco cycle at the Secretaría de Educación Pública. After a brief visit to the United States, Mayakovsky returned to Moscow, where he enthusiastically promoted Rivera's work.[6]

By the mid-1920s, a number of Rivera's Montmartre comrades had become prominent figures in the Soviet art world. Boichuk, for instance, was an influential teacher at the Kiev Art Institute, where, inspired by Rivera's example, he and his followers developed an ill-fated Ukrainian version of Mexican muralism.[7] Shterenberg, the influential instructor at Moscow's VKHUTEMAS (State artistic and technical studios) and cofounder of OST (Society of easel painters), himself invited Rivera to Moscow. Through the efforts of Mayakovsky, Boichuk, Shterenberg, and others, Rivera's reputation preceded his visit. When he arrived, in October 1927, as part of a Mexican delegation to the revolution's tenth-anniversary celebrations, the Russian capital welcomed him not only as an important visiting artist but as an international celebrity. Before long, he had delivered numerous lectures, taught fresco painting at the Lenin Academy, and was even contracted by Soviet Minister of Education Anatoly Vasilievich Lunacharsky to paint a fresco in the Red Army Club.

Yet despite his many champions and his own enthusiastic willingness, Rivera never painted the mural. His tenure in Moscow coincided with an upheaval in the Soviet art world instigated by Stalin's consolidation of power and his notorious hostility to modern art. As a result, the Stalinized Communist Party favored the proto-Social Realism of the Association of Artists of Revolutionary Russia (AKhRR), which strove for a return to late-nineteenth-century Russian academic genre painting.

To resist this reactionary movement, in 1928 a diverse group of Moscow's leading Communist modernists formed the Oktyabr (October) group, a union that strove to subordinate all art "to the task of serving the concrete needs of the proletariat, the leaders of the peasantry, and the

backward national groups," while at the same time striving to incorporate modernist contributions, the "achievements of the last decades, when the methods of the rational and constructive approaches to artistic creation, which had been lost by the artists of the petite bourgeoisie, were restored and developed considerably."[8] Until it was forced to disband, in 1932, Oktyabr remained as strongly opposed to the nationalist rhetoric of AKhRR as they were to its promotion of conservative academic techniques. Without advocating a particular style or medium, the group fought a losing battle to perpetuate the cosmopolitan internationalism that characterized the period of optimism immediately following the revolution. Its membership included not only Russian painters, directors, architects, designers, and photographers, such as Shterenberg, Eisenstein, El Lissitzky, Aleksandr Deineka, Gustav Klucis, Aleksandr Rodchenko, Varvara Stepanova, and the brothers Leonid and Viktor Vesnin, but also visiting foreigners like Rivera, as well as expatriates and refugees who had settled in Russia more permanently, such as the German architect and former director of the Bauhaus Hannes Meyer and the Hungarian painter Béla Uitz, cofounder of the group. Through support of the Oktyabr platform, Rivera registered his opposition to the direction being taken by "official" art in Russia. His relationship with Lunacharsky and the Communist leadership subsequently soured and he returned to Mexico six weeks after May Day, disillusioned and deeply critical of the Stalinist regime.

James Wechsler

1 Diego Rivera with Gladys March, *My Art, My Life: An Autobiography* (New York: Dover Publications, Inc., 1991), pp. 93–94.

2 *Pravda*, May 8, 1928, quoted in Vladimir Tolstoy, Irina Bibikova, and Catherine Cooke, eds., *Street Art of the Revolution: Festivals and Celebrations in Russia, 1918–33* (New York: Vendome Press, 1990), p. 189.

3 According to Rivera's catalogue raisonné, a *Red Square* of 1928—oil on canvas, 16 15/16"x 21 7/8" (43 x 55.6 cm)—is in the collection of The Museum of Modern Art, New York. See *Diego Rivera, Catálogo General de Obra de CABALLETE* (Mexico City: Dirección General de Publicaciones, INBA, 1989), p. 106. While the work is reproduced in the volume, its current location is unknown. No such painting exists in the Museum collection, nor does it appear in its record of deaccessions.

4 Rivera, quoted in Bertram D. Wolfe, *The Fabulous Life of Diego Rivera* (New York: Stein and Day, 1963), p. 221. Wolfe is paraphrasing a lecture Rivera gave at the Moscow Academy of Fine Arts in the spring of 1928.

5 Ibid., p. 66.

6 For a thorough account of Vladimir Mayakovsky's visit to Mexico see William Harrison Richardson, "Mayakovsky's Idiosyncratic Mexico," in Richardson, *Mexico through Russian Eyes, 1806–1940* (Pittsburgh: University of Pittsburgh Press, 1988), pp. 127–40.

7 See Matthew Cullerne Bown, *Art under Stalin* (New York: Holmes & Meier, 1991), pp. 53–56.

8 October (Association of Artistic Labor), "Declaration," 1928, reprinted in Charles Harrison and Paul Wood, eds., *Art in Theory, 1900–1990: An Anthology of Changing Ideas* (Oxford and Cambridge, Mass.: Blackwell, 1992), pp. 465–66.

JOSÉ CLEMENTE OROZCO'S New York works

The three great Mexican muralists, "*Los Tres Grandes*"—Diego Rivera, David Alfaro Siqueiros, and José Clemente Orozco—all visited the United States for extended periods in the early 1930s.[1] An earlier visit by Orozco to the southwestern United States, from 1917 to 1919, had culminated in the destruction of over sixty of his drawings by U.S. customs officials who deemed the pictures immoral. Nevertheless, in 1927 Orozco returned to the United States, where he remained until 1934. The Mexican modernist movement had deeply influenced American art since the 1920s; conversely, the United States—primarily New York, where he spent most of his time—fostered striking developments in Orozco's work during his later visit.

In Manhattan, Orozco struggled to find housing, resources, and suitable exhibition opportunities. He scrambled to secure portrait commissions, make sales, and complete three major murals in the United States.[2] While continuing his studio work on themes that exposed the harsh realities of the Mexican Revolution and daily life in his country, Orozco turned his critical eye toward the new urban reality he encountered. He could write admiringly to Jean Charlot in Mexico, "You should see the machines for excavating rock and burying the iron that will support a skyscraper . . . the real American artists are the ones who make the machines."[3] At the same time, Orozco's series of drawings and easel paintings focused on the great city's overwhelming scale and on the feeling of alienation it engendered. Notable among these are at least nine oil-on-canvas works created in 1928, including *The Subway*, in the collection of The Museum of Modern Art.[4] In a manner quite unlike the American Precisionists' contemporaneous paeans to industrial form, Orozco explored modern architecture's imposition on the individual, with emphasis on its brutality. Alejandro Anreus has noted, "He came to understand that U.S. modernity, as expressed in New York City, was a sophisticated product of capitalist ideology and Western modernization, with very destructive intrinsic forces."[5]

Orozco had always employed architectural elements to anchor and contain his compositions, and his awareness of this strategy was sharpened as a result of his mural projects. In his depictions of Mexico in revolution, the white rectilinear outlines of adobe homes, the receding lines of a room's interior, or the shape of a blackened doorway frequently appear in the background, framing his figures. For Orozco, Mexican architecture referred to tradition, evoking humble surroundings and the basic provisions of life, and ennobling the characters in the images. The buildings are light in color and are positive symbols closely linked to the people. However, the overwhelming dark, blurred shapes of Orozco's New York buildings reflect his ultimate skepticism. In *The Subway*, for example, he uses the low ceiling and dark receding space of the train to enclose three bulky and anonymous male riders. The light abstract pattern of the subway railings and poles, and the curvilinear forms of the seat edges and backs, create a flattened and static pattern on the lugubrious surface, effectively caging the riders. A shadowy atmosphere of angst and isolation pervades the painting. A related charcoal drawing shows an endlessly receding subway platform with black-silhouetted figures trudging toward its depths.[6] *The Dead* (1931), one of the last cityscapes in this series, confirms Orozco's negative view, depicting the nightmarish chaos of breaking, collapsing skyscrapers from a bird's-eye view.

Orozco felt art should be about the universal truths of the human condition. An unrelenting social critic, his principles at times drove him away from others, including his Mexican peers. In New York, he continued to rally against the preconceptions and stereotypes ordained for modern Mexican art. Orozco rejected the picturesque folkloric imagery that was often employed in the service of Mexican nationalism. He was particularly critical of this period of Diego Rivera's work, which, with a nod to Italian *quattrocento* frescoes, employed a charming Social Realism to honor indigenous

themes. Anreus quotes a 1946 interview by José Gomez Sicre in which Orozco proudly distinguishes his own city scenes from Rivera's popular work of this time:

> I never liked the industrial forms of the city, be it underground trains, skyscrapers, or anything else. I did use them as themes for paintings, not just because of the powerful forms but because it was the reality around me, what I knew. You know, my paintings of New York were not well received; they wanted me to paint Indians with flowers, like Rivera. I think I captured something of the brutality of the city in those New York paintings; they are not pretty pictures.[7]

Despite the fact that he had not previously worked in lithography, Orozco also created nineteen lithographs while in New York. One of his earliest role models was the famous satirical printmaker José Guadalupe Posada, and Orozco was eager to try the technique. George C. Miller, a renowned artist's lithographic printer based on 14th Street in Manhattan, printed seventeen of the images from Orozco's drawings on zinc plates; two editions were pulled by Will Barnet, an artist, instructor, and printer at the Art Students League.

As in his painting production during this time, the majority of Orozco's lithographs are variations of scenes from his murals, or of his images of the Mexican Revolution. The first and last lithographs, however, relate specifically to his New York experience: *Vaudeville in Harlem* (1928) and *Hanging Negroes* (c. 1933–34) (*Negros ahorcados* also known as *The Hanged Men*, *Negroes*, or *The American Scene*), both in the collection of The Museum of Modern Art.[8] These two anomalous works seem to refer directly to the African American community.

There was mutual empathy between the black art community and the Mexican modernists. Many African American artists of the 1920s and '30s admired Orozco, Rivera, Siqueiros, and others; the Mexicans generally supported the African American struggle for equality. The *Mexicanidad* movement was akin to the New Negro era in its focus on racial pride and ethnic recovery. Several African Americans had direct contact with the Mexicans.[9] In 1933, the influential artist and instructor Charles Henry "Spinky" Alston went to Radio City to watch Diego Rivera working on *Man at the Crossroads*. Alston would reminisce:

> Orozco and Rivera were tremendous influences on all artists, black and white, in this country. . . . I happened to be on the mural project so I was particularly aware of the Orozcos and the Riveras. As a matter of fact, I used to go down to Radio City when Rivera was painting the [mural] they destroyed. And between his broken English and my broken French, we managed to communicate.[10]

Orozco visited Harlem at least once with the poet Federico García Lorca, who was in New York from 1929 to 1930.[11] Orozco was also aware of the strong precedent of the Mexican artist and illustrator Miguel Covarrubias, who had embraced Harlem and whose depictions of it were the object of much popular acclaim; in a letter to Charlot dated March 20, 1928, Orozco noted acidly that Covarrubias had not even offered to help him.[12] Is this sufficient evidence to support the idea that Orozco had a strong connection to the African American community?

It should be noted that Orozco's titles alone specifically locate these images; indeed, Orozco had been attracted previously to the subjects of both lithographs. His interest in small theater and

39. **José Clemente Orozco**. *The Subway*. (1928). Oil on canvas, 16 1/8 x 22 1/8" (41 x 56.2 cm)

burlesque in Mexico was notable from the earliest brothel scenes he drew during the years 1910–19. This appetite continued in New York, where he frequented Coney Island and memorialized its freak shows in works such as *Coney Island Sideshow* (1928). *Vaudeville in Harlem* also shares common tropes with *The Subway*, including its architectural framing and anonymous crowd. A sketchy and undeveloped image, the print lacks environmental specificity but reveals much about Orozco's tentative experimentation with the new medium.

Hanging Negroes, on the other hand, evidences the vigorous marks of a self-assured artist. After five years of making prints, Orozco was finally comfortable with the greasy lithographic pencil and the scraped surface of the plate. The image reveals his continued interest in the grotesque: his earlier drawings of the horrors of war had featured mutilations and hangings. Orozco praised the works by Francisco de Goya that he had seen in 1928 in two exhibitions in New York, at The Hispanic Society of America and The Metropolitan Museum of Art. "You can only feel the humility one feels in the presence of a storm, a star, or any other spectacle of nature," he wrote.[13] Indeed, Goya, in the series to which Orozco referred, had also depicted hanging and mutilated men; Charlot wrote that he and one of Orozco's supporters, Anita Brenner, called Orozco's series "*Los horrores de la revolución*" a "good-natured parallel to Goya's *Los desastres de la Guerra*."[14]

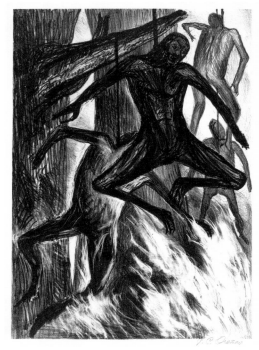

40. **José Clemente Orozco**. *Hanging Negroes*.
(c. 1933–34). Lithograph, printed in black,
comp.: 12 11/16 x 8 15/16" (32.3 x 22.7 cm),
sheet: 15 13/16 x 11 1/2" (40 x 29.2 cm)

Anreus has proposed that Alma Reed, Orozco's liberal patron and dealer, suggested the timely theme to him, and that the image may have been based on a widely reproduced photograph of 1930 depicting the lynching of George Hughes in Texas.[15] Whatever its source, *Hanging Negroes*, if for no other reason than its title, was appropriately included in two controversial exhibitions.[16] "An Art Commentary on Lynching," sponsored by the National Association for the Advancement of Colored People (NAACP), was held at the Arthur U. Newton Gallery at 11 East 57th Street, New York, from February 15 through March 2, 1935. The exhibition was spearheaded by Walter White of the NAACP and juried by philosopher, art historian, and writer Alaine Locke; collector and patron Albert C. Barnes; and Audrey MacMahon of the College Art Association. It included thirty-nine artists of different races, including Henry Bannarn, George Bellows, George Biddle, Julius Bloch, Samuel Brown, Paul Cadmus, John Stuart Curry, Allan Freelon, Thomas Hart Benton, Wilmer Jennings, Reginald Marsh, William Mosby, E. Simms Campbell, and Hale Woodruff.

The second exhibition, "The Struggle for Negro Rights," opened at the ACA Galleries on West 8th Street on March 2, 1935. Sponsored by various activist groups, including the Communist Party's John Reed Club, the Artist's Union, the Artists' Committee of Action, the League of Struggle for Negro Rights, the International Labor Defense, and the Vanguard, this exhibition was mounted in opposition to the Costigan-Wagner Bill, a piece of antilynching legislation that, according to the

ACA exhibition organizers, the NAACP exhibition promoted. The ACA project championed instead the broader "Bill of Civil Rights for Negro People." Forty-three artists participated, including Stuart Davis, Philip Evergood, Hugo Gellert, William Gropper, Louis Lozowick, and Hyman Warsager.

These exhibitions and their underlying politics polarized the art community. Five artists, however—Orozco, Sam Becker, Aaron Goodelman, Isamu Noguchi, and Harry Sternberg—agreed to send works to both exhibitions. This gesture may be read as an abdication of responsibility or as an attempt to raise art above the mundane concerns of legislation. Renato Gonzalez Mello has suggested that Orozco chose not to become too involved in the various racial and social conflicts in the United States. In analyzing Orozco's caricatures, he finds that they imply "a detached view of American racial categories, under the dubious assumption that Mexicans do not have such a preposterous and exclusionary system."[17]

Deborah Cullen

1 Diego Rivera and Frida Kahlo traveled in the United States from 1930 to 1934. They were in New York in 1933 and 1934. David Alfaro Siqueiros worked in Los Angeles in 1932 and traveled to New York in 1936.

2 José Clemente Orozco painted the mural *Prometheus* at Pomona College, Claremont, California, in 1930. Between 1930 and 1931, he created a five-fresco cycle at the New School for Social Research in New York City. From 1932 to 1934 he executed the fresco cycle *The Epic of American Civilization* at Baker Library, Dartmouth College, New Hampshire. In 1940, shortly after his return to Mexico, The Museum of Modern Art invited Orozco back to New York, commissioning the portable mural *Dive Bomber and Tank,* which he produced in the museum's lobby.

3 Orozco, letter to Jean Charlot, January 4, 1928. In Orozco, *The Artist in New York: Letters to Jean Charlot and Unpublished Writings, 1925–1929*, trans. Ruth L. C. Simms (Austin: University of Texas Press, 1974), pp. 31–32.

4 Other related works dated 1928–1930 include *Eighth Avenue*; *The Elevated*; *Elevated*; *New York Factory (Williamsburg)*; *Queensboro Bridge, New York*; *Fourteenth Street, Manhattan*; *The World's Highest Structure*; and *Subway Post. The Subway* was one of the first works by a Latin American artist accepted into the collection of The Museum of Modern Art. It was donated by Abby Aldrich Rockefeller in 1935.

5 Alejandro Anreus, *Orozco in Gringoland: The Years in New York* (Albuquerque: University of New Mexico Press, 2001), p. 3.

6 See ibid., p. 81, fig. 27. The location of this work is unknown.

7 Orozco, quoted in ibid., p. 140. The unpublished typed manuscript of the interview was found among the papers of José Gomez Sicre in Miami, Florida.

8 *Hanging Negroes* appears to be an individual work, not one created for a benefit or portfolio, as is sometimes stated.

9 See Lizzetta LeFalle-Collins and Shifra M. Goldman, *In the Spirit of Resistance: African American Modernists and the Mexican Muralist School* (New York: American Federation for the Arts, 1996). Many African American artists had direct contact with the Mexicans, including Hale Aspacio Woodruff, who worked on a Rivera mural in Mexico in 1934. Romare Bearden singled out Rivera and Orozco as role models in his 1934 essay "The Negro Artist and Modern Art," reprinted in *The Portable Harlem Renaissance Reader*, ed. David Levering Lewis (New York: Viking, 1994), p. 135. Langston Hughes spent the year of 1935 in Mexico on a Guggenheim fellowship.

10 Charles Alston, interviewed by Al Murray, audiotape, October 19, 1968, Archives of American Art, The Smithsonian Institution, Washington, D.C. A transcript of audiotape is available at www.archivesofamericanart.si.edu. It is interesting to note that Alston's two-panel mural *Magic and Medicine* (1936), created for Harlem Hospital, was first exhibited at The Museum of Modern Art that year in the exhibition, "New Horizons in American Art." *Magic and Medicine* clearly shows Alston's indebtedness to the Mexican model as well as other influences, including African art, Harlem Renaissance art, and modern European art.

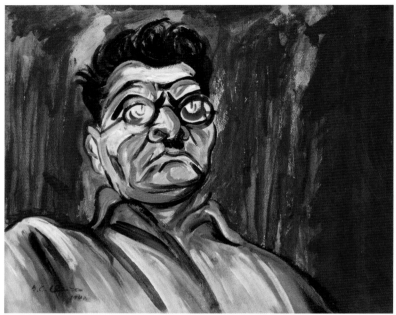

41. **José Clemente Orozco**. *Self-Portrait*. 1940. Tempera on cardboard, mounted on composition board, 20 1/4 x 23 3/4" (51.4 x 60.3 cm)

11 Anreus states that there is no mention of Federico García Lorca in Orozco's letters. But García Lorca's letters mention their meeting, as well as Orozco's paintings of New York City. According to Anreus, Luis Cardoz y Aragon recalled that Orozco mentioned he had visited Harlem with García Lorca. Anreus also states that Orozco's letters to Charlot and his wife, Margarita, contain references to his general fascination with Harlem nightlife, which was in vogue during this time. See Anreus, *Orozco in Gringoland*, pp. 86; 157, n. 11; 158, n. 15.

12 Orozco wrote, "They say he [Miguel Covarrubias] doesn't like the idea of any more painters from Mexico coming here and I believe it from the way he treated me; he didn't even say, just to be polite, that he would introduce me to people or help me in some way. May God repay him! He is earning a mint of money." Orozco, letter to Charlot, in Orozco, *The Artist in New York*, p. 44. Covarrubias (1904–57) went to New York in 1923. As early as December 1924, he was publishing drawings in *Vanity Fair* and *The New Yorker*. In 1924, Covarrubias was guided through Harlem by Carl van Vechten. He drew in the neighborhood's nightclubs and took an interest in its life, depicting its hardships as well as its increasingly popular jazz musicians. Covarrubias produced portraits of Harlem's inhabitants, particularly in the dance halls. His *Negro Drawings* of 1927 reflected modern art trends from Cubism to Art Deco; that same year, one of his works was selected for the cover of Langston Hughes's book *The Weary Blues*.

13 See Orozco, *The Artist in New York*, p. 75, n. 58. Goya's *Desastres de la guerra*, a suite of eighty etchings created between 1810 and 1816, contains several images of hanging bodies.

14 Ibid., pp. 31, 38–39.

15 Anreus, *Orozco in Gringoland*, p. 88, n. 50.

16 For a complete discussion of these exhibitions, see Marlene Park, "Lynching and Antilynching: Art and Politics in the 1930s," *Prospects: An Annual of American Cultural Studies*, vol. 18 (New York: Cambridge University Press, 1993), 311–365.

17 Renato Gonzalez Mello, "Orozco in the United States: An Essay on the History of Ideas," *José Clemente Orozco in the United States, 1927–1934* (Hanover, N.H.: Hood Museum of Art, Dartmouth College, and New York: W.W. Norton & Co., 2002), pp. 22–61.

JOAQUÍN TORRES-GARCÍA'S *Composition* and
ROBERTO BERDECIO'S *The Cube and the Perspective*

In 1932, the year he created *Composition*, Joaquín Torres-García left Paris to live in Spain. Shortly thereafter, in 1934, the difficulty of this decision led to his return to his native Uruguay, where he would remain until his death, in 1949. His departure from Paris meant the end of a particularly fruitful period of experiences and exchanges, including meetings with his fellow Uruguayan Pedro Figari and with Piet Mondrian; intellectual dialogue with Theo van Doesburg during Torres-Garcia's involvement with the *Cercle et Carré* group; friendships with Julio González, Jean Arp, and Sophie Taeuber-Arp; and a reunion with Picasso, whom he had met in González's studio.

Torres-García developed a very particular conception of modern art and was one of the few Latin American figures who were firsthand participants in the early modernist scene in Europe. Throughout the avant-garde era, he would remain unmarked by the apocalyptic and iconoclastic temptations of his time. His painting—flat, symbolic, schematic, and, often, achromatic, as in *Composition*—is simultaneously an iconic writing, a frieze of visual ideas, and the mute manifesto of a kind of hermeticism that aspires to the ideal of universality—which painting itself always defers. In short, Torres's work defies categorization.

Composition was exhibited in 1943 in the first exhibition of the Latin American collection. In 1945, Alfred Barr included the painting in his initial outline for the first large show of the Museum's collection, placing it among "post-Cubist" currents in the Americas along with works by artists such as Lyonel Feininger, Stuart Davis, and Amélia Peláez del Casal.[1] Yet *Composition* was ultimately not chosen for the exhibition, and would have to wait until 1972 to be brought out of Museum storage again.

Composition was donated to the Museum by the Uruguayan architect Román Fresnedo Siri shortly after Lincoln Kirstein's 1941 trip to Montevideo, during which Kirstein had acquired another work by Torres-García and two paintings by his children, Horacio and Augusto. Kirstein's scanty notes offer a glimpse of the impression of eccentricity that the distinguished artist might have made on him: "Constructivist panels have a certain charm, in spite of muddy color. . . . Talks about 'purism': won't eat meat. . . . A type like Elbert Hubbard, Frank Lloyd Wright. Feels left out and abandoned in Montevideo: opposed by Zorilla San Martín. Decent honest man. Nervous desperate."[2]

Composition marked the Museum's only acquisition of a relatively abstract painting—or in any event a painting neither figurative nor narrative—by a Latin American artist until well into the 1950s.[3] Apparently, and paradoxically, the work was not seen as abstract, by virtue of its symbolic force and of its pictograms with quasi-universal meaning, devices typical of Torres's art. By contrast, Barr, during the same period, had deemed Roberto Berdecio's painting *The Cube and Perspective* (1935) sufficiently abstract to be included in his 1945 exhibition of the collection under the category "Abstract Painting," alongside works by Mondrian, El Lissitzky, Jean Hélion, Kurt Schwitters, and Pablo Picasso.[4] In his responses to a Museum of Modern Art artist questionnaire, Berdecio argued adamantly against this:

> This work is not an "abstraction" as it erroneously has been termed. It is a concrete and realistic painting of a double-subject matter: it is either a cube or a perspective, according to the distance of the spectator in front of the painting. . . . In *The Cube and the Perspective*, the movement of the spectator has been taken into consideration as he or she comes toward the painting, creating a relationship between both that determines,

within a space of time, the change of subject matter. In other words, this work is a simple study of one solution to the problem of visibility . . . in relation to an active spectator instead of a static, fixed composition for a static spectator. This principle of dynamic composition, in which the time element is incorporated, has in mural painting its full possibility of realization [*sic*].[5]

This incident is symptomatic of the complexities and misunderstandings that affect modern Latin American art and its reception in the United States, as well as of Barr's viewpoint on modernity in general and abstraction in particular.[6] Certainly *The Cube and the Perspective* may seem like a relatively abstract work, a geometric pictorial exercise, or an attempt at metaphysical painting. This explains why Berdecio, in his response to the Museum, made a point of emphasizing that his work grew out of mural painting and stressed that it was a "formal experiment." Asked about the circumstances of its production, he stated, "It was intended primarily as a test of the durability of the medium outdoors. I had it on the roof of my studio for three months in the rain and sunlight, and also because the painting should be placed at a great distance from the spectator to appreciate the transformation of the subject-matter as he or she approaches it."[7]

Advocating the need for a concrete referential foundation in painting, Torres-García argued that the visual arts should have a symbolic register, which could be supplied through symbols readable as "universal forms."[8] A certain Platonism survives in the search for a "symbolic timelessness" that this entailed,[9] and here, despite the harsh criticisms leveled against Torres-García by a young generation of artists inclined toward pure abstraction,[10] the Uruguayan painter remains the first Latin American exponent of a kind of abstraction determined more by a schematic treatment of forms than by their destruction. Berdecio, by contrast, passionately defended the possibility of a "kinetic perspective" in which plastic forms would be transformed with the movement of spectators, and that would underscore the pathos and emotion of the great realist murals.[11] It is not the least of paradoxes that although these positions are so opposite, they have a correspondence with Latin American abstraction, which discarded the symbolic forms of Torres-García's work but took over his orthogonal and constructive design principles to achieve the utopia of the "moving canvas" with kinetic and Op art, which took the idea of "optical pathos" to its limits. Perhaps the divergences between Torres-García and Berdecio converge in these artists: the aspiration toward a perception in which earthly matter seems to vanish, and the idea of a ceaseless transformation of visible forms through the movement of the viewer.

Luis Enrique Pérez-Oramas

1 "Museum Collection: Categories Made By A.H.B. Jr. for Tentative Plan of Arrangement of Galleries for Museum Collection Exhibition June 1945," The Museum of Modern Art Archives, New York, DCM VII. ADD, B.E.1.:4.

2 Lincoln Kirstein, "Latin-American Painting: A Comparative Sketch," unpublished manuscript, 1943, The Museum of Modern Art Archives, New York.

3 The only exceptions were works by Matta (Roberto Sebastián Antonio Matta Echaurren), which were acquired in response to the powerful influence exerted by the art of this Chilean painter in postwar New York. Although abstract in nature, Matta's works did not entirely dispense with narrative elements, even if it transfigured them through surreal freedom and oneiric metaphor. In this sense his paintings were removed from the schematic, geometrical tradition of the "other" abstraction.

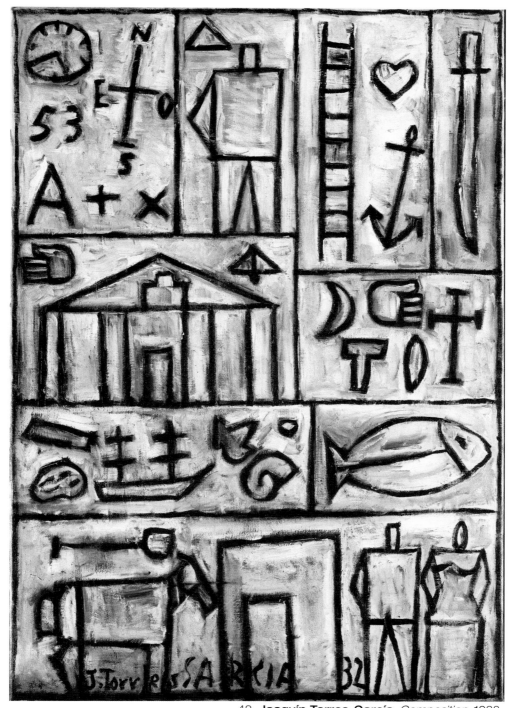

42. Joaquín Torres-García. *Composition*. 1932.
Oil on canvas, 28 1/4 x 19 3/4" (71.8 x 50.2 cm)

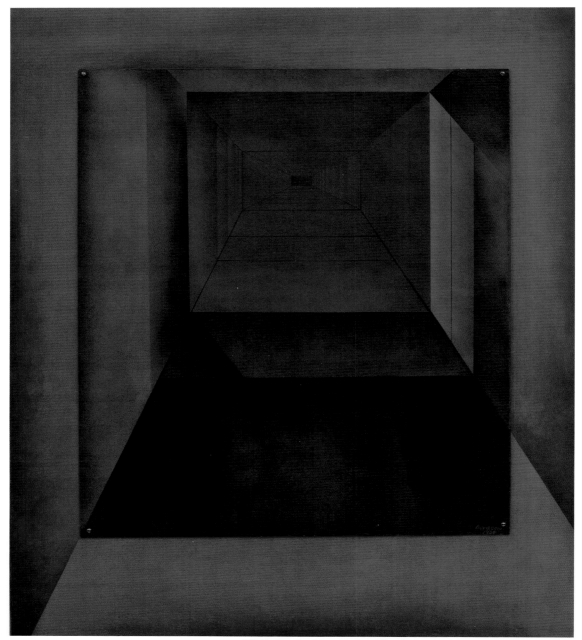

43. **Roberto Berdecio**. *The Cube and the Perspective*. 1935.
Enamel airbrushed on steel panel mounted on wood. 30 x 26" (76.2 x 66 cm)

4 See "Museum Collection of Painting and Sculpture: First General Exhibition," departamental files, Department of the Registrar, 45618-20c: 4.

5 Roberto Berdecio, questionnaire, artist files, Museum Collection Files, Department of Painting and Sculpture, The Museum of Modern Art, New York.

6 For Alfred Barr, the problem of the "purging of the theme" from abstract painting always went hand-in-hand with a concern for the work's "expressive content." See Sybil Gordon Kantor, *Alfred H. Barr, Jr. and the Intellectual Origins of the Museum of Modern Art* (Cambridge: The MIT Press, 2002), p. 110.

7 Berdecio, questionnaire, artist files.

8 Joaquín Torres-García, *Lo aparente y lo concreto en el arte* (Buenos Aires: Asociación de Arte Constructiva, 1947).

9 See Tomás Lloréns, "Raque de la Atlántida," in *Torres-García* (Madrid: Museo Nacional Centro de Arte Reina Sofía, Madrid, 1991), p. 29.

10 See Tomás Maldonado, *Torres-García contra el arte moderno*, bulletin of the Asociación de Arte Concreto-Invención, Buenos Aires, December 1946, in Marcelo Pacheco, *Arte Astratta Argentina* (Buenos Aires: Fundación Proa, 2002–3), p. 175.

11 See Emilia Hodel, "Kinetic Perspective Theory of Art Developed by Bolivian," *The San Francisco News*, November 16, 1940.

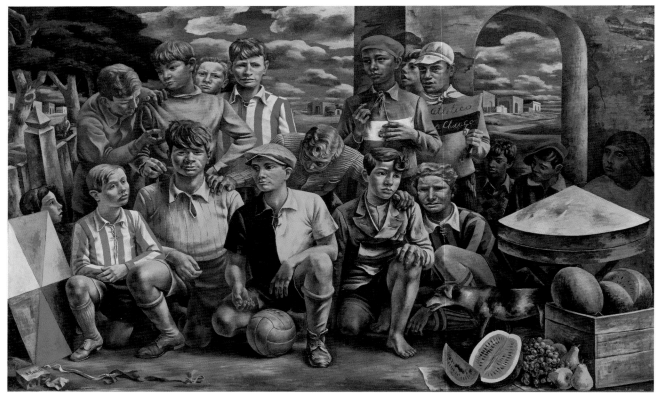

44. **Antonio Berni**. *New Chicago Athletic Club*. 1937. Oil on canvas, 6' 3/4" x 9' 10 1/4" (184.8 x 300.4 cm)

In 1942, Lincoln Kirstein visited the Argentine artist Antonio Berni while traveling on behalf of the Museum for the purpose of acquiring works by contemporary artists from Latin America. According to Kirstein, Berni initially refused to sell *New Chicago Athletic Club* (1937), a monumental painting of a soccer team in the suburbs of Buenos Aires. The artist drove a hard bargain but finally agreed to a sale price of $1,000. Kirstein reported to Alfred H. Barr, Jr., "This is the most expensive picture I bought in Latin America; in a sense I think it is the most important Argentine picture I saw."[1] In a letter to Kirstein, Berni imagined the acquisition as the harbinger of greater recognition of his *Nuevo Realísmo* (New Realism) in the United States:

> My friend, it is a great personal satisfaction for one of my paintings to be represented in the collection of a United States museum. I want the American public's initial contact with my work—made possible thanks to you—to be a truly spiritual communication that affirms the New Realism, an interest shared by numerous American artists that is the path towards artistic unity throughout the continent.[2]

Berni formulated his theory of *Nuevo Realísmo* after his years in Madrid and Paris, and after his 1933 collaboration with the Mexican muralist David Alfaro Siqueiros on an experimental mural

project for which the team also included Lino Eneas Spilimbergo, Juan C. Castagnino, and Enrique Lázaro. Created in the basement of the country home of Natalio Botana, in Don Torcuato, a province of Buenos Aires, the mural, *Ejercicio plástico* (Plastic exercise), depicts the prone figure of a nude woman. According to Mari Carmen Ramírez, it was "the first mural painting created exclusively by mechanical means—air brush, mechanical brush, film as well as still camera and artificial lighting."[3] Siqueiros presented *Ejercicio plástico* as a demonstration of the potential of modern technology and collaborative teamwork, which he believed would extend the pivotal role of muralism from Mexico to the rest of Latin America.[4]

Following this experience, Berni wrote critiques of Siqueiros's project and of the limitations of muralism as an art for the masses, as well as texts outlining his *Nuevo Realismo*.[5] In "*Siqueiros y el arte de las masas*" of 1935, he recognized the inherent contradiction of accepting patronage from the wealthy to carry out such experimental projects, and drew a distinction between muralism's status as an official state art of Mexico and the situation elsewhere:

> Mural painting may be no more than one of many forms of expression of popular art. To make mural painting the main weapon in the fight for an art of the masses within a bourgeois society is to condemn the movement to passivity or opportunism. The bourgeoisie, progessively more fascist, will not relinquish its walls to proletarian aims. . . . We have the most palpable proof of this in Buenos Aires with Siqueiros['s mural]. . . . The pretext of undertaking a technical experiment cannot justify the lack of content. In order to realize his mural, Siqueiros had to cling to the first life raft the bourgeoisie offered him.[6]

It was during this period of critical reflection that Berni painted *The New Chicago Athletic Club*, which may be considered a summation of his New Realism. With its contemporary populist subject, monumental scale, and compositional scope, the painting competes with the mural format. Each of the soccer-team members is rendered with almost photographic attention to physiognomy. This, the athletic subject matter, and the figures' attire underscore the painting's contemporaneity, yet Berni also employs a number of seemingly contradictory representational idioms within the same composition. A traditional still life apears in the foreground at the far right, and the hieratic figure who observes the scene below recalls early Renaissance frescoes. The archway on the right, behind the figure holding the red-and-black banner that identifies the athletic club, is probably a reference to metaphysical painting, which had interested Berni earlier in his career. The still life and the architectural fragment are anachronisms; at the same time, the disembodied archway and the view of a fenced-in neighborhood and leafy trees are inconsistent with traditional compositional perspective. At the far left, a boy kneels behind a large kite comprising six triangular sections. The kite may be a playful reference to Berni's own earlier Surrealist work *La puerta abierta* (The Open Door) of 1932, in which cubes that resemble the kite appear as indicators of disruptions in scale and context, and signal the simultaneous recognition and rejection of nonrepresentational painting.[7] In fact, visual references to figurative paintings from the Renaissance through modernity reveal a series of rhetorical, spatial, and compositional disconnects.

Marcelo Pacheco has suggested that beginning with his reinterpretation of Surrealism and throughout his oeuvre, Berni combines disparate representational strategies to parodic effect.[8] In 1934, after becoming a member of the Communist Party and collaborating with Siqueiros, Berni painted two monumental works depicting political unrest and working class subjects:

Manifestación (Demonstration), in the collection of the Museo de Arte Latinoamericano de Buenos Aires, and *Desocupación* (Unemployment), in a private collection.[9] In *New Chicago Athletic Club* Berni employs visual references to his own earlier artistic practices, and to the art history that influenced him and the Mexican muralists: early-Renaissance frescoes. He also incorporates various modes of figurative painting, and in so doing uses artifice to point to realism as representation, rather than as a transparently mimetic technique. At the same time, in choosing this particular subject, he playfully refers to the metaphor of politically engaged teamwork that both he and Siqueiros employed to describe their artistic collaboration. This suggests that he viewed *The New Chicago Athletic Club* as a kind of demonstration of his New Realism—art that would appeal to the masses and would be an alternative to both Mexican muralism and Social Realism.

Unfortunately the reception of the work within the Museum did not live up to Berni's enthusiastic hopes in 1942. When it was acquired, both Kirstein and Berni viewed it as part of a broader current of realism extending through North and South America. In fact, Kirstein's reference to the artist in the publication accompanying the Museum's exhibition *The Latin American Collection of The Museum of Modern Art*, in 1943, makes this explicit: "Antonio Berni of Rosario de Santa Fe is the Argentine who perhaps most resembles a North American of the epoch of the W.P.A. and the Treasury Section of Fine Arts."[10] Postwar developments in the United States, however, meant that both Latin American and U.S. artists who worked in a figurative idiom with political content came to be regarded as outside the mainstream of contemporary art. Although the painting was included in the 1943 exhibition of the Museum's Latin American collection, and although the Museum once more acquired works by Berni, most of them prints, in the 1960s, after he won the Grand Prize for Drawing and Printmaking at the 1962 Venice Biennale, *New Chicago Athletic Club* has not been shown again at the Museum. It was, however, borrowed by the Bronx Museum in 1988–89 for the traveling exhibition "The Latin American Spirit: Art and Artists in the United States, 1920–1970." Important holdings of Berni's works from this period are now in the Museo de Arte Latinoamericano de Buenos Aires (MALBA), and the publication of a number of important monographs on his work has also contributed to the recognition of his oeuvre internationally.[11]

Miriam Basilio

1 Lincoln Kirstein, "Antonio Berni," EMH.Il15a, The Museum of Modern Art Archives, New York.

2 Antonio Berni, letter to Kirstein, Buenos Aires, August 13, 1942. Registrar's File #224, "The Latin American Collection of The Museum of Modern Art, 31 March–6 June 1943," The Museum of Modern Art Archives, New York. The letter is in Berni's French, and reads,"Mon ami, c'est pour moi une grande satisfaction que un de mes tableux figure leur un museé des 'EE.UU. Je desire que ce premier contact avec le public americain-contact dout vous m'avez dormé l'occasion-sórt une veritable communication spirituelle d'affirmation du "Nouveau Realisme," qui est l'inquietude de nombreux artistes d'Amerique et le chemin de l'unite artistique continentale".

3 Mari Carmen Ramírez, "The Masses Are the Matrix: Theory and Practice of the Cinematographic Mural in Siqueiros," in *Portrait of a Decade: David Alfaro Siqueiros 1930–1940* (Mexico City: Instituto Nacional de Bellas Artes, 1997), pp. 68–95.

4 Siqueiros's phrase was "*un equipo o team poligrafico*" (a team or polygraphic team). See his manifesto *Ejercicio plástico* (1933), excerpted in Ramírez and Héctor Olea, eds., *Heterotopías: Medio síglo sin lugar, 1918–1968* (Madrid: Ministerio de Educación, Cultura y Deporte, 2000), pp. 476–78.

5 Berni, "El Nuevo Realismo," in *Forma: Revista de la sociedad Argentina de artes plásticas* (Buenos Aires) no. 1 (August 1936). Excerpted in *Berni: Escritos y papeles privados*, ed. Marcelo Pacheco (Buenos Aires: Temas Group Editorial, 1999), pp. 79–82.

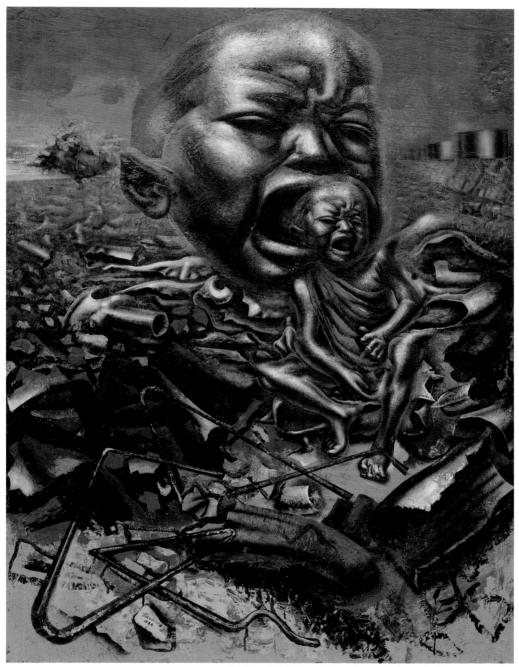

45. **David Alfaro Siqueiros**. *Echo of a Scream*. 1937.
Enamel on wood, 48 x 36" (121.9 x 91.4 cm)

6 Berni, "Siqueiros y el arte de las masas," *Nueva Revista* (Buenos Aires), January 1935. Excerpted in Ramírez and Olea, eds., *Heterotopías*, pp. 479–81. "La pintura mural no puede ser más que una de las tantas formas de expression del arte popular. Querer hacer del movimiento muralista el caballo de battalla del arte de masas en la sociedad burguesa, es condenar el movimiento a la pasividad o al oportunismo. La burguesía, en su progresiva fascistización, no cederá hoy sus muros monopolizados para fines proletarios. . . . La prueba más palpable la tenemos en Buenos Aires con Siqueiros. . . . El pretexto de hacer una expriencia técnica no puede justificar el vacío de contenido. Siqueiros, para realizar una pintura mural, tuvo que amarrarse a la primera tabla que le ofreció la burguesía."

7 *La puerta abierta* is in the collection of the Museo de Arte Latinoamericano de Buenos Aires.

8 See Pacheco, "Antonio Berni: Un comentario rioplatense sobre el muralísmo mexicano," in *Otras rutas hacia Siqueiros* (symposium organized by Curare, Espacio Crítico para las Artes, April 25–27, 1996), ed. Olivier Debroise (Mexico City: Instituto Nacional de Bellas Arte, and Curare, Espacio Crítico para las Artes, 1996), pp. 227–47.

9 In 1925, Berni traveled to Madrid and other Spanish cities, and from 1926 to 1930 he lived in Paris. The following year he returned to Argentina and joined the Communist Party. While living in Europe he took an interest in the work of Giorgio de Chirico; later he associated with André Breton, Marcel Duchamp, Tristan Tzara, and Salvador Dalí, as well as with Henri Lefebvre and Louis Aragón. See Adriana Lauría, "Cronología," in *Berni: Escritos*, ed. Pacheco, pp. 262–70.

10 Kirstein, *The Latin American Collection of The Museum of Modern Art* (New York: The Museum of Modern Art, 1943), p. 29.

11 See Pacheco, ed., *Museo de Arte Latinoamericano de Buenos Aires: Colección Costantini* (Buenos Aires: Americo Arte Editores, Landucci Editores, 2001); *Berni: Escritos*, ed. Pacheco; Jorge Glusberg, *Antonio Berni en el Museo Nacional de Bellas Artes* (Buenos Aires: Museo Nacional de Bellas Artes, 1997); and Jorge López Anaya, *Antonio Berni: Estudio crítico* (Buenos Aires: Banco Velox, 1997).

WIFREDO LAM'S *The Jungle* and MATTA'S "Inscapes"

Arguably the most well-known work of art by a Latin American artist, Wifredo Lam's *The Jungle*, (1943) is a paradigm: an emblem of the influence of School of Paris technique and theory in Latin America, the work is also a signifier for the shift in representation developed by the American avant-garde in the period between the wars. In 1950, the Cuban anthropologist Fernando Ortíz described this epic painting as follows:

> In *La jungla* there is neither the thick and exuberant virgin flora of Cuba nor of Africa. In this verdant architecture there are only sugarcane [plants], palm leaves, tobacco leaves, corn leaves . . . plantain leaves, and weeds. . . . It is not jungle vegetation, but agrarian vegetation, tilled vegetation, a gift of the Earth Mother to man who revels in it. Mulatto foliage. Foliage that is evocative, not because of its opulence but because of its "lujuria," as the Cuban *guajiro* would say, alluding to its prodigious fecundity.[1]

This description of Lam's image is significant because it illuminates the relationship between the painting's title, *The Jungle* and its actual subject matter, a sugarcane field. Lam's cane field is populated with figures that have been variously read as *orishas*, or deities from the Afro-Cuban Santería religion; sugarcane cutters; runaway slaves; and religious celebrants being possessed by spirits.[2] This sugarcane field-cum-jungle represents Lam's visceral reaction to the contemporary environment—both social and political—in which Afro-Cubans were living when he returned to the island after a fifteen-year absence.

In Lam's reading of the landscape, the sugarcane field as jungle perpetuates the intolerable situation of the figures in the scene. In literary and pictorial representation the jungle is signified as thick, dark, heavy, oppressive, unending, and dangerous. Despite Ortíz's insistence on this foliage as an agrarian product and "gift from the Earth Mother," it is clear that the crops in Lam's jungle are overgrown, untilled, and truculent. This contradiction is significant: Lam renders a staple crop—sugar—as a deathtrap. Ortíz's own thoughts on the influence of the tobacco and sugarcane industries on the social, political, and neocolonial history of Cuba are bound up in this reading of Lam's painting.[3]

Ortíz's dubbing of the vegetation as "mulatto foliage" is particularly significant in that it reiterates the hybrid nature not only of the vegetation but also of the figures in its midst. In fragmenting the figure, Lam juxtaposes a variety of signifiers for race: Africanized masks, hyperbolic exaggeration of body parts, and "jungle" vegetation. In turn, this further underscores Lam's original intent, presenting the figures simultaneously as victims of their surroundings and guardians of their culture. Nearly choked on the picture plane by the lush, lascivious jungle growth, Lam's figures face one another confused and enraged. The image is a seismic conflation of environment and beings, of Santería ceremony and labor, spiritual frenzy and colonial history. The chaos of the scene is intended to underscore the plight of the worker in the Cuban landscape, surrounded by the staple crop that signifies both livelihood and enslavement.

This racialized figure was of particular interest to Lam, who said, "I wanted with all my heart to paint the drama of my country, but by thoroughly expressing the negro spirit, the beauty of the plastic art of the blacks. In this way I could act as a Trojan horse that would spew forth hallucinating figures with the power to surprise, to disturb the dreams of the exploiters."[4] Solidifying Lam's interest in his Cuban roots at this time was his work illustrating Aimé Césaire's book *Cahiers du retour au pays natal* (Notebook of a return to the native land): a Spanish translation of the book published in 1942 had featured Lam's Surrealist-inspired drawings. Lam's insistence on replicating more

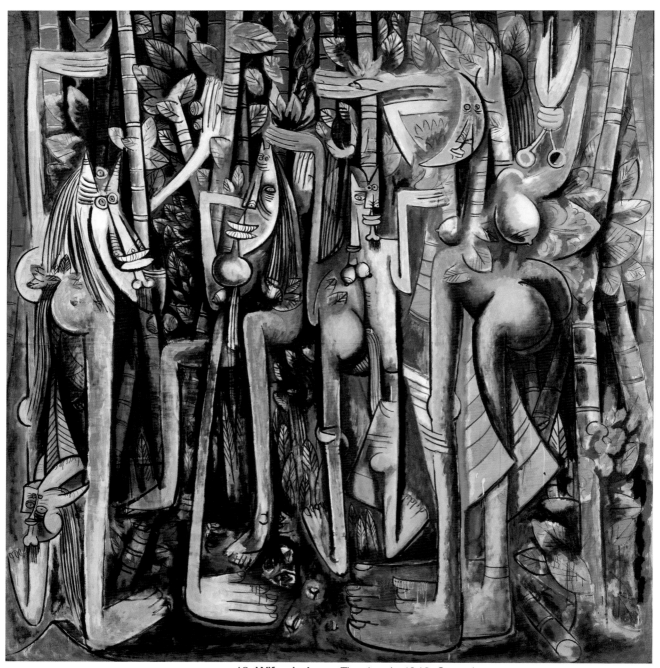

46. **Wifredo Lam**. *The Jungle*. 1943. Gouache on paper mounted on canvas, sheet: 7' 10 1/4" x 7' 6 1/2" (239.4 x 229.9 cm)

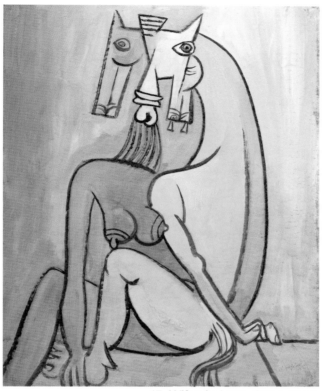

47. **Wifredo Lam**. *Satan*. 1942.
Gouache on paper, 41 7/8 x 34" (106.4 x 86.4 cm)

"meaningful" vegetation in the background of his Cuban-period paintings is first alluded to in these images, which he created upon his return to the Caribbean. Gerardo Mosquera notes,

> Lam's arrival does not produce an astonishment in the face of the tropics but a feeling of belonging. It becomes the confirmation and final revelation of his own space. It is a "return to the native land" in the sense of Césaire's long poem, and the work he will do henceforth can be read as testimonies—notebooks—of his return.[5]

As notebooks, Lam's Havana paintings read like eyewitness accounts of this confluence of colonial history, power relations, and a racialized population. By positing rhetorical strategies in his Havana paintings, like *The Jungle* Lam constructs a potent visual narrative about the circulation of power, labor, and bodies in the Americas. He uses fruit, specifically the Cuban *frutabomba* or papaya, to represent fertility and the female body, thus granting gender to the landscape as well as the figures in the scene. The rounded form of the fruit hangs from both the body and the darkened background created by the foliage that encroaches upon it. The landscape of sugarcane and tobacco, Afro-Cuban culture, and the collective national unconscious are bound together in the representation of a single figure, that of the black female.

An endless Surrealist landscape, Lam's jungle represents a signifying space, where the discourse of anticolonialism is visualized through the landscape and the figures that are caged in its forms. *The Jungle*, then, represents Lam's affirmation of *Cubanismo*—the act of embracing emblems of authentic Cuban culture—as well as his dedication to illuminating the harsh realities of life for Afro-Cubans and, certainly, his attempts to place his paintings within the larger framework of avant-garde modernity. Lam's jungle is not only the field of sugarcane, the sole source of income for so many Afro-Cubans, but also the land itself. It is everything that engulfs the island.

Roberto Matta Echaurrean, known as Matta, presented the landscape as the signifier for human psychology. During the 1930s he developed his concept of "psychological morphology" and created his first "inscapes," which he thought of as landscapes of the inner mind. Futuristic in form, these inscapes often juxtaposed a barren vision of an indefinable landscape with abstract forms drawn from basic organic shapes and conceived as the aesthetic form of the artist's own psychological state. Similarly, Matta's psychological morphology represents his concept of an introspective mental state that draws its forms from organic materials such as clouds, rocks, water, microscopic organisms, and other natural substances. The Surrealists believed that organic forms were particularly successful in creating associations in the mind of a viewer, since they were part of the natural environment. By creating work steeped in vaguely recognizable forms, Matta hoped to catalyze visual associations with the workings of the viewer's own inner mind.

In Matta, the inscape becomes the place where a personal history of psychology and psyche is written and displayed. In Lam, the public discourse of the history of the black presence in Cuba is written in imagery that features the very real components of the landscape that he has labeled "the jungle." The work of both Matta and Lam can be approached through the language of landscape as a space that is both literal and metaphorical, a space in which a history that is inscribed upon the body can be reconsidered and renegotiated.

Rocío Aranda-Alvarado

1 Fernando Ortíz, "Las Visiones del cubano Lam," *Revista Bimestre Cubana* 66 (December 1950): 259. I have translated this quotation from the following: "*En La Jungla no está la tupida y exuberante floresta virgen de Cuba ni la de Africa . . . solo hay cañas de azúcar, hojas de palma, de tabaco, de maíz, de malanga, de plátanos, de curujeyes y de 'yerba mala.' . . . No son vegetación selvática sino agraria y trabajada, regalo de la Madre Tierra al hombre que la goza. Fronda mulata. Vegetación evocatíva, no por su opulencia sino por su 'lujuria,' como diria el guajiro cubano aludiendo a la pródiga fecundidad.*"

2 See Maria Balderrama, ed., *Wifredo Lam and His Contemporaries, 1938–1952* (New York: The Studio Museum in Harlem, 1992).

3 See Ortíz, *Cuban Counterpoint: Tobacco and Sugar*, trans. Harriet de Onís (New York: Knopf, 1947).

4 Wifredo Lam, quoted in Max-Pol Fouchet, *Wifredo Lam* (New York: Harry N. Abrams, 1976), p. 199.

5 Gerardo Mosquera, "Modernidad y Africanía: Wifredo Lam in His Island," *Third Text* 20 (Fall 1992): 56.

48. **Matta** (Roberto Sebastián Antonio Matta Echaurren).
Condors and Carrion. (1941). Pencil and crayon on
paper, 23 x 29" (58.4 x 73.7 cm)

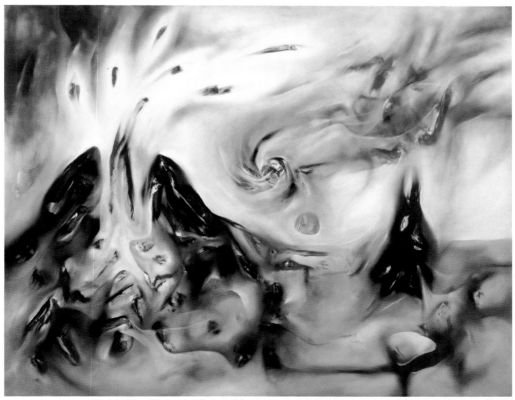

49. **Matta** (Roberto Sebastián Antonio Matta Echaurren). *Listen to Living*. 1941.
Oil on canvas, 29 1/2 x 37 7/8" (74.9 x 94.9 cm)

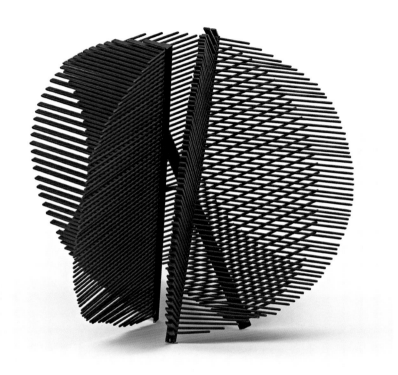

50. **Gego** (Gertrude Goldschmidt). *Sphere*. (1959).
Welded brass and steel, painted black, 22" (55.7 cm) diam., on three
points spaced 8 5/8 x 7 1/2 x 7 1/8" (21.8 x 19 x 18 cm) apart

Gego did not make the trip from Caracas to New York in 1965 for the opening of "The Responsive Eye" at The Museum of Modern Art, but we can imagine groups of modishly dressed gallerygoers standing before her 1959 sculpture *Sphere* in MoMA's galleries. Its vibrating lines must have looked at home among paintings by Bridget Riley and Victor Vasarely, positioning Gego at the core of the wildly popular international Op art trend. While Gego was sending her work from Caracas to what was then the center of the art world, Hélio Oiticica was immersing himself deeper within the margins of his hometown, Rio de Janeiro. In 1965 we would have found Oiticica learning how to samba in the Mangueira *favela* of Rio. That year he showed his "*Parangolés*"—fabric capes designed to be worn in the streets for carnival by Oiticica's Mangueira samba team—at the Museum of Modern Art in Rio. These "*Parangolés*" were the culmination of Oiticica's rejection of conventional artistic practice. Since 1960, he had abandoned the two-dimensional surface of painting and was making art that functioned less as images and objects and more as things to be held and worn, or spaces to be entered and explored.

Although these artists's works were generated under very different contexts, during the 1960s Gego and Oiticica, as well as Oiticica's compatriot Lygia Pape, together transformed the seemingly immutable language of hard-edged geometric abstraction into expressive and lyrical forms of

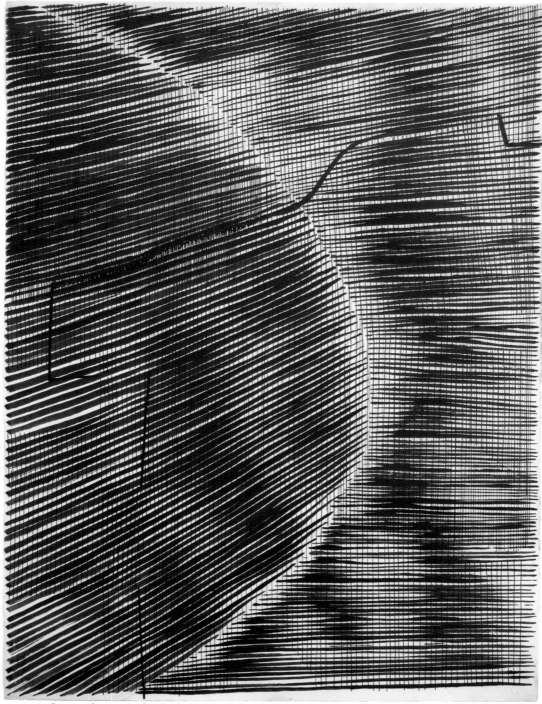

51. **Gego** (Gertrude Goldschmidt). *Untitled*. 1963. Ink on paper, sheet: 30 x 22" (76.2 x 55.9 cm)

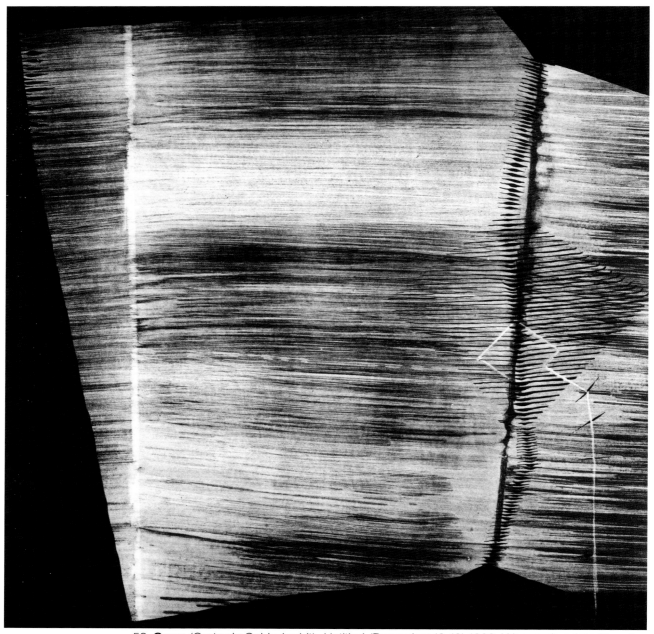

52. **Gego** (Gertrude Goldschmidt). *Untitled*. (December 12-19) 1966. Lithograph, printed in color, comp.: 22 1/16 x 22 1/16" (56.1 x 56.1 cm), sheet: 22 1/16 x 22 1/16" (56.1 x 56.1 cm)

53. **Gego** (Gertrude Goldschmidt). *Untitled*. 1969.
Ink and pencil on paper, sheet: 25 3/4 x 19 3/4" (65.4 x 50.2 cm)

54. **Lygia Pape**. *Book of Creation*. 1959–60. Gouache on cardboard, each 12 x 12" (30.5 x 30.5 cm) (eight of eighteen components)

installation and performance. They would all find an unprecedented degree of freedom in the structure of geometric forms. These artists' drawings and prints from the late 1950s and the 1960s map their departure from making conventional art, and offer hints as to how their viewers' experiences can be redefined as interactive and dynamic, transforming the viewers themselves from onlookers to participants. At a time when avant-garde movements in Brazil and Venezuela struggled to redefine modern art, Oiticica and Pape signed the 1959 Neo-Concrete Manifesto. In this document the poet Ferreira Gullar, speaking for the youngest generation of artists, rejected the rationalism of their teachers' brand of geometric abstraction and proclaimed their intention to make art that had social and spiritual impact, art that would destroy the boundaries between art and life.[1]

In 1972, when Oiticica exhibited his series of gouaches from 1957–58, he dubbed them "*Metaesquemas*" (Meta-schemes). Looking back on these very early works, he recognized them as the creative threshold that simultaneously represented his last articulation tied to conventional pictorial space and his desire to escape its set of conventions.[2] Using an elemental constructivist palette restricted to black, white, blue, and red, he tweaked and stretched rectangular units and created unbalanced and animated surfaces that distorted the primacy of the grid and the flatness of the picture plane. With these drawings, Oiticica was making a final attempt to upset the balance and autonomy of the pictorial image before abandoning the idea of painting completely.

55. **Lygia Pape**. *Untitled*. 1959. Woodcut printed in black,
comp. and sheet: 19 11/16 x 19 11/16" (50 x 50 cm)

During roughly the same period, in 1955–59, Pape was making an extensive series of small-scale monochromatic woodcuts that she called "*Tecelares*" (Weavings).[3] In these works she emphasized the organic qualities of her restricted choice of materials: woodcut, black ink, and Japan paper. She also introduced subjectivity into her geometric forms by foregrounding the delicate wood-grain pattern inherent in the woodcut process. In the example here, from 1959, the wood-grain pattern of the printed figure infuses the surface of the work with unexpected expressive gesture, but this gesture comes readymade from nature, not from the artist's hand. Because the woodcut is an important vernacular medium in Brazil, by executing these explicitly modern constructivist compositions in woodcut Pape also tied the prints to local tradition.

56. **Hélio Oiticica**. *Untitled No. 4066*. 1958. Gouache on cardboard, sheet: 22 7/8 x 21" (58.1 x 53.3 cm)

57. **Hélio Oiticica**. *Untitled*. 1959. Gouache on cardboard, 19 7/8 x 26 3/4" (50.5 x 68 cm)

Like Oiticica and Pape, Gego abandoned pictorial space and embraced the expressive potential of organic forms, but this made her an outsider in relationship to Caracas's dominant avant-garde, Venezuela's kineticist movement. While Gego employed the kineticists' motif of vibrating lines in *Sphere,* by the mid-1960s her work had begun to challenge their primacy. During her most productive years as a draftsman and printmaker—1960 to 1966—she explored the expressive potential of line, investing it with an enigmatic and irreverent character.[4] By 1966, in an untitled lithograph in the MoMA collection, Gego intersected a field of parallel lines with irregular, renegade marks. When she returned to making sculpture in the late 1960s, she created total environments: ephemeral installations in which she would drape netting crafted with bits of wire from the gallery's ceiling. These installations, which she called "*Reticuláreas*"—a coinage from the Latin word for "network" and the Spanish words for "mesh" and "area," with an added reference to grids or graphs—constituted an all-encompassing labyrinthine web that the viewer was forced to negotiate physically. In MoMA's untitled 1969 drawing, Gego depicted a detail of a *Reticulárea* web; it effectively captures how the triangular units of the web were stretched and distorted by their own weight, and hints at the illusion of infinitely receding space that the viewer experienced while immersed in this web.

Working during periods of unprecedented modernization in their respective countries, Gego, Oiticica, and Pape each sought to reestablish the primacy of the viewer within the specificities of their respective contexts. In one way or another, they all transformed the internationalism of

58. **Hélio Oiticica**. *Untitled No. 348*. 1958.
Gouache on cardboard, 18 1/8 x 22 3/4" (46 x 58 cm)

geometric abstraction into locally based practices. This extraordinary group of prints and drawings constitutes a visionary blueprint that outlines the artists' ambitious efforts to reinvest geometric abstract art with utopian purpose.

Harper Montgomery

1 Ferreira Gullar, "Neo-Concrete Manifesto," reprinted in Dawn Ades, *Art in Latin America: The Modern Era, 1820–1980* (New Haven and London: Yale University Press, 1989), pp. 335–37.

2 Hélio Oiticica, "Metaesquemas 57/58," reprinted in *Hélio Oiticica* (Paris: Galerie Nationale du Jeu de Paume, Rio de Janeiro: Projeto Hélio Oiticica, and Rotterdam: Witte de With Center for Contemporary Art, 1992), pp. 27–28.

3 For images of other prints from this series see Guy Brett, *Lygia Pape* (New York: The Americas Society, 2001).

4 Iris Peruga examines the development of Gego's line in her essay "Gego. El prodigioso juego de crear," in *Gego, 1955–1990* (Caracas: Museo de Bellas Artes and Fundación Gego, 2001), pp. 10–77.

MATHIAS GOERITZ'S *Message Number 7B, Ecclesiastes VII*, RAFAEL MONTAÑEZ ORTIZ'S *Archeological Find, 3* and JESÚS RAFAEL SOTO'S *Olive and Black*

"A work of art," writes Pascal Quignard, "however small it may be, adds something to what already exists that previously could not be found."[1] One might think this quotation a paraphrase of an old definition of painting, appearing, for example, in Cennino Cennini's *Il libro dell'arte* (c. 1390), according to which art's task consists of "presenting to plain sight what does not actually exist."[2] The sentence evokes the famous model of the artist-creator who is able to enrich the world with his work, although behind the medieval theorist's enigmatic statement there probably also lurks the idea that art can bestow the illusory appearance of life on something not actually living, producing perfect simulacra, phantoms that look lifelike.

The work of Jesús Rafael Soto and Rafael Montañez-Ortiz may be seen as linked by the simultaneous search for and negation of this kind of artistic illusion. A significant counterpoint to both is the work of Mathias Goeritz.

When Soto was a young artist in the city of Maracaibo, Venezuela, he heard one day about a white canvas containing within it only another white square. From then on, without ever having seen the work of the Suprematist painter Kasimir Malevich, he embarked on a quest to undermine the apparent stability of visible matter in his works.[3] If matter was energy, Soto thought, then painting had not managed to represent it as such; instead of imitating or reproducing its formal appearances, a way had to be found to show it as just that—optical energy. In *Olive and Black* (1966), Soto exploits the moiré effect produced by the juxtaposition of parallel lines on a mobile surface, or in the vision of a moving spectator. Matter seems to vanish before one's very eyes, and the work's basic design appears as an energy field, an unstable, vibrating mass. Studying the work of Piet Mondrian in around 1952, Soto noticed a certain optical vibration at the points where Mondrian's perpendicular lines intersected. By isolating those moments and then repeating them in countless forms and variations, Soto found a way to produce works whose optical energy seemed to dematerialize their physical substance. Trying to go beyond the legacy of Mondrian, particularizing it with a serial method of his own, Soto sought to add something that had not existed. Here is another way of interpreting Quignard's paraphrase: a work of art is valid if, however small it may be, it adds something to its own tradition that previously did not exist.

Between 1961 and 1967, the same years in which Soto found a way forward by creating kinetic works in series, Montañez Ortiz was producing his "Archeological Finds," works that are the remains of voluntary, public acts of destruction. In performances and "happenings" that were contemporary with the activities of the Fluxus group in Europe and the United States, Montañez Ortiz made the destructive act an *ars poetica*—the wellspring of another kind of creation. This Puerto Rican artist championed a sensual materialism that would advance the idea of process-oriented art.[4] Notions of ritual, of community and collective testimony, of shamanlike performance, of the contemporary materialization of a type of catharsis, and of an apocalyptic, privileged moment were given voice in these destructive acts.[5] It might seem that Montañez Ortiz's driving force was to dismantle something that had previously existed, not to add one; the demolished chairs and mattresses in his "Archeological Finds," which might be seen as a kind of readymade, are left in ruins, the aftermath of a creative sacrifice. It is paradoxical, then, that to the same extent that Soto sought to visually dematerialize the materiality of his media, as in his works from the late 1950s and 60s, such as the "Logs" (Leños) and "Vibrations" or "Vibes" (Vibraciónes), what predominates in Montáñez Ortiz's work is materiality itself, as insensate monument and improbable presence, its formless appearance highlighting the inrush of what previously had not

59. **Mathias Goeritz**. *Message Number 7B, Ecclesiastes VII.*
1959. Construction of nails, metal foils, oil, and iron on wood panel,
17 7/8 x 13 5/8 x 3 3/8" (45.1 x 34.5 x 8.4 cm)

existed. However strongly the memory of the creative or, rather, destructive act endures, the "Archeological Finds" are startling presences, ruins of a world determined to produce unvarnished entities, looming up out of the forgotten past. It is an ancient truth, dating back to the time of Aristotle, that nothing can really be said to be "formless";[6] all that exists, by the mere fact of existing, exists as form. Something is said to be "formless," then, when its form does not correspond to the usual names by which we identify things.[7] *Archeological Find, 3* (1961) has the form of a demolished mattress, the funereal beauty of the junk heap, and the ruin and gloomy aura of the murky bogs to which all beings are condemned to return.

Goeritz's work brings together the kinetic optimism of a Soto and the materialistic pessimism of a Montañez Ortiz. His search for a "kinetic effect" is quite different from Soto's,[8] however, and his

60. **Rafael Montañez Ortiz**. *Archeological Find, 3*. (1961).
Burnt mattress, 6' 2 7/8" x 41 1/4" x 9 3/8" (190 x 104.5 x 23.7 cm)

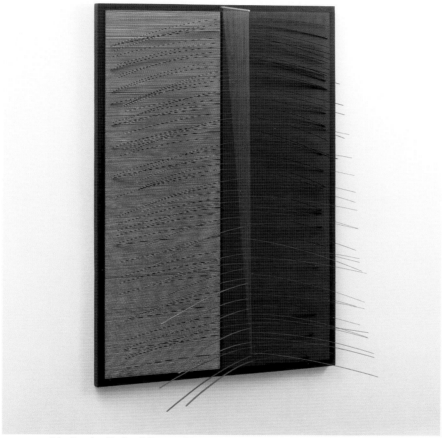

61. **Jesús Rafael Soto**. *Olive and Black*. 1966. Flexible mobile, metal strips suspended in front of two plywood panels painted with synthetic polymer paint and mounted on composition board, 61 1/2 x 42 1/4 x 12 1/2" (156.1 x 107.1 x 31.7 cm)

continuous originary investigation translated into works influenced by cave painting, mystically minded sculptures, and monumental inscriptions in the landscape.[9] His "Shrouds" and "Messages" series, including *Message Number 7B, Ecclesiastes VII* (1959),[10] were made during the period of emergence of *art informel*, and of a rebellious antiaesthetic that swept the globe in the work of artists ranging from the Fluxus group to Piero Manzoni, Yves Klein, and Montañez Ortiz, even as Soto's dematerializing methods defied it. These works by Goeritz, however, contain a prophetic intent, and correspond through their titles to a series of biblical quotations that must be read in its admonishing sequence: it is the voice of a thundering God, made manifest in the magnificent aridity of matter. At once aggressive and beautiful, Goeritz's "Messages" call to mind those medieval liturgical objects—tabernacles, ciboria, monstrances—that use no iconic or imagistic presence. Beginning with a found illustration—a readymade—Goeritz would often

subcontract the building of his works' supports to carpenters and the application of gold leaf to gilders, recalling the anonymous, collective methods used to make medieval objects.

Like a lone horseman, Goeritz pitted his enduring interest in the primitive and originary against Mexican muralism's rhetorical utopian promises. In this fascinating regressiveness he displayed a type of modernity out of step with both avant-garde ideology and the idea of progress. Instead, the idea emerges that in all art, however advanced it may seem, something from the darkest past persists. Revealing that trace is one of the challenges faced by the artist. Thus Goeritz could interpret the metaphysical meaning of Malevich's *White on White* of 1918 by transforming it into one of his "Messages," in gold on gold,[11] recalling that behind the Suprematist idea of negative presence, the model of the medieval icon had survived. Goeritz was interested not in having his work add something that did not already exist to the world, but in phrasing that "something" in a powerful, emotionally moving form, as in the resounding voice of Ecclesiastes. Perhaps, unlike Cennini but like the eighth-century Byzantine theologian Saint John Damascene, Goeritz thought of the image as a "similarity that reproduces a prototype in such a way that a difference always remains between them."[12] It was precisely in the awareness of that difference that he produced his entire body of unclassifiable work.

Luis Enrique Pérez-Oramas

1 Pascal Quignard, *Les Ombres errantes*, Dernier Royaume I, (Paris: Grasset, 2002), p. 123.

2 " . . . *dando a dimostrare quello che non e sia.*" Cennino Cennini, *The Craftsman's Handbook: The Italian "Il Libro Dell' Arte,"* trans. Daniel V. Thompson, Jr. (New York: Dover Publications, c. 1933, 1954), p. 1.

3 See Ariel Jimenez, *Conversaciones con Jesús Soto* (Caracas: Fundación Cisneros, 2002), p. 25.

4 See Rafael Montañez Ortiz, "Destructivism: A Manifesto by Rafael Montañez Ortiz," in *Rafael Montañez Ortiz: Years of the Warrior 1960, Years of the Psyche 1988* (New York: El Museo del Barrio, 1988), pp. 52-53.

5 See Kristine Stiles, "Rafael Montañez Ortiz," in ibid., p. 24.

6 Aristotle, *Metafísica*, VII, 8, 1033a/1033b (Madrid: Aguilar, 1973), p. 991.

7 "Form for Aristotle will be found constantly associated with discourse: the form of something is that part of it that can be circumscribed in a definition." See Pierre Aubenque, *Le Problème de l'être chez Aristote* (Paris: Presses Universitaires de France, 1962), pp. 459–60.

8 See Oswaldo Sánchez, "Mathias Goeritz: The Ministries of Space," in Rina Carvajal, Suely Rolnik, Sánchez, et al., *The Experimental Exercise of Freedom* (Los Angeles: Museum of Contemporary Art, 1999), p. 158.

9 Among Goeritz's mystically inspired works can be included the series of crucifixions entitled *Salvador de Auschwitz* (Savior of Auschwitz, 1954); among the monumental works, *La serpiente para el eco* (The serpent for the echo, 1952–53) and *Torres de ciudad satélite* (Satellite town towers, 1957). See Lily Kasner, *Mathias Goeritz: Obra 1915–1990* (Mexico: Instituto Nacional de Bellas Artes, 1998).

10 See Francisco Reyes Palma, "Mensajes Metacromíaticos," in *Los Ecos de Mathias Goeritz* (Mexico City: Antiguo Colegio de San Ildefonso, Instituto de Investigaciones Estéticas, 1997).

11 See ibid., p. 178.

12 See Hans Belting, *Bild und Kult. Eine Geschichte des Bildes vor dem Zeitalter der Kunst*, 1990, French trans. as *Image et culte. Une Histoire de l'image avant l'époque de l'art* (Paris: Les Editions du Cerf, 1998), p. 195.

MARISOL'S *LBJ* and
FERNANDO BOTERO'S *The Presidential Family*

Each in its own way, *The Presidential Family*, by Fernando Botero, and *LBJ*, by Marisol, are pointedly humorous updates of the state portrait. Created in 1967, when both artists were living in New York City, these works have been identified with Pop art, but also suggest that the artists' dialogue with Pop conventions was informed by their respective cultures of origin. Marisol's *LBJ*, an over-life-sized wood construction with pencil and paint applied to its surface, is a monumental portrait of a block-headed U.S. President Lyndon B. Johnson wearing a black suit and narrow black tie. He holds three diminutive portraits of his wife and two daughters in the palm of his hand. Marisol's playful morphological pun extends beyond the block-headed president to the avian contours of the three women: their shape, based on that of gray house-wrens, is a reference to the nicknames of Mrs. Claudia Taylor Johnson, known as Lady Bird, and her daughters Lynda Bird and Luci Baines.[1] The portrayal of LBJ as a towering and protective father figure was fitting given the circumstances under which he became president—the assassination of John F. Kennedy. At the same time, the wide discrepancy in scale between the president and his family also suggests a paternal, even somewhat arrogant figure. The fact that LBJ was directing the American war in Vietnam at the time encourages us to draw a parallel between U.S. foreign military intervention and the relationship between the sexes. By manipulating scale, Marisol successfully interjects political commentary into a humorous Pop art rendering of the controversial president.

Botero's *Presidential Family*, a monumental painting of figures representing elite classes in Latin American countries, cites Spanish court portraiture. Botero employed his signature style to render the figures and landscape in exaggeratedly rotund proportions. According to the artist, this was a formal strategy he devised to depict volume on a flat picture plane. The technique was inspired by Spanish colonial polychrome sculpture and painting, as well as by the sense of scale found in works by self-taught Latin American artists. The bloated appearance of the figures—an elderly woman with a child, possibly her granddaughter, on her knee; a woman in ostentatious attire; a cleric; a man in a suit and hat; and a saluting general—hints at satire. The objects held by several of the figures—for example the small toy airplane held by the girl, the dainty purse and gloves in the hands of the matron, and the cleric's tiny rosary beads—underscore the humorous effect when viewed against each figure's disproportionately large size. These articles, along with the snake and cat in the lower foreground, and the fox stole worn by the matron, suggest a metaphorical reading. Just as each of the male figures is the allegorical representation of a social class (politics, the military, and the church), the fox, snake, and cat traditionally embody sinister traits. Upon closer inspection, the plump crossed legs and womanly figure of the little girl portray an individual too mature to be seated on the older woman's lap. The contrast between her stereotypically feminine appearance and the toy she holds calls attention to the double meanings that proliferate throughout the composition, not the least of which is the phallic visual pun created by comparing the smoke curling from the businessman's cigarette to the contours of the black plume billowing from the volcano among the Andean peaks that surround the figures.

The artist himself appears in the painting. Standing in front of a canvas, he is caught in the act of painting the portrait—a picture within a picture that references Spanish court portraiture. In fact the artist identified Francisco Goya's *Familia de Carlos IV*, of 1800 (The Prado Museum, Madrid), as his model.[2] In the context of Botero's painting, it is interesting to note that the prevailing art-historical interpretation of the Goya portrait is that the artist exaggerated the royal family's physical imperfections, satirizing the personal and political degradation of the Spanish monarchy by juxtaposing their unattractive appearance with their luxurious clothes and surroundings. In

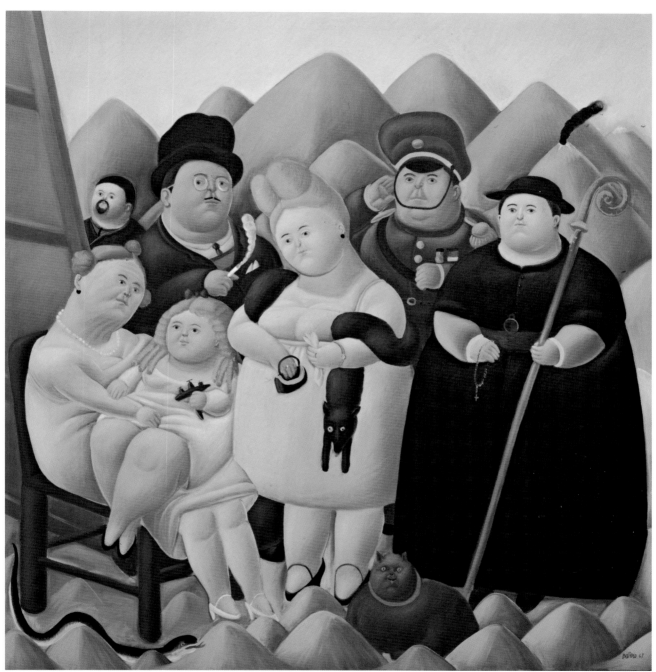

62. **Fernando Botero**. *The Presidential Family*. 1967. Oil on canvas, 6' 8 1/2" x 6' 5 1/4" (203.5 x 196.2 cm)

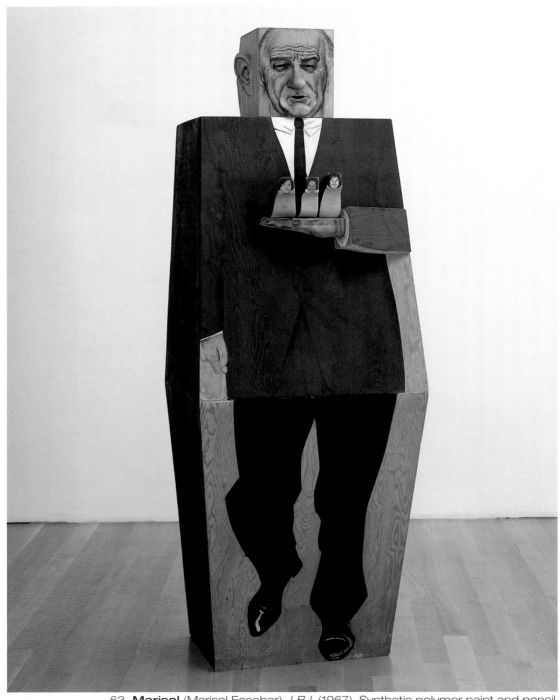

63. **Marisol** (Marisol Escobar). *LBJ*. (1967). Synthetic polymer paint and pencil on wood construction, 6' 8" x 27 7/8" x 24 5/8" (203.1 x 70.9 x 62.4 cm)

choosing a Spanish model, Botero may have been alluding to several anachronisms from that society that endure in Latin America, in particular the tradition of military *pronunciamientos* (coups) and the political power of the Catholic Church.

In an essay of 1969, Marta Traba recognized the tension between irony and caricature in Botero's art.[3] According to Traba, the ambivalence of his work, in conjunction with what he has called his "deliberate archaism"—his references to art-historical traditions, particularly Spanish-colonial art and Latin American folk art—encouraged formalist and apolitical readings of his work.[4] The artist himself, while stressing the formal function of his use of volume and proportion, has remarked that there was indeed an element of political satire in his works of the 1960s.[5]

LBJ was part of Marisol's series "Figures of State," which included portraits of the French leader Charles de Gaulle, the Spanish General Francisco Franco, Prime Minister Harold Wilson of the United Kingdom, and the British Royal Family, and was first exhibited in the United States in November 1967 at the Sidney Janis Gallery.[6] Lester and Joan Avnet, who donated the work to The Museum of Modern Art, purchased it shortly after the Janis exhibition. Botero's painting was first shown at the 1967 Carnegie International exhibition, where it was acquired by Mr. Warren D. Benedek, who then donated it to the Museum. In entering the collection shortly after they were made—and while the artists were living in New York, garnering critical attention as a result of exhibitions in the United States—these works typify conditions under which many works by artists from Latin America entered the Museum collection in the 1960s.

Miriam Basilio

1 Daniel Chapman, "Marisol . . . A Brilliant Sculptress Shapes the Heads of State," *Look,* November 14, 1967, pp. 78–83.

2 Fernando Botero, in a questionnaire signed and dated October 22, 1969, in "Object Record: Fernando Botero," Museum Collection Files, Department of Painting and Sculpture, The Museum of Modern Art, New York.

3 Marta Traba. "Las dos líneas extremas de la pintura colombiana: Botero y Ramírez Villamizar," Eco: *Revista de la cultura de Occidente*, August 1969, pp. 354–86.

4 Ibid., p. 372.

5 [Werner Spies], "Entrevista a Fernando Botero: El más colombiano de los pintores colombianos," in Werner Spies, ed., *Fernando Botero: Pinturas, Dibujos, Esculturas* (Madrid: Ministerio de Cultura, Dirección General de Bellas Artes y Archivos, Centro Nacional de Exposiciónes, 1987), pp. 43–56.

6 Chapman, "Marisol . . . ," p. 78.

ANTONIO FRASCONI'S *VIET NAM!* and
CILDO MEIRELES'S *Insertions into Ideological Circuits*

The multiples of both Antonio Frasconi and Cildo Meireles carry messages of social commitment. Although the works in the collection of The Museum of Modern Art—Frasconi's *VIET NAM!* (1967) and various pieces from Meireles's series *Inserções em Circuitos Ideológicos* (Insertions into Ideological Circuits, 1970–1984)—share a common purpose of instigation and protest, the manner in which they voice dissent is very different.

Frasconi is renowned for his politically engaged woodcuts. Since his early cartoons appeared in the newspapers of Uruguay (c. 1930), he has consistently addressed all manner of injustice, including racism, slavery, economic oppression, imperialism, militarism, and torture. He has depicted migrant workers in California, copper-miners in Montana, and coal-miners in Pennsylvania. He had produced a large body of eloquent works concerning the plight of the

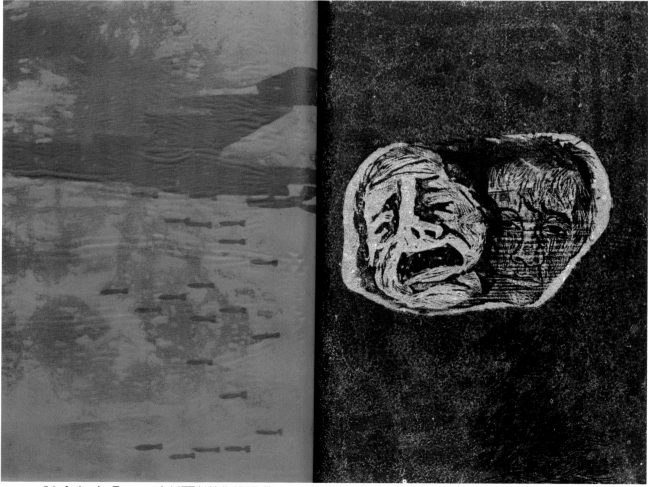

64. **Antonio Frasconi**. *VIET NAM!*. 1967. Illustrated book with thirteen woodcuts printed in black, and seven relief halftones, five printed in black and two printed in color, page: 21 1/16 x 13 15/16" (53 x 35.4 cm) (irreg.)

desaparecidos, the "disappeared," in Latin America; the traces of the anti-Franco resistance in Spain; and images of police brutality during the Civil Rights struggles in the United States. Emerging from his leftist politics and strong social consciousness, Frasconi's work is "moving yet not sentimental, partisan yet nonsloganeering, and clearly critical yet not cynical."[1]

Frasconi's work synthesizes social realism with a Western modernist language that incorporates *japonisme*, expressionism, and abstraction. His narrative works employ every technique available to create compelling compositions and surfaces. Frasconi's oeuvre is distinguished in particular by a significant production of portfolios, books, codices, and literary illustrations. He has created a large body of work that intertwines with and responds to great texts; his images have illuminated the writings of Bertolt Brecht, Italo Calvino, Federico García Lorca, Langston Hughes, Herman Melville, Gabriel Mistral, Pablo Neruda, Octavio Paz, Henry David Thoreau, and Walt Whitman, among others.

Frasconi typically covers a topic in depth, using images to circle around a subject and incorporating close-ups and dramatic perspectives to sharpen a point. Charles Parkhurst has noted Frasconi's use of repeated images, narrative progressions, repetitions and stutters, and unfolding structures—all of which embrace an experiential continuity, unfolding in time—in the artist's book *VIET NAM!*, which he likens to a film experience:

> By interleaving with the prints, alternate translucent sheets showing the black shape of a giant B-52 bomber, first going one way dropping bombs, then returning—the same image, back and forth on sheet after sheet, frighteningly conveying the relentless and inexorable impact of these deadly machines on the people of Vietnam.[2]

Nat Hentoff too has described *VIET NAM!*'s "kinetic, almost cinematic flow."[3] Not coincidentally, Frasconi screened a fifteen-minute film, *The Neighboring Shore,* at the Venice International Film Festival in 1960. He was honored with the festival's Grand Prix for this labor of love, in which he employed over 100 woodcuts to complement Whitman's poem.

VIET NAM!, like most of Frasconi's work, shows a deep concern with the handmade quality of the woodcut. Drawing is essential to these works, created on remnants of lumber, and printed by hand—without a press—in small editions.[4] Frasconi's woodcuts are thus conceived and shaped by an individual eye and an expressive hand to forge a story. Although his images may be printed in editions, the fractured nature of his prints stresses their unique authorship. Frasconi's deep involvement with poetry and literature, as well as his evident interest in cinema, support the reading of his multiples as literally extraordinary, that is, outside the ordinary: his art serves as a mythic commentary on the grand truths of life.

Cildo Meireles's multiples are strikingly different. Throughout his career, Meireles has worked in a large variety of art forms, including sculpture, installation, environments, film, and happenings. In his engagement with multiples he has utilized forms that are essentially anonymous, or considered workmanlike and nonartistic: press type, rubber stamps, and commercial offset lithography. Unlike Frasconi, Meireles relinquishes a signature sense of authorship, producing subtle, text-based guerrilla ciphers that seek to enlist the participation of a general audience.

Meireles's *Inserções em Circuitos Ideológicos* series consists of messages placed on mass-produced objects. To activate the meaning of these objects he let them be reincorporated into normal public use. These projects address the role of the artist and artwork in society. As Ronaldo Brito notes, they "speak in the language of Insertion rather than the language of Style, to move with the flux against the fetish of the Object, to listen to the Anonymous Murmurings, rather than the Voice of the Author."[5] Thus the "Insertions" projects were not conceived to reveal the subjective eye of the artist but rather to concretize a political zeitgeist. Meireles condensed a generalized discontent and gave it a voice in the form of a statement or question. These observations would surface when a cold beverage was raised at lunchtime, or during the purchase of a newspaper. Suddenly appearing in the hands of the general public, the "Insertions" were intended as both articulation and provocation. They were not transformations but tiny eruptions. Meireles himself noted a critical difference between the "Insertions" and Marcel Duchamp's appropriation of the readymade object as a work of art: "The Insertions . . . would act in the urban environment not as industrial objects set in the place of the art object, but as art objects acting as industrial objects. They were like graffiti, supported within a circulating medium."[6]

The *Inserções em Circuitos Ideológicos* took two forms: *Coca-Cola Project* and *Cedula Project*. In *Coca-Cola Project* the artist took full, capped glass Coca-Cola bottles and rubbed, as Meireles himself stated, "information and critical messages" onto them with small white transfer letters. These were then placed back into circulation—indefinitely—by means of the Brazilian deposit system, which enabled recycling and refilling the bottles. The "critical message" read "Yankees, go home!"; the "information" expressed the goal of the project.

Cedula Project worked in much the same way, except here messages were rubber-stamped onto banknotes. Meireles later continued his investigation with very large, commercially printed, offset lithograph editions, *Zero Cruzeiro* (1978) and *Zero Dollar* (1984). These symbolic banknotes with no value infiltrated the currencies of Brazil and the United States.

Art historian Paulo Herkenhoff has discussed one particular message from *Cedula Project*:

> During the dictatorship, Meireles struck at the heart of the regime by stamping banknotes with the question: "Quem matou Herzog?" ("Who killed Herzog?") in reference to the suspicious death in prison of the journalist Wladimir Herzog. Herzog's death was officially declared a suicide, although it was widely known that he had been subjected to torture. The question was as uncomfortable to the regime as it was threatening to an intimidated population. The note—and the unwanted message—circulated quickly, for people would neither keep the money nor destroy it.[7]

As Mari Carmen Ramirez has argued, the intention of all the "Insertions" was political: confrontation between either the individual and capitalism (in the case of the Coca-Cola bottles) or the individual and the state (in the case of the banknotes). Meireles's action, she asserts, was a "direct intervention in a circuit in order to counter-circulate information. . . . because the entire operation was designed to defy centralized systems of control, mass media itself was rejected due to its dependence on and/or complicity with the state apparatus."[8]

65. **Cildo Meireles**. *Insertions in Ideologic Circuits*. 1970. Rubber stamp, printed on both sides of a Brazilian one cruziero bill, comp. and sheet: 2 9/16 x 5 13/16" (6.5 x 14.7 cm)

66. **Cildo Meireles**. *Insertions in Ideologic Circuits*. (c. 1970). Rubber stamp, printed on both sides of a Brazilian fifty cruzados novos bill, comp. and sheet: 2 1/2 x 5 1/2" (6.4 x 14 cm)

67. **Cildo Meireles**. *Insertions in Ideologic Circuits*. (c. 1975). Rubber stamp, printed on both sides of a Brazilian five-hundred cruzados novos bill, comp. and sheet: 2 1/2 x 5 1/2" (6.4 x 14 cm)

68. **Cildo Meireles**. *Zero Cruzeiro*. 1978. Photolithograph printed on both sides, comp. and sheet: 2 3/4 x 6 1/8" (7.1 x 15.6 cm)

69. **Cildo Meireles**. *Zero Dollar*. 1984. Photolithograph printed on both sides, comp. and sheet: 2 11/16 x 5 13/16" (6.8 x 14.7 cm)

While Meireles's "Insertions into Ideological Circuits" specifically avoided the forms or language of authorship, Frasconi's lifework was marked by his unique style of heroic depictions of the individual's plight. The dignity and empathy with which he rendered various situations, or responded to great literary works, can indeed be understood through his interest in the cinematic. *VIET NAM!* fits neatly into this category, telling a tragic and wordless tale through a series of sequential images raised to a near-mythic level. Meireles, on the other hand, eschewed parables. His simple political statements and questions, pedestrian in form, leached into the heart of basic commerce, where their plaintive whispers could make small ruptures in the business of daily life.

Deborah Cullen

1 David Craven, "Frasconi's Multicultural and Engaging Prints," *Antonio Frasconi: An Artist's Journal* (Cortland: Dowd Fine Arts Gallery of the State University of New York College at Cortland, 1989), p. 13.

2 Charles Parkhurst, "An Appreciation," in *Frasconi Against the Grain: The Woodcuts of Antonio Frasconi* (New York: Collier Books, 1975), p. 147.

3 Nat Hentoff, Introduction, in ibid., p. 22.

4 Although the vast majority of Frasconi's work is produced this way, it should be noted that he is not averse to experimentation. He also employs lithography, embossing, and offset, and in 1978 the Xerox Corporation awarded him with a grant for experimentation with the Xerox color photocopier.

5 Ronaldo Brito, in Brito and Eudoro Macieira de Sousa, *Cildo Meireles* (Rio de Janeiro: Funarte, 1981), quoted here from Guy Brett, "Cildo Meireles," in Brett, *Transcontinental: An Investigation of Reality. Nine Latin American Artists* (London: Verso, 1990), p. 47.

6 Cildo Meireles, "Information 1970/89," in Paulo Herkenhoff, Gerardo Mosquera, and Dan Cameron, eds., *Cildo Meireles* (London: Phaidon Press Limited, 1999), p. 109.

7 Herkenhoff, "A Labyrinthine Ghetto: The Work of Cildo Meireles," in ibid., p. 50.

8 Mari Carmen Ramirez, "Tactics for Thriving on Adversity: Conceptualism in Latin America, 1960–1980," in Luis Camnitzer, Jane Farver, and Rachel Weiss, eds., *Global Conceptualism: Points of Origin, 1950s–1980s* (New York: Queens Museum of Art, 1999), p. 67.

RAFAEL FERRER'S *50 Cakes of Ice*

Rafael Ferrer's *50 Cakes of Ice* is a photographic triptych documenting an ephemeral work the artist created in the Museum's sculpture garden in 1970. Ferrer carried out several temporary guerilla works during this same tumultuous period, including three leaf pieces at the Leo Castelli Gallery, New York, in 1969.[1] That same year, he participated in the influential exhibition "Anti-Illusion: Procedures/Materials," at the Whitney Museum of American Art, where he created an ice piece in the Whitney's sculpture court and the work *Hay, Grease, Steel*—composed of exactly that—in the galleries. In early 1970, Ferrer fashioned *Deflected Fountain, for Marcel Duchamp* in the Philadelphia Museum of Art's outdoor fountain.[2] This group of works was created in part simultaneously with the artist's practice in drawing and painting as playfully aggressive responses to "the stifling dictates of the Minimalist dogma."[3]

For the exhibition "Information," on view at The Museum of Modern Art from July 2 to September 20, 1970, Ferrer positioned fifty large slabs of ice on a terrace of the Sculpture Garden during the evening of June 30 and allowed them to melt in the summer heat.[4] As they did so, they fell over and slid into the patio's easternmost pool.[5] His photographs, which were then presented in the exhibition, show the beginning of the project's setup, the process of its installation, and the period shortly after, as the blocks slumped over the edge of the stage. The images are joined in a tripartite composition that marks the passage of time. The ice did not submit to artistic order. While it was placed in ranks, and initially stood in tidy rows, it soon melted into a messy, tumbling spill. The cakes fell over, casualties of the sun.

Ferrer lined up his blocks of ice in a loose grid formation around Donald Judd's *Untitled* (1968), a five-part green sculptural work that was installed in the center of the raised terrace. In the summer's heat, Ferrer encircled Judd's "specific objects" with his icy rectangles, creating a translucent echo that amplified Judd's structures. They appeared as rapidly reproducing offspring of Judd's perfect metal progressions, flawed and fragile organic derivations that ultimately failed to endure the test of time. While Judd's work sought to avoid metaphor and focused on abstract concerns such as surface, volume, color, and scale, Ferrer's use of ice resounded both formally, through his use of material, and conceptually, through his personal implication of Minimalist formal language.

Ice has had a particular resonance for Ferrer as a Puerto Rican artist. He has written, "Winter ice for a tropical child is unforgettable," and he has often used the following quote from Gabriel García Marquez's book *One Hundred Years of Solitude*:

> "It's the biggest diamond in the world."
> "No," corrected the gypsy, "It's ice."[6]

Several Puerto Rican artists working in the wake of Ferrer's seminal 1970 project share his feeling for this medium. His peer Antonio Martorell, for example, created complex multimedia works dealing with the magical quality of snow for the Caribbean child.[7] In 1980, at the San Juan Art Student's League in Puerto Rico, Martorell presented the exhibition "White Christmas," which he transformed and reprised in his 1997 installation "Blanca Snow in Puerto Rico," held at the Hostos Center for the Arts and Culture in the Bronx. His point of departure for these shows was his memory of an airplane full of snow delivered to a public park in San Juan in 1951, as a holiday gift from the city's mayor, Felisa Rincón (nicknamed Doña Fela). Martorell witnessed this media event

70. **Rafael Ferrer**. *50 Cakes of Ice*. 1970.
Three photographs, each: 9 7/8 x 13 5/8" (24.9 x 34.6 cm), overall: 9 7/8 x 41" (24.9 x 104.1 cm)

as a child, and transformed the memory into two installation works that foreground a Puerto Rican anxiety.[8] Commercially overshadowed by the United States, and, in the case of Christmas, by the dominant, northern image that it should be snowy, Puerto Ricans have been made to feel that snow is the "real" holiday ambience and tropical weather a poor substitute. A recent example of the continuing interest in ice and snow is found in the work of Arnaldo Morales, a younger artist who has frequently explored the concept of freezing in his mechanical sculptures.[9]

Ferrer's adaptation of the visual and formal language of Minimalism resonates with the work of another avant-garde Puerto Rican artist, Carlos Irizarry, some of whose work "took the form of environments and constructions in acrylic and Plexiglas."[10] Best known as a printmaker, Irizarry was among the first on the Island to employ a photographic silkscreen technique. It has been noted that "his groundbreaking technique of superimposing grids onto pictorial fields dominated by mechanically reproduced images integrated the ideas of two leading movements of the 1960s—Minimalism and Pop Art."[11] The 1970 diptych *My Son, the Soldier* is a moving indictment of the Vietnam War. Irizarry employs a grid to structure his protest against the war's destruction of so many young lives. The squares, filled with portraits of soldiers killed over one week's time, emphasize the enormous and continuous loss. Like Ferrer's felled ranks of liquefying slabs, the seemingly endless replication only heightens the sense of futility.

Irizarry, also like Ferrer, employed social gestures in his art practice, albeit to more distinctly political ends. In 1979 he was jailed for a conceptual work in which he distributed flyers announcing that he would bomb an airplane flight in protest of Puerto Rico's colonial status.[12] Ferrer may leave his commentary on the status of Puerto Rico ambiguous, but an heir of Irizarry's intention is Adál, who has been working since 1994 on *El Spirit Republic de Puerto Rico* (The Spirit Republic of Puerto Rico), a multidisciplinary work exploring the political and psychological condition of Puerto Ricans.[13] Legally citizens of the United States, they often live as foreigners in this country. Among the whimsical yet complex art objects Adál has created, *El Puerto Rican Passport* (1995) is a multivalent and humorous work. Over the years, the artist has issued these "passports" from his original edition of 500 at various performances and events. Through this Spanglish document, he creates his own evidence of Puerto Ricans' elusive nationhood.

Deborah Cullen

El Sovereign State of Mind
of *El* Spirit Republic *de Puerto Rico*
hereby *suplica a todos*, whom it may concern, to permit
el ciudadano / national of *Loisaida, aquí nombrado,* to pass *sin
algún* delay or *impedimento* and, in case of need, to *darle*
all lawful *ayuda* and protection.

EL SPIRIT REPUBLIC DE PUERTO RICO
EL PUERTO RICO
EMBASSY

FIRMA DEL PORTADOR / *EL* SIGNATURE *DEL* BEARER
No es válido until signed

EL SPIRIT REPUBLIC *DE* PUERTO RICO

EL PASSPORT

EL PASSPORT NO. / NO. DE PASAPORTE
EPRE 95

Tipo	Fotografo
Apellido	Maldonado
Nombre	ADAL
Nacionalidad	Boricua
Fecha de Nacimiento	11/1/48 Sexo M
Lugar de Nacimiento	Utuado
Fecha de Expedición	12/1/95 Fecha de Caducidad Nunca
Autoridad	El Passport Agency

71. **Adál**. *El Puerto Rican Passport*. 1995. 10 1/4" x 5"

1 The work of Rafael Ferrer (born in 1933 in Santurce, Puerto Rico) is an interesting yet understudied bridge between conceptual practices in Puerto Rico and in the United States. As early as 1961, Ferrer created an aggressively sexual installation for an exhibition with Rafael Villamil at the University of Puerto Rico. In 1964 he installed tableaux that parallel the work of Edward Kienholz, at the University of Puerto Rico, San Juan, creating a scandal noted by the Island's newspapers. Despite this, Ferrer found support for travel from a branch of the University of Puerto Rico. In 1967, after he met Robert Morris in New York, both artists were invited to Puerto Rico to present an exhibition of environmental sculptures. See Marimar Benítez, "The Special Case of Puerto Rico," in Luis R. Cancel, ed., *The Latin American Spirit: Art and Artists in the United States, 1920–1970* (New York: The Bronx Museum of the Arts, in association with Harry N. Abrams, 1988), pp. 93–94, for an overview of Ferrer's groundbreaking activities in twentieth-century Puerto Rican art. See also Laura Roulet, *Contemporary Puerto Rican Installation Art: The Guagua Aérea, The Trojan Horse and The Termite* (San Juan: Editorial de la Universidad de Puerto Rico, 2000), p. 30, for more detail on the 1961 installation, and p. 95, note 32, for the citation of the one review of the Morris-Ferrer exhibition in Puerto Rico: "Los eventos Morris en el campus de Mayaguez," *Revistas de Arte* 3 (December 1969).

2 There is an eight-part photograph of this work in the collection of The Museum of Modern Art.

3 *Deseo, An Adventure: Rafael Ferrer* (Cincinatti: Contemporary Arts Center, 1973), p. 53.

4 Ferrer, *Drawing* (New York: Nancy Hoffman Gallery, 1995), p. 4. The receipt for the ice, sold to The Museum of Modern Art on June 30, 1970, is reproduced in this booklet, which also contains the memorandum for fifteen cakes of ice (4,500 pounds) and "28 bushels of Philadelphia leaves" for works transpiring between May 19 and May 22, 1969 (p. 20), and the slip for fifteen cakes of ice for the Whitney Museum of American Art, ordered on April 19, 1969 (p. 24).

5 The history card for this work in the Department of Registration of The Museum of Modern Art states, "The Museum Garden easternmost pool was filled with eight tons of ice in blocks and photographed periodically during the evening of June 30, 1970. These three photographs were then on view in the gallery during the *Information* exhibition."

6 Gabriel García Marquez, quoted in Ferrer, *Drawing*, p. 5. See also the section titled "Ice" in Carter Ratcliff's essay for the exhibition catalogue, *Deseo*, p. 17. Ratcliff later discussed Ferrer's 1979 public art work *Puerto Rican Sun*, installed in the Bronx, in relation to Romanticism and the construction of identity through images of nature, such as sun and hurricanes. See Ratcliff, "Ferrer's Sun and Shade," *Art in America* 68, no. 3 (March 1980): 80–86.

7 Antonio Martorell was born in 1939 in Santurce, Puerto Rico. He apprenticed with Lorenzo Homar and became renowned for his graphic and calligraphic works. While this text considers one particular aspect of Martorell's work, it should be noted that he is better-known for his continuation of the renowned graphic tradition of Puerto Rico. It should be mentioned that Ferrer has also created a distinguished body of prints. "MoMA at El Museo" features graphic works by Lorenzo Homar (born in 1913 in San Juan, Puerto Rico), Rafael Tufiño (born in 1922 in Brooklyn, New York), and José Alicea (born in 1928 in Ponce, Puerto Rico), master printmakers about whom much has been written. A younger heir to this tradition is Juan Sánchez (born in 1954 in Brooklyn, New York), whose work is also highlighted in this exhibition. The graphic tradition of Puerto Rico is richly documented; for more information on each of these artists, as well as a concise bibliography for further reading, see Fatima Bercht and Deborah Cullen, eds., *Graphics*, vol. 4 of the 5-vol. publication *Voces y Visiones: Highlights from El Museo del Barrio's Permanent Collection* (New York: El Museo del Barrio, 2003).

8 See Roulet, *Contemporary Puerto Rican Installation Art*, p. 37, for descriptions of the two installations. Martorell's memoir of the event, "White Christmas," is printed in an appendix in that book (pp. 101–8).

9 Morales's *CCI 2 F2-E1 No. 96* (1996), exhibited that same year on the Island, is composed of a refrigeration coil encased inside a hanging, horizontal, seventeen-foot PVC tube. Electrically connected, the work produces cold air continuously, eventually freezing over the tube and increasingly chilling the gallery air over the duration of the exhibition. See the exhibition catalogue, *Alto Riesgo: Electrobjetos de Arnaldo Morales* (Rio Piedras, Puerto Rico: Museo de Historia, Antropologia y Arte de la Universidad de Puerto Rico, 1996). Morales has employed refrigeration parts on several occasions, and these works are particularly effective when presented in Caribbean environments. At first pleasant, in time they become worrisomely cold. They also drain the electrical resources of the presenting institutions, alluding to "air conditioning," environmental alteration, and human waste.

10 See Benítez, "The Special Case of Puerto Rico," p. 94. Carlos Irizarry was born in 1938 in Santa Isabel, Puerto Rico.

11 Yasmin Ramírez, "Carlos Irizarry," in Bercht and Cullen, eds., *Graphics*, p. 22.

12 See Benítez, "Arte y política: El caso de Carlos Irizarry," *Revista del Centro de Estudios Avanzados de Puerto Rico y el Caribe*, no. 1 (July–December 1986): 86–90. Irizarry was jailed from 1979 until 1983. The United States invaded Puerto Rico in 1898, and imposed U.S. citizenship on its inhabitants in 1917. Thus Puerto Ricans carry U.S. passports.

13 Adál (born in 1947 in Utuado, Puerto Rico) is known for his photography, mixed-media works, and performance art. See Adál, *Jíbaro: Blueprints for a Nation. Installations* (Bethlehem, Pa.: Lehigh University Art Galleries, 2002), the catalogue for a traveling exhibition.

WALTÉRCIO CALDAS'S *Mirror of Light* and
CILDO MEIRELES'S *Thread*

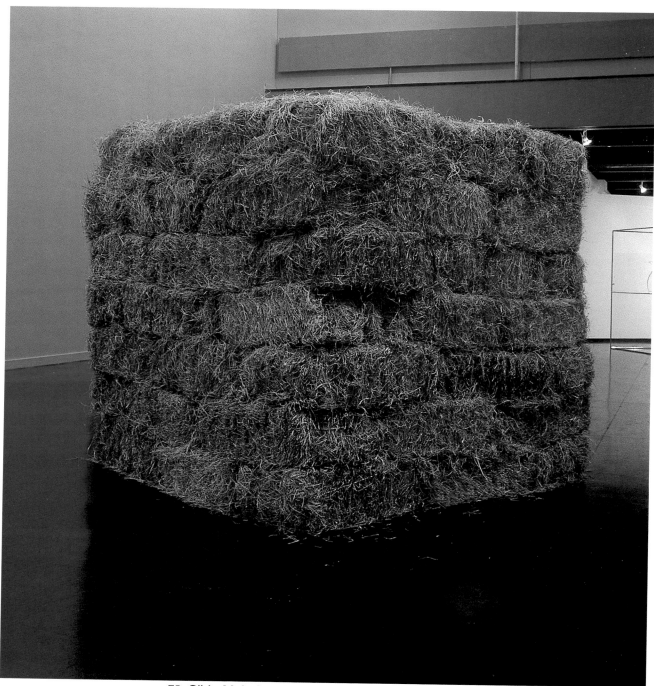

72. **Cildo Meireles**. *Thread*. 1990–95. Forty-eight bales of hay, one 18-carat gold needle, 58 meters of gold thread, dimensions variable, 7' 1" x 6' 1 1/16" x 6' (215.9 x 185.5 x 182.9 cm) approx.

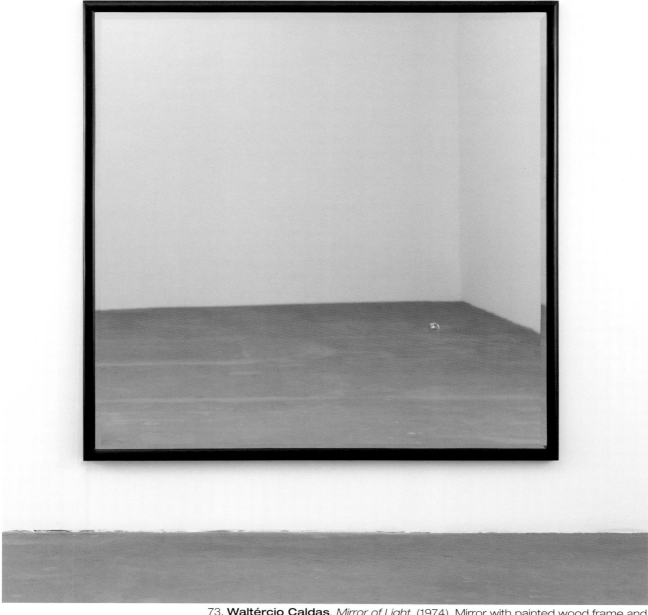

73. **Waltércio Caldas**. *Mirror of Light*. (1974). Mirror with painted wood frame and electric light in metal fixture, 6' 1 7/8" x 6' 1 7/8" (187.6 x 187.6 cm)

Although the contrasts between Waltércio Caldas's *Mirror of Light* (1974) and Cildo Meireles's *Thread* (1990-95) are more obvious than their similarities, the two works share an ability to absorb the space they occupy. *Mirror of Light* reflects that space, and, even when it is crowded with objects, can produce a feeling of abyssal emptiness; *Thread*, on the other hand, concentrates on the area outside itself, and that space, even when empty, becomes saturated with the work's massive presence. In relation to both works one may speak of a "logic of the secret" in which visual communication is the result of dissimulation.

We might ask, for example, what the little red light glowing on the flawless surface of Caldas's mirror signifies. What is it telling us? Since it is red, not green, what does it forbid, threaten, or warn of? As for Meireles's sculpture, what is the thread alluded to in the work's mysterious title? A tiny golden filament envelops this giant cubic bale of hay, its beautiful radiance an almost imperceptible contrast to the material of this rough, organic, perishable geometry. Why? And, above all, where does this "Ariadne's thread" lead? Part of the logic of the secret is that we need to be told that a secret exists in order for it to be effective, and we need to be told this through a gesture—the Duke of Mantua's secretary whispering in another figure's ear, for example, in a celebrated fresco by Mantegna—for the secret to produce its aesthetic or political effects.[1]

This is the kind of logic that unites *Mirror of Light* and *Thread*: we see a little red light glowing on the surface of a giant mirror and we understand that this perfect representation of transparency—the mirror—thus contains a very slight, perhaps indecipherable opacity. We see a monumental block of hay and discover, between the work's title and the glint of the golden thread that encircles the bale, the presence of a mystery—a needle in a haystack.

Meireles's work makes manifest an expression common to almost all languages and one which, since ancient times, has indicated the presence of a mystery, the existence of a secret. In *Thread* the golden strand winding around the bale of hay leads, at some point we can barely see, to a golden needle that has been stuck into the haystack and on which Meireles has written his name and an identification number for the work. The title—as a metonymy—and the signature of the artist are buried "like a needle in a haystack."

Meireles's work is always realized through a repertoire of contrasts. It may be a contrast of physical scale, as when the artist sets a tiny gambling die in the center of an enormous room,[2] or perhaps the contrast is symbolic, as when he makes an installation out of bones, coins, and Eucharist wafers.[3] The contrast may also have political meaning, as when an installation saturated in red becomes a metaphor for the blood of the dictatorship's enemies,[4] or when the artist stamped real currency with the inscription "Who killed Herzog?" after the murder of a prominent journalist so named, and then recirculated the money.[5]

Meireles has always been concerned with exposing the structure by which aesthetic, ideological, and political values are circulated socially. His work often seems coded—something to be carefully interpreted, its meaning hidden, like a lost golden needle in a haystack. *Thread* is thus an allegory that is always indebted to the viewer, a work that shrinks from our understanding in the same measure that it is offered to our perception. It draws together many images and references, from Hieronymus Bosch's well-known painting *The Hay Cart*, which depicts the vanity of the world's riches, to the accumulations of organic matter produced by contemporary artists associated with Land art or *arte povera*.

Caldas, on the other hand, has engaged in a constant interrogation of a single action: the spectator's confrontation with the artwork. He is perfectly aware of his place in art history, and of his work's instrumental role in the contemporary Latin American art scene. *Mirror of Light*, in which the only thing that is *not* a reflection is the little red light, may recall the dream of Western painting: the ability to absorb the world.[6] Yet this work, its black frame evoking the Dutch or Spanish Baroque, is also an antipainting. It is a mirror, and as such it is made of the only material capable of making concretely visible an idea of tautology that has informed a main trend in conceptual art from Marcel Duchamp to Joseph Kosuth: to repeat the world; to reproduce whatever looks at it; to make a chair be either a chair or its conceptual equivalent; to make a viewer be the viewer, a void the void, a museum the museum. If in *Thread* the opaque quality of the secret predominates, in *Mirror of Light* the transparency of the secret shines through.

One day early in the twentieth century, while looking at their faces reflected in an airplane propeller on display at Le Bourget, Duchamp said to Fernand Léger, "Painting is finished. Who can do anything better than this propeller? Can you?"[7] On another occasion in the same period, in 1914, Duchamp made a tiny yellow dot and a second red one on a postcard. Many years later he wrote of this work, which he oddly titled *Pharmacie*, "At that time I bought a cheap reproduction of a winter evening landscape that I called 'Pharmacy,' after having added two small smudges, one red and another yellow, on the horizon. Two little lights were visible in the background of the landscape. Had I added a red one and a green one, it would have looked like a pharmacy."[8] Thus conceptual art was born at the dawn of the twentieth century and goes on shining today, like a little red light in a mirror that hides its secrets, or like a needle lost in a haystack.

Luis Enrique Pérez-Oramas

1 On the "logic of the secret" see Louis Marin, "Annociations toscanes," in *Opacité de la peinture. Essais sur la représentation au Quattrocento* (Paris: Usher, 1989), pp. 139–40.

2 Cildo Meireles, *Cruzeiro do Sul* (Southern Cross), 1969–70, wooden cube, one part pine, one part oak, 3/8 x 3/8 x 3/8" (9 x 9 x 9 mm), collection of the artist. One might say that *Thread* is the opposite of *Southern Cross*: in the latter a minimal cube, occupying a point in an enormous empty space, is "symbolically and spatially monumental"; in the former, a giant cube, no less monumental, saturates the space that contains it. See Paulo Herkenhoff, "A Labyrinthine Ghetto: The Work of Cildo Meireles," in Herkenhoff, Gerardo Mosquera, and Dan Cameron, eds., *Cildo Meireles* (London: Phaidon, 1999).

3 Cildo Meireles, *Missão/Missões (How to Build Cathedrals)*, 1987, installation of 600,000 coins, 800 communion wafers, and 2,000 bones, 7' 8 1/2" x 6' 6 3/4" x 6' 6 3/4" (235 x 200 x 200 cm), Collection of the artist. See *Cildo Meireles* (Valencia: Instituto Valenciano de Arte Moderno, 1992), p. 89.

4 Cildo Meireles, *Desvio para o Vermelho I: Impregnação* (Red shift I: Impregnation), 1967–84, installation of white room with red objects, including carpet, furniture, electrical appliances, ornaments, books, plants, food, liquids, and paintings, overall 32' 9 3/4" x 16' 4 5/8" (1000 x 500 cm) See Cameron, "Desvio para o Vermelho," in Herkenhoff, Mosquera, and Cameron, eds., *Cildo Meireles*, p. 82.

5 A journalist well-known in Brazil, Wladimir Herzog was the victim of a political assassination in October 1975, during the period of the military dictatorship. Herkenhoff, Mosquera, and Cameron, *Cildo Meireles*, 51.

6 As described by Federico Zuccari: "I would say that if we place a large, fine crystal mirror in an exhibition hall with excellent paintings and marvelous sculptures, it is clear that as I look at it, that mirror will not only be the terminus of my gaze, but also an object that in turn clearly and distinctly represents all the paintings and sculptures to me visually. And

yet these paintings and sculptures are not found in it with their respective substances. They appear in the mirror only in their spiritual forms. Those who wish to understand what the idea of art is, in general, must philosophize thus." See Federico Zuccari, "L'idea de' Pittori, Scultori, et Architetti, divisa in due libri (1607)," in Victor I. Stoichita, *L'Instauration du tableau, Métapeinture à l'aube des Temps Modernes* (Paris: Méridiens Klincksieck, 1993), 114. I have taken the liberty of translating the term *disegno* as the expression "idea of art," in order to avoid potential confusion with the material notion of the art of drawing. Stoichita's book is, moreover, fundamental for understanding the epistemological role of easel painting in the modern West.

7 Marcel Duchamp, quoted in Dora Vallier, "La Vie dans l'oeuvre de Fernand Léger," 1954, quoted in Kynaston McShine, "La Vie en Rrose," in Anne d'Harnoncourt and McShine, eds., *Marcel Duchamp* (New York: The Museum of Modern Art, and Philadelphia: Philadelphia Museum of Art, 1973), p. 128.

8 Duchamp, quoted in Marc Patouche, *Marcel Duchamp* (Paris: Manoeuvres Editions, 1991), p. 41. Not surprisingly, the title of Duchamp's work can be seen as referring ironically to Plato's identification of artistic simulacra with the notion of *pharmakos*, a hypnotic potion and poison. See Jacques Derrida, "La Pharmacie de Platon," in *La Dissémination* (Paris: Editions du Seuil, 1972).

JEAN-MICHEL BASQUIAT'S *Untitled* and
FELIX GONZALEZ-TORRES'S *"Untitled" (Perfect Lovers)*

In 1988, while discussing Felix Gonzalez-Torres's arrival on the New York art scene, the prescient Coco Fusco remarked, "Quite a hot item at the moment, Gonzalez-Torres's work, his dealer was quick to warn me, has 'universal qualities.' No consensus has been reached, it appears, about the ethnic label's viability with collectors."[1] Fusco noted that Gonzalez-Torres's marketing did not take advantage of the "Latin boom," effectively pitching his work without employing that specific identity hook.

Although the two artists under consideration in this essay, Gonzalez-Torres and Jean-Michel Basquiat, share the obvious parallel of similarly meteoric and tragically short careers, it is interesting that neither artist has been seriously contextualized within Caribbean, Latino, or Latin American art. More specifically, neither has been included in any discourse on contemporary Puerto Rican visual art, an arena in which both artists had strong connections.[2] To be sure, both artists' oeuvres have received ample critical coverage—much of it redolent with discussions of identity and biography. Both artists, however, have been identified under different but singular umbrella terms that have steered discussions of their complex productions: "gay" (Gonzalez-Torres) and "black" (Basquiat).

Gonzalez-Torres used simple, common materials—often readymades composed of mass-produced items—to create intimate works about memory, loss, love, and sexuality. His work was seen as potently political yet subtle and very personal. Informed by a brand of gentle, humanistic conceptualism, Gonzalez-Torres employed a latterday Minimalist language in the service of a somewhat activist liberal agenda. His work was generous, engaging the viewer in his projects. He became internationally renowned for poignant public billboards, humble images (a hand, a bed, clouds) that evoked social commentary without didacticism; his most revered installations consisted of stacks of offset prints, or piles of foil-wrapped candies to which spectators could help themselves. During a time of raging debates over identity and sexuality, and of fury over the lack of action to fight the devastating AIDS pandemic, Gonzalez-Torres's work was provocative, sincerely emotional, and intelligent. It was poetic yet coolly urbane, and a part of its deeply felt resonance was perhaps due to the human warmth and romantic space for possibility that it offered in angry times. "The works," Robert Storr wrote, "often sensuous and directly audience-centered, complicate the questions of public and private space, authorship, originality, and the role of institutionalized meaning. He used the stuff of interior design—electric light fixtures, jigsaw puzzles, paired mirrors, wall clocks, and beaded curtains—to queer exhibition spaces in the most simple and poignant ways."[3]

Gonzalez-Torres's works were economical in means yet profoundly moving. *"Untitled" (Perfect Lovers)* (1987–90, 1991),[4] for example, comprises two identical, abutting, battery-operated, black-and-white Seth Thomas clocks. The neutral units of measure are transformed through their redundancy and composition into a meditation on human connection, mortality, and time's savage inevitability. The work evokes two human heads—perhaps of the same sex—nuzzling together as fleeting minutes tick past. Andrea Miller-Keller has described the work as "a metaphor for two bodies and souls linked by love who understand that at some future date one will 'run down' before the other. . . . The regulation black rim around each clock takes on new meaning when the clocks are understood in this context: the rim becomes a black border signifying that mourning and grief are unavoidable in the natural ebb and flow of life. . . . Not incidentally, their black outlines together combine to form an infinity sign."[5]

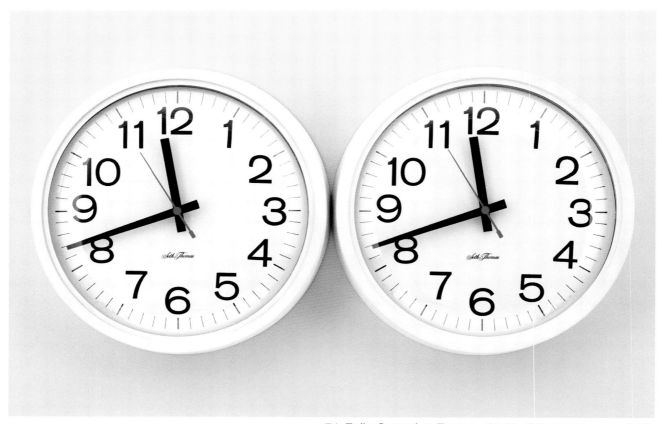

74. **Felix Gonzalez-Torres.** *"Untitled" (Perfect Lovers).* 1991.
Clocks, paint on wall, overall: 14 x 28 x 2 3/4" (35.6 x 71.2 x 7 cm)

Poised at the height of postmodernist discourse, Gonzalez-Torres defended the artist's freedom to position his work strategically. He once stated, "I'm just an extension of certain practices, minimalism or conceptualism I think we're part of a historical process . . . we are part of *this* culture, we don't come from outer space."[6] The comment is quite revealing: Gonzalez-Torres affirms his stance as an international artist, with universal reference points and purview. He asserts his continuity with major art-historical movements, not regional specificities. While stating this, he acknowledges the dominant Western/American ethos implied by the "this" of his statement. However, his use of "we" reveals his acute awareness of his own outsider status relative to the primary cultural bulwark. He maintains his group identity with the heterogeneous cultural, ethnic, religious, and sexual tributaries that infuse the majority, and also implies that in some way all culture is affected by the creeping global influence of Western civilization. However, Gonzalez-Torres also insisted on problematizing, subverting, or rupturing any idea of singular culture. In a different interview he savored this idea: "When we insert our own discourse into these forms, we soil them. We make them dark. We make them our own and that is our final revenge."[7]

There is perhaps no culture more conflicted about its relationship to, and the influence of, Western/American culture than Puerto Rico, which straddles the line between U.S. statehood and Caribbean identity as a euphemistically termed "commonwealth." Thus it is striking that while Gonzalez-Torres's work has often been discussed in terms of his sexual politics, his subtle references to *Latinidad* have rarely been examined. Fusco points out that Gonzalez-Torres's examination of power, violence, and identity resonates within Latin countries, many of which have had recent military governments, and which often have large—but persecuted—gay populations. More formally, the artist's light installations echo the elaborate, prominent displays in the streets and plazas of Puerto Rico during the Christmas holiday season leading up to Three Kings' Day (the Feast of the Epiphany, January 6). His offerings of candy can be seen, in part, as allusions to the gifts carefully piled on the altars of saints and deities in popular Catholic and Afro-Caribbean practices. Gonzalez-Torres frequently employed images of water, beaches, and seabirds, tantalizingly juxtaposed against the urban reality of New York. His entire practice, predicated for the most part on the use—albeit with restraint and elegance—of mass-produced, cheap products available to those of humble means, can be viewed as a response to a certain inventive aesthetic of accumulation that has been fruitfully and critically discussed in terms of Puerto Rican and Chicano artists.[8]

Russell Ferguson writes that Gonzalez-Torres consciously struggled against fulfilling any quotas— that he was frustrated "with expectations that as a gay man, or as a Cuban-American, he should be producing work that is more assertive on behalf of those identities. He insists on the right to complexity, the right to a sense of identity that goes beyond rigid categories."[9] Gonzalez-Torres himself noted, "It would be very expected, very logical and normal and natural for me to be in alternative spaces . . . but it's more threatening that people like me are operating as part of the market—selling the work."[10] Thus he was aware that despite his use of an accepted formal language, his identity itself was an infiltration of the mainstream.

Basquiat, on the other hand, has been frequently subsumed under a generic notion of "blackness." The issue of race concerned him, and he made prominent series of paintings in tribute to great musicians and sports figures. Additionally, Basquiat's combative, conflicted relationship with his strong-willed, entrepreneurial father, Gerard, has been extensively discussed. When Basquiat's father and mother separated, in 1968, his father raised the children, and thus became Basquiat's visible parent. Basquiat became closely identified with his Haitian lineage. Early criticism of Basquiat's art aligned the raw power of his work with simplistic concepts of fetish or naïveté. However, as Robert Farris Thompson has noted, Basquiat had no knowledge of Kreyol or vodun, and he never visited Haiti.[11]

Yet Thompson, Franklin Sirmans, Rene Ricard, and others have noted that Basquiat spoke fluent Spanish and used it to communicate with his mother, of whom he famously stated, "I'd say my mother gave me all the primary things. The art came from her."[12] In inscribing Basquiat as "black," then, his Puerto Rican or Latino identity was inadvertently overwritten. Similarly, Raquel Z. Rivera has discussed how prominent Puerto Rican contributors to the burgeoning hip-hop movement were constructed as "virtual blacks." She has accurately argued that even though this art form was created through the multiethnic contributions of artists from Manhattan, Brooklyn, and the Bronx, it was nonetheless subsumed under the dominant notion that the movement was a "black" cultural forum.[13]

Although a plethora of lengthy and often morbidly detailed biographical analyses mention Basquiat's mixed Caribbean background, only Thompson has attempted to connect him to it as

an artistic influence, principally through his use of language and his interest in music. As Thompson observes, Basquiat's work reflects the international urban synthesis common to the New York milieu in which he was active. Basquiat was a part of a rapping, clubbing, DJing, and graffiti scene. Certainly his connections to the graffiti artists were strong: he originally became known for his enigmatic graffiti-poetry, much of which was done in collaboration with Al Diaz, and tagged "Samo©." Basquiat associated with Rammellzee and Fab 5 Freddy, and he supported A-1, Toxic, and other young writers. Early in his career, he participated in an experimental band, Gray, a staple of the Mudd Club, a vital downtown nightclub in that scene. Throughout his life he maintained an active interest in a wide range of music, from experimental to international and opera.

In *Untitled* (1985), Basquiat collages snippets of handwritten texts and drawings, scattering them over the page. A dense concentration of schematic two-dimensional forms at the bottom of the page (columns of text, a strip of piano keys, drawings of variously sized glasses marked "Gin") create a horizon of sorts, opening up toward the top of the image into three-dimensional representations. A bare foot, a bandaged foot, and aerial views of a piano and of roadways circle around a haiku-like text. Fragmentary phrases and markings jostle free-floating images evenly over the sheet. The text, printed three different times from upper left to lower right, serves as an indicator of depth of field without actually serving to create it. Basquiat's drawing surfaces are constructed by scattering images over a shallow surface. Here, the sense of the page's flatness is enhanced by the use of affixed scraps. The work combines miscellany from daily life, creating a momentary glimpse into the brain's synaptic process.

Basquiat maintained an interest in writing-as-drawing, and in the intersection of language, signage and signs, and symbols of all sorts, from graphics to hobo signs. He was often described as a consumer of culture, flipping insatiably through books on anatomy and art history, watching endless hours of cartoons and movies, and always listening to eclectic forms of music. Visually and aurally perceptive, Basquiat was a voracious scourer and redeployer. His strategic combinations of image and idiom were a form of sampling or mixing.

In a manner reminiscent of Gonzalez-Torres—but with much more aggressive sarcasm—Basquiat also acknowledged his own Western/American hybridization while aggressively disavowing the Haitian-primitive-naíve reading of his work. Witness this telling exchange in a 1982 videotaped interview with a hapless Marc Miller:

> MM: There's a certain, let's use the term, crudity, to your heads. . . . Do you like it that way or would you like to get them more refined in a realistic way?
> JMB: . . . I haven't met that many refined people. Most people are generally crude.
> MM: Yeah? And so that's why you keep your images crude. . . .
> JMB: Believe it or not, I can actually draw.
> MM: . . . You're what, Haitian-Puerto Rican, is that—do you feel that's in your art?
> JMB: Genetically?
> MM: Or culturally. . . . I mean, for instance, Haiti is of course famous for its art.
> JMB: That's why I said genetically. I've never been there. And I grew up in, you know, the principal American vacuum, you know, television mostly.
> MM: No Haitian primitives on your walls?
> JMB: At home? . . . Haitian primitives? What do you mean? People?[14]

75. **Jean-Michel Basquiat**. *Untitled*. (1985). Cut-and-pasted paper and oilstick with acrylic gel medium on paper, sheet: 41 1/2 x 29 1/2" (105.4 x 75 cm)

Gonzalez-Torres and Basquiat were not marketed under the rubric of Latino or Latin American art; their early embrace by the mainstream did not necessitate such a marketing strategy. Further, by luck and by accident, they were not circumscribed by geography. It would be enlightening and enriching, however, to consider these two artists' work within a Caribbean context, and specifically in terms of Puerto Rican contemporary art, among many other readings. Nestor Otero's installations, Pepón Osorio's adorned objects, and Aaron Salabarrías Valle's situations, for example, should be reconsidered through Gonzalez-Torres's oeuvre; and new relationships can be seen among Rafael Ferrer's face drawings, Carlos Rivera Villafañe's paintings, and James de la Vega's street chalkings through the work of Basquiat. While it is not surprising that mainstream critical reception has ignored these issues altogether, it is startling that the slim extant discussions of contemporary Puerto Rican visual art have not yet claimed these two major art stars as a part of the legacy. But it is not too late.

Deborah Cullen

1 Coco Fusco, "Hispanic Artists and Other Slurs," http://www.lafactorianyc.com/library/articles/hisp_art_slur.html.

2 Gonzalez-Torres was born in 1957 in Guaimaro, Cuba. From 1971 to 1979 he lived in Puerto Rico where he studied art at the Universidad de Puerto Rico, Recinto Rio Piedras, and participated in the art scene there, following which he moved to New York. Gonzalez-Torres died of AIDS in Miami in January 1996, at the age of thirty-eight. Jean-Michel Basquiat was born in Brooklyn in 1960. His father, Gerard Basquiat, was a Haitian immigrant and his mother, Matilde Andradas, was a Brooklyn-born Puerto Rican. During his teen years, after his parents' separation, Gerard took a job in Puerto Rico. Jean-Michel lived with him for 2.5 years, in Mira Mar, outside Old San Juan, where he attended an Episcopalian school from 1974 through late November 1976. While Basquiat subsequently remained based in Brooklyn and New York, he did return to Puerto Rico on several occasions, including the winter of 1981, when he painted several works on the island of Culebra. Basquiat died in New York in August 1988, from a drug overdose, at the age of twenty-seven.

3 Robert Storr, "Felix Gonzalez-Torres, Etre un Espion: Interview with Felix Gonzalez-Torres," *ArtPress*, January 1995, pp. 24–32.

4 There are two versions of *Perfect Lovers*. The first (1987–90), which is rimmed in black, is in an edition of three, with one Artist's Proof. The second (1991), is in the collection of The Museum of Modern Art. This too is in an edition of three, but has white edges.

5 Andrea Miller-Keller, "Pleasures of the Unexpected: Modern-Day Alchemy," *Radcliffe Quarterly*, Spring 1998, p. 26.

6 Gonzalez-Torres, quoted in Storr, "Felix Gonzalez-Torres, Etre un Espion." Emphasis added.

7 Gonzalez-Torres, quoted in Nancy Spector, "Felix Gonzalez-Torres," *Felix Gonzalez-Torres* (New York: Solomon R. Guggenheim Museum, 1995), p. 15.

8 See Tomas Ybarra-Frausto, "Chicano Movement/Chicano Art," in Ivan Karp and Steven D. Lavine, eds., *Exhibiting Cultures: The Poetics and Politics of Museum Display* (Washington, D.C.: Smithsonian Institution Press, 1991), pp. 128–50. Ybarra-Frausto has described how "the aesthetic display projecting a sort of visual biculturalism" is crystallized within "the barrio environment—a visual culture of accumulation and bold display." He also discusses how altars "are iconic representations of the power of relationships, the place of contact between the human and the divine." These sharply observed points have been easily transferred to kindred artists like Pepón Osorio, Amalia Mesa-Bains, and Franco Mondini-Ruiz; however, they have not yet filtered down to artists such as Gonzalez-Torres, who have deployed precisely these dynamics (accumulation, display, contact) in a stripped-down, conceptual form. Charles Merewether has analyzed Gonzalez-Torres's work via Marcel Mauss's concept of the gift, in "The Spirit of the Gift," *Felix Gonzalez-Torres* (Los Angeles: The Museum of Contemporary Art, 1994), pp. 61–75.

9 Russell Ferguson, "The Past Recaptured," in *Felix Gonzalez-Torres* (Los Angeles: The Museum of Contemporary Art), p. 33.

10 Gonzalez-Torres, quoted in David Deitcher, "Contradictions and Containment," *Felix Gonzalez-Torres*, vol 1: *Text* (Stuttgart: Cantz Verlag, 1997), p. 105. Originally quoted in an interview with Tim Rollins, *Felix Gonzalez-Torres* (Los Angeles: A.R.T. Press, 1993), p. 20.

11 Robert Farris Thompson, "Royalty, Heroism, and the Streets: The Art of Jean-Michel Basquiat," in Richard Marshall, ed., *Jean-Michel Basquiat* (New York: Whitney Museum of American Art, 1993), p. 29.

12 Franklin Sirmans, "Chronology," in Marshall, ed., *Jean-Michel Basquiat*, p. 233. Originally quoted in Steven Hagar, *Art after Midnight: The East Village Scene* (New York: St. Martin's Press, 1986), p. 39.

13 Raquel Z. Rivera, "Hip-Hop, Puerto Ricans, and Ethnoracial Identities in New York," in Agustín Laó-Montes and Arlene Dávila, eds., *Mambo Montage: The Latinization of New York* (New York: Columbia University Press, 2001), pp. 235–61. Rivera recently expanded on the ideas in this important essay in her book *New York Ricans from the Hip Hop Zone* (New York: Palgrave Macmillan, 2003).

14 Marc Miller and Basquiat, interview published in Phoebe Hoban, *Basquiat: A Quick Killing in Art* (New York: Penguin Books, 1998), p. 169. Miller's interview was videotaped for Paul Tschinkel's *Art/New York* video series.

ANA MENDIETA'S *Nile Born*, JOSÉ LEONILSON'S *34 with Scars* and DORIS SALCEDO'S *Untitled*

In its standard definition, mourning is an individual's reaction to the absence of a beloved object that may be understood in individual or social terms, that is, it may be a person, country, or abstract principle that irretrievably disappears.[1] Grief is a state in which individuals process loss by withdrawing into themselves; on occasion this withdrawal may become pathological and give rise to bouts of melancholy or suppressed rage, which must be vented or expressed in some way. This essay analyzes the work of Ana Mendieta, Doris Salcedo, and José Leonilson in relation to absence and the strategies for confronting it, and considers the art object as an occasion for working through grief. As Mendieta once noted, "All art comes from sublimated rage."[2]

A sense of loss is a constant in the work of these three artists, but each approaches it differently. Through symbolic reunification with the (mother) earth, Mendieta works out the trauma of her separation from family and country, her native Cuba, at an early age. Leonilson anticipates the grief of his own death before the fact of it—at a moment when he was still able to internalize his terminal illness—in work simultaneously intense and austere. And Salcedo represents the grief of survivors of acts of extreme violence, including the relatives of the *desaparecidos*, the "disappeared," families whose grief—whose need for closure—is unending due to the uncertainty surrounding the fate of their loved ones. The pain of the bereaved often locates an object in which traces of the absent loved one may be found: like reliquaries, a favorite object stands in for him or her, the part for the whole, and serves as a focal point of absence and desire. For Mendieta, the substitution is metaphorical and is expressed in the archetypal silhouette of the woman/mother. Leonilson allegorizes illness in sensitive works made with scarlike stitches on a canvas/skin/body, which often manifest explicit biographical traces such as the artist's age, height, or weight. Salcedo includes real remnants of the victims of violence or their testimonies, opening up spaces of memory, encounter, and communion.[3] As Charles Merewether has noted, "Embedding her work in the walls of the museum, Salcedo transforms the museum—the symbolic center of modern culture—into a public space of mourning."[4]

Salcedo's work has set out to make intelligible the effects of political violence in her native Colombia. Her sculptures, objects, and installations become memorials, not in the classic sense of a commemorative monument that embodies a collective, socially shared history but by making visible the personal stories of individuals whom history disregards or scorns, bearing witness to "the tears in the fabric of history and the rupture about which history remains silent."[5] Through personal histories narrated by the survivors of tragedy, Salcedo re-creates the violent act by transferring it to the very objects (such as secondhand furniture or clothing) that are her subjects. The sculptural process involves the juxtaposition and effacement of their defining features, and the changes she effects render them dysfunctional, denying them the particular traces of humanity that are the result of their ergonomic characteristics and relationship with the body.[6] Each of these works is a response to a specific event and is dedicated to both victims and survivors. By particularizing the act on which the work is based, Salcedo goes against the grain of one of the most insidious aspects of contemporary violence: the silence to which the survivors are subjected out of fear of reprisal. To name each act is to differentiate it from other acts of violence and reclaim it from statistics, restoring its personal dimension: this happened to a real person. In this sense the central premise of Salcedo's work has been to bear witness to a violent act, through the voiceless traces that linger behind, so that the disgrace of forgetting does not compound the tragedy. She has said, "As an artist who works with memory, I confront past events whose memory has purposefully been effaced, in which the objects that bear the traces of violence have been

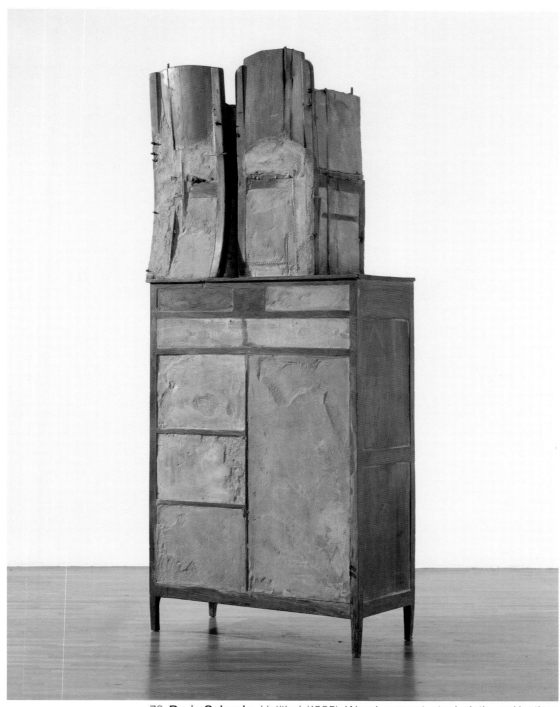

76. **Doris Salcedo**. *Untitled*. (1995). Wood, cement, steel, cloth, and leather,
7' 9" x 41" x 19" (236.2 x 104.1 x 48.2 cm)

77. **Ana Mendieta**. *Nile Born*. (1984). Sand and binder on wood, 2 3/4 x 19 1/4 x 61 1/2" (7 x 48.9 x 156.2 cm)

destroyed in order to impose oblivion. In this case, I wanted to try to turn this intentional oblivion, this 'no longer there,' into 'a still here,' a presence."[7]

Each of Salcedo's works is a response to a specific event, as noted earlier, but beyond their purely personal dimension they become the means of shifting the seemingly untransferable dimension of private grieving to the public sphere, "transforming an individual tragedy into a social phenomenon," evoking "the memories of pain inscribed in each viewer's memory."[8] Salcedo goes in search of the other whose voice has been silenced by the power structure, and who, having no access to language to mediate his or her loss, remains plunged in the most extreme solitude. If we acknowledge that the tragic circumstances of particular individuals causes society to bond with them empathetically, we must recognize that acts of violence may also be articulated in language, denying visibility to entire civilian populations, which in turn facilitates their destruction.[9] To reinstate the visibility—the humanity—of the victim, Salcedo seeks the people behind the violent act. She says,

> I try to learn absolutely everything about their lives, their trajectories, as if I were a detective piecing together the scene of a crime. I become aware of all the details in their lives. I can't really describe what happens to me because it's not rational: in a way, I become that person, there is a process of substitution. Their suffering becomes mine; the center of that person becomes my center and I can no longer determine where my center actually is. The work develops from that experience.[10]

An untitled work of 1995 in the MoMA collection is part of a long series Salcedo began at the beginning of the decade that juxtaposes pieces of household furniture to form monolithic sculptures. The bulk and volume of the sculptures are exacerbated by the use of concrete to fill

the empty spaces within each piece of furniture, as well as the spaces between them, symbolically burying them and rendering them dysfunctional.[11] Like unfinished narratives of a terrible event, the individual works are organized in groups in an empty, architectonic space where they become silent installations of solemn restraint.[12] In several of the works in this series, metal rods are run through pieces of furniture, their ends jutting out of the holes; traces of clothing can often be found embedded in the concrete, their supple presence contrasting with the hardness of the other materials. In the untitled work, two chairs, their surfaces and empty spaces eliminated by cement, are placed side by side on top of a chest of drawers. The cracks that form between the cement and the wood remind us that the coexistence of their materials—warm and organic alongside cold and inorganic—is coerced. In a sense, the use of concrete, a material commonly used in architectural construction, to fill the spaces between the furniture makes interior and exterior coincide; architecture and furnishings are condensed into a single space and bulk. The chairs, with their legs, backs, and seats, are at once anthropomorphic constructs and places for the body, but, paradoxically, this place is denied to us. The empty spaces of the chairs—which usually receive a body—are occupied by blocks of cement whose solid mass signifies the final displacement of the body, and, in the case of the chest of drawers, of the clothing that surrounds and covers it.

A feeling of unease overpowers the viewer who stands before Salcedo's austere installations of furniture and objects. These stagings, these places of grief, allow us a moment of communion, touching something in us that we share as human beings, something "that is awakened in tragedy."[13] Salcedo attempts to create a temporary community in grief. If, for her, the formal characteristics of each work are "defined by the nature of the victim's ordeal," each spectator's own experience with loss is invoked in the work's reception.[14] Salcedo is aware that art cannot compensate for the loss of something irretrievable; it can only ease the pain of those who, bereft of their loved ones, try to "survive with half their soul amputated."[15] That is her motivation, her essence, and her ethical imperative.

One of Mendieta's preoccupations in her early work was to address the body "as the passive subject of violence."[16] From 1972 to 1975, the year she created the first of her *Siluetas* (Silhouettes), the prolific series with which she would later be identified, the common thread in her work is the female body as locus of violence and sacrifice. In Mendieta's early performances of that period, documented on film and in photographs, it is her own body that is staged; the *Siluetas* are a continuation of her work with the body, but it has evolved into an archetypal body. In her early enactments, Mendieta was driven by the idea of implicating viewers in a scene of violence in such a way that they cannot remain outside the event. As Merewether has aptly remarked, the reenactment of a rape scene for photographic documentation preserves the event in a kind of eternal present, "constructing an audience as participant."[17] In this sense, Mendieta's work is directly related to Salcedo's stagings, but where Salcedo obliterates the actual image of violence, Mendieta directly, realistically represents the violent act.

Nile born (1984), one of the last works Mendieta created before her premature death, consists of a stylized silhouette in clay on a wood surface. Unlike most of the artist's performance *Siluetas*, which are invariably expressive acts in time and space that we experience through her photographic or video documentation, this work can be considered an autonomous sculpture in the traditional sense of the term. Begun in 1983, these *Siluetas*, of which there are very few examples, are in some ways paradoxical, for they contradict one of the characteristic features of the series: the intrinsic relationship of the *Silueta* to the place where it was created. Presumably

owing to her involuntary exile, Mendieta, from a very early age, set great store by cultural identity as a form of political resistance.[18] She developed a means of grieving for her absent mother by establishing communion with the landscape through her earth and body works, complex pieces that combine sculpture, performance, earth art, and photographic images. Merewether notes, "Mendieta's work articulates what we could call the negative dialectic of exile. It occupies a borderland, the lack of home, wandering, a solitude that dreams of an imagined community but that nevertheless is resigned to live in a community of absence."[19]

While Mendieta's early *Siluetas* are a representation of her own body in union with the landscape, in her subsequent work she mythologizes the nostalgia for place, binding it unequivocally to the mythologies of the Afro-Cuban tradition. In a series of rupestrian sculptures the artist made in a cave in Jaruco Park, outside Havana, during a trip to Cuba after a twenty-year absence, the silhouette in the landscape becomes a double allusion: identification with the absent mother, expressed by a prone female figure whose dominant trait is the vulva; and communion with the earth, a form of recovering the loss of homeland and becoming one with it. In fact, given the ritual nature of this communion, most of the *Siluetas* no longer exist; since they are precarious reconfigurations of materials from the landscape itself, ultimately they have been reabsorbed by it. "The exploration of the relationship between myself and nature that I have done in my artwork," Mendieta wrote, "has been a clear result of the fact that I was uprooted from my country in adolescence. To make my silhouette in nature maintains or establishes the transition between my country of origin and my new home. Although the culture I live in is part of me, my roots and my cultural identity are the result of my Cuban inheritance."[20]

In the introduction to a series of interviews with Leonilson during the course of his illness, the Brazilian critic Lisette Lagnado notes that the autobiographical content of his work should be interpreted as, "beyond the evidence of his ailment, the marks of his resistance against the anguish of death."[21] In my opinion this resistance takes the form of grief, whose defining characteristics it shares: melancholy, introversion, and rage. Created during the year in which his illness became an undeniable reality, "when the allegory of illness dominated his language completely,"[22] *34 with Scars* (1991) is unmistakably a self-portrait. It is also a memento mori (the Latin phrase means "Remember that you must die"), a type of image that signals that life is finite, death inevitable. The work consists of a square swatch of translucent white voile embroidered all along its edges; its only interior inscriptions are two stitched "scars," accented by subtle marks of acrylic paint, and the number "34," which corresponds to the artist's age. *34 with Scars* is one of the last works Leonilson completed before his death, from AIDS, in 1993. It was a period in which his work became increasingly spare, in which the empty space of the paper or canvas began to assume greater importance relative to the drawing or inscription, a reference to the disease that little by little undermines the fragile vessel. "The body braces itself against the anticipation of loss. There is an irrefutable desire to be transparent to others, a search for meaning to his work, starting with a return to its origins."[23] Leonilson's work, which had always been precarious in character, became even more stripped down, ethereal, and dematerialized, a metaphor for his own condition. And this fragile work is his death shroud, his grief, his epitaph, in advance. As Salcedo has said of her own work, "Extreme precariousness produces a paradoxical image, one that is not defined; an image in which the nature of the work is never entirely present. It's indeterminate, so silence is all there is."[24]

José Roca

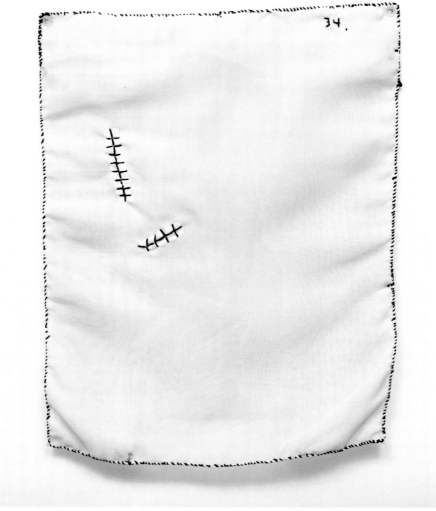

78. **José Leonilson**. *34 with Scars*. 1991. Synthetic polymer paint,
embroidery thread, and plastic tacks on voile, 16 1/8 x 12 3/16" (41 x 31 cm)

1 The author titled this essay, "Instancias de Duelo (Instances of Morning)." Mourning "is regularly the reaction to the loss
 of a loved person, or to the loss of some abstraction which has taken the place of one, such as one's country, liberty,
 an ideal, and so on." Sigmund Freud, "Mourning and Melancholia," in *Standard Edition of the Complete Psychological
 Works of Sigmund Freud*. Ed. and trans. James Strachey. Vol. XIV (London: The Hogarth Press, 1917), p. 243.

2 Ana Mendieta, quoted in Eva Cockroft, "Culture and Survival: Interview with Mendieta, Willie Birch and Juan Sánchez,"
 Art and Artists (New York), February 1984, p.16. Originally quoted in Charles Merewether, "De la inscripción a la
 disolución: un ensayo sobre el consumo en la obra de *Ana Mendieta*," in *Ana Mendieta* (Santiago de Compostela:
 Centro Galego de Arte Contemporánea, 1996), p. 93.

3 "All the works I've made so far contain first-hand evidence from a real victim of war in Colombia." Doris Salcedo, quoted in an interview with Carlos Basualdo, in Nancy Princenthal, Basualdo, Andreas Huysssen, et al., *Doris Salcedo* (London: Phaidon, 2000), p. 14.

4 Merewether, "To Bear Witness," in *Unland—Doris Salcedo* (New York: New Museum of Contemporary Art, 1998), p. 20.

5 Ibid., p. 17.

6 "Salcedo's enlistment of these utilitarian objects in the service of active memory is simultaneous with their functional death: the several kinds of physical quarantine to which they are submitted include being shielded behind translucent skin and immobilized by concrete." Princenthal, "Silence Seen," in *Doris Salcedo*, p. 43.

7 Salcedo, "Traces of Memory: Art and Remembrance in Colombia," in *ReVista: Harvard Review of Latin America*, Spring 2003, p. 28. Salcedo is referring to a sculptural performance she did on November 6 and 7, 2002, to commemorate the tragedy of the Palacio de Justicia, Bogotá, in 1985.

8 Ibid., p. 30.

9 Salcedo writes, "There are always plenty of political, historical, or personal reasons that motivate those that wish to kill, that declare entire civilian populations as invisible ones, as military targets, so they won't see the individuals who suffer and can center their attention on the historical reason that justifies and legitimates their killings." Ibid., p. 29.

10 Salcedo, quoted in the interview with Basualdo, p. 14.

11 Salcedo notes, "Used materials are profoundly human. They all bespeak the presence of a human being. Therefore metaphor becomes unnecessary." Quoted in ibid., p. 21.

12 The work in the collection of The Museum of Modern Art was featured in the 1995 Carnegie International exhibition in Pittsburgh as part of a large-scale installation.

13 Salcedo, "Traces of Memory," p. 29. In this essay, the artist refers to the philosopher Franz Rosenzweig.

14 Salcedo, quoted in the interview with Basualdo, p. 18.

15 Salcedo, artist's notes reproduced in Princenthal, Basualdo, Huysssen, et al., *Doris Salcedo*, p. 132.

16 Merewether, "De la inscripción a la disolución," p. 83.

17 Ibid., p. 92.

18 Ana Mendieta was separated from her parents and sent out of Cuba in 1961, when she was twelve years old, as part of the Peter Pan airlift that brought Cuban children to the United States. She spent the rest of her childhood in orphanages and foster homes. Only twenty years later—in 1981—was she able to revisit Cuba.

19 Merewether, "De la inscripción a la disolución," p. 110.

20 Mendieta, unpublished notes, quoted in ibid., p. 109.

21 Lisette Lagnado, *Leonilson. São tantas as verdades* (São Paulo: Serviço Social da Indústria, Departamento Regional de São Paulo, 1998), p. 82.

22 Ibid., p. 29.

23 Ibid., p. 82.

24 Salcedo, quoted in the interview with Basualdo, p. 25.

KCHO'S *In the Eyes of History* and LOS CARPINTEROS'S *Coal Oven*

Each of the drawings *Coal Oven* (1998), by the Cuban artistic collective Los Carpinteros (Alexandre Arrechea, Marco Castillo, and Dagoberto Rodríguez), and *In the Eyes of History* (1992–95), by the Cuban artist Kcho (Alexis Leyva Machado), is a monumental rendering of a fanciful coffeemaker that doubles as an improbable architectural structure. Members of the generation of Cuban artists that gained international prominence in the 1990s, Los Carpinteros and Kcho share an interest in using drawing as a conceptual medium to explore the concepts of utopia, architecture, and everyday life in Cuba, while reflecting on the very nature of artistic practice.

In *Coal Oven* Los Carpinteros depict an everyday kitchen appliance on a colossal scale, thereby drawing a visual analogy between the contours of an aluminum stovetop espresso pot and a brick factory building. Here the coffeepot spout, from which steam rises as coffee brews, conflates with a factory smokestack. *Coal Oven*, like other drawings and sculptures by these artists, assumes the form of an architectural structure never intended to be built, and humorously explores the limits of utopian designs.

The Spanish word *carbón* means "charcoal" as well as "coal," and the work's title thus alludes to the act of drawing. The resemblance of the coffeepot to a factory may be seen as an allusion to the collective working method of Los Carpinteros. From the group's inception, both their name— Los Carpinteros, or "the carpenters"—and their work have pointed to the link between artistic production and labor in traditional Cuban industries, among them tobacco, coffee, and carpentry. In an interview with Cuban curator and art historian Eugenio Valdés Figueroa, Los Carpinteros related their working methods for an early project to the tobacco industry:

> [The] model for the production of our art came from that sui generis industry: its union activity, the creation of a single object through the artisanship of various individuals, the finite nature of the product in the hands of the consumer.[1]

This act of assuming a collective identity, and the association of art and labor, could be viewed as a means of questioning the hierarchy between art and craft. The artists have asserted that drawing is fundamental to their working process, serving as a means to discuss their ideas and sometimes as a catalyst for works in other media:

> What happens with drawings in our case is very particular. In order to be able to converse, we need a drawing in front of us. At times a verbal dialogue is not sufficient. But this does not mean that each and every drawing ends up as a piece of sculpture.[2]

This collective discussion, the artists' means of filtering their ideas, may be compared to the performance of the factory/coffeepot and the role of drawing within the creative process.

Kcho's *In the Eyes of History* shows a structure of twigs and wire whose curvilinear outlines echo those of Vladimir Tatlin's *Monument to the Third International* of 1919–20. A coffee filter placed on the top of the structure transforms it into an improvised drip coffeemaker. Kcho's charcoal-and-watercolor plan for a monumental structure mimics architectural plans in its inclusion of details indicating construction methods and materials. To the left of the page, twigs joined together with wire form a right angle, and a mesh filter with coffee grinds resting at the bottom appears with captions. Other details reiterate the materials to be used: "*ramas de arbol y alambre*" (tree

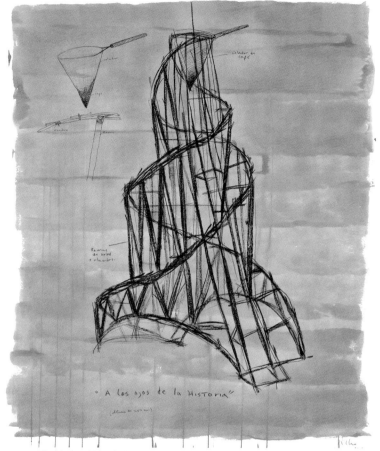

79. **Kcho** (Alexis Leyva Machado). *In the Eyes of History*. 1992–95.
Watercolor and charcoal on paper, sheet: 60 x 49 1/4" (152.4 x 125.1 cm)

branches and wire), or "*colador de café*" (a coffee filter). The fact that these details are not drawn to scale but appear to be larger than the structure of which they form a part draws attention to the proposed materials and to the transformation from monument to coffeemaker. Below the monument itself, the artist has added the words "*altura de 265 cm*" (265 cm high), reinforcing the contrast between the ambitious scale of Tatlin's project and the humble materials and size of his own.

In the Eyes of History relates to a sculpture of the same title, from 1992, made of driftwood and twine, and also with a coffee filter on top of it. In an interview in 1996, Kcho discussed the context in which the sculpture was created:

80. **Los Carpinteros**. *Coal Oven*. 1998. Watercolor, pencil, and colored
pencil on paper, sheet: 7' 2 1/4" x 51 1/4" (219.1 x 130.2 cm)

You must remember that I made that in 1991. It's a bit distant from how I see things today. But it is like the skeleton of a utopia. This is how I thought of it: in Cuba, if you have a refrigerator and it breaks, you have to find a way to make it work again, because you're never going to get another refrigerator. . . . As far as Tatlin's tower goes, it was architecture that never worked—a bad idea from the beginning. So I had to find a way to make it useful doing something else. It is a utopian socialist symbol that doesn't work.[3]

It should be remembered that the work was made during what the Cuban government called the "Special Period"—a time of particularly grim economic conditions in Cuba that were the result of the fall of the former Soviet Union and the harsh economic embargo enforced by the United States. At the time, artists faced a scarcity of materials, they could not accept U.S. dollars in payment for work, and Castro's regime intensified its censorship of the arts.[4]

Both the sculpture and the drawing are part of a series of works by Kcho that make reference to modernism. Included in this series is *The Infinite Column I* of 1996, also in the collection of The Museum of Modern Art—a tower of boats made of wood fastened with metal clips, and recalling Constantin Brancusi's work of the same name. Kcho's reinterpretation of iconic modernist works by artists such as Tatlin and Brancusi suggests that he is alluding to modernism itself as utopian discourse. In the case of his artistic dialogue with Tatlin's projected monument, he may be drawing a parallel between the brief period during which the work of artists in the former Soviet Union intersected with canonical modernism and the position of artists working outside so-called art centers. Kcho has commented on the tokenism that characterizes the inclusion of artists from Africa and Latin America in "global" exhibitions:

Every time that something comes from someplace outside of Europe or America and invades this established space, it seems exotic or is made to seem exotic. . . . There is only one art circuit: this one. But look at it, in this show in Madrid [the 1994–95 exhibition *Cocido y crudo* at the Museo Nacional Centro de Arte Reina Sofia, Madrid] with sixty artists from "all over the world" there were only six Latin Americans. The vast majority were still European or American. We Latin American artists were just satellites floating around the edges.[5]

Miriam Basilio

1 Los Carpinteros, quoted in Eugenio Valdés Figueroa, "Trajectories of a Rumor: Cuban Art in the Postwar Period," in Holly Block, ed., *Art Cuba: The New Generation* (New York: Harry N. Abrams, 2001), pp. 17–23.

2 Los Carpinteros, quoted in Rosa Lowinger, "The Object as Protagonist: An Interview with Los Carpinteros, Alexandre Arrechea, Marco Castillo, and Dagoberto Rodríguez," *Sculpture*, (Washington, DC) 1999, v. 18, no. 10, December 1999, pp. 24–31.

3 Kcho, quoted in Jen Budney, "Kcho: No Place like Home," *Flash Art*, v. 29, no. 188, May/June 1996, pp. 82–86.

4 See Gerardo Mosquera, "New Cuban Art Y2K," in Block, ed., *Art Cuba*, pp. 13–15. See also Figueroa, "Trajectories of a Rumor."

5 Kcho, quoted in Budney, "Kcho," p. 82.

GABRIEL OROZCO'S *Maria, Maria, Maria*, VIK MUNIZ'S "Personal Articles" and FERNANDO BRYCE'S "South of the Border"

In "South of the Border" (2002), a series of twenty-nine ink-on-paper drawings, Fernando Bryce renders an illustrated pamphlet from 1958, published by the U.S. Department of Defense to introduce employees to highlights of Latin American countries they might visit during their tours of duty. Each drawing reproduces a page from the original publication, which comprises introductory texts and photographs. Bryce's work appropriates imagery from mass culture, using decontextualization and irony to question cultural stereotypes. In carefully rendering the printed pamphlet as individual ink drawings, the artist emphasizes his technical ability and individual subjectivity and simultaneously draws attention to the language, images, and function of this type of tourist literature.

The choice of a Department of Defense pamphlet from the Cold War period is not accidental. The text combines descriptions and illustrations of architectural landmarks, ethnic types, and natural resources designed to educate American military personnel about cultural norms and the economic importance of the region for the United States. From our contemporary perspective these representations of Latin America as a potential economic resource for the U.S. government—one populated by flamboyant dancers, picturesque Indians, and rural laborers—open themselves up to varied interpretations. Rather than attempting to copy the pamphlet's appearance exactly and risk confusing his duplicate with the original, Bryce has purposefully reproduced the 1958 standardized typeface in ink by hand. Likewise, rather than emulating the slick, hard-edged appearance of the printed photographs, he has used a range of brushwork to create the effect of light and shadow. Through such intentional contrasts between the original and his renderings, he calls attention to his technical repertoire and mastery of the medium. Bryce has referred to his working method as "mimetic analysis," underscoring his subjective response to his sources.[1] Thus the specificity of his point of view invites the viewer's own participation in the interpretation of such works, as both artist and spectator question the often-taken-for-granted "neutrality" of tourist literature, in this case the 1958 pamphlet *South of the Border*.

Vik Muniz's "Personal Articles" (2000) is a series of sixty-four photolithographs showing invented news articles, and mimicking the fonts, typography, and layout of newspapers for ironic effect. Like Bryce, Muniz underscores his own subjectivity through his referencing of printed media and artistic intervention; he does so, however, by confusing his fabrication with the original, rather than by calling attention to his technique. For his fabricated news clipping *Hey! Never Mind Content—Look at the Context* the artist appropriates the *New York Times* masthead and format, thereby encouraging the viewer's confusion. Subtitled "Architectural Tour of Chelsea Galleries," the article, with its accompanying photograph of a woman in an empty, white-box exhibition space, is a humorous nod to recent discussions about the effect of exhibition design on the aura of works of art, as well as to the politics of museum display. Other prints in the series, such as *New Lascaux Amusement Park to Bring Renewed Wealth and Lots of Excitement to Vazere Valley*, poke fun at the mass-marketing of art, while still others, such as *Hey! If You're So Damn Smart, Why Can't You Ever Get a Date?*, suggest private jokes in which mass media are manipulated to voice personal concerns. The photolithograph *Hey! Never Mind Content—Look at the Context!* serves as a humorous index to the series as a whole and points to the importance of the intersection of content and context in shaping the reception of a work of art.

In his drawing *Maria, Maria, Maria* (1992), Gabriel Orozco similarly appropriates a printed document to question its usual function and call attention to the role of individual subjectivity. The artist erased

A Pocket Guide:

South of the Border

THE OFFICE OF ARMED FORCES INFORMATION AND EDUCATION
DEPARTMENT OF DEFENSE
1958.

But in recent years the meaning has changed. Today, modern
progress is transforming most of the countries south of
the border an has made them truly "Lands of Tomorrow."
Latin America's rate of industrial growth has almost
paralleled that of the United States in the last 15 years.
Some Countries - such as Brazil, Colombia, and Venezue-
la - have even topped the United States rate.
The rate of industrialization may be expected to increa
se markedly, to keep up with the rising population.
Latin America's population is now about equal to that
of the United States and Canada combined, and
within 50 years it may reach a maximum of 500 million.

Venezuela and Mexico are among the world's top oil producers.

Gay, colorful Fiestas are held everywhere South of the border.

Picking coffee, El Salvador's chief product.

81. **Fernando Bryce**. "South of the Border." 2002. Black ink on paper,
top: 16 1/2 x 11 3/4" (41.9 x 29.9 cm); bottom: 11 5/8 x 8 1/4" (29.5 x 21 cm)

Late Edition

New York : **Today,** Mostly sunny, high 58. **Tonight,** cloudy and chilly, loe 14. **Tomorrow,** More sun, windy, 59. **Yesterday,** Forget it, it's been here and gone. See the Full Report on Pages 33-35.

VOLUME CXLIXX •••• No. 301,513 **$6.50**

GLOBE-PHOTO

Chelsea Architectural Tour ". . .unencumbered by art of any sort."

"Hey! Never Mind the Content-
Look at the Context!"

Architectural Tour of Chelsea Galleries

by Barry Indianapolis
TIMES STAFF

anhattan—New York City's epartment of Cultural Affairs is ving its first Annual walking rchitectural tour of the Chelsea llery district. The tour is igned to provide the experi- ce of Chelsea's glamorous llery spaces totally unencum- red by art of any kind. The gal- ries involved in the project ve pledged to remain empty ring the weekend of the tour. sure to wear comfortable oes and loose clothing. eadsets will be provided and e pre-planned route will have a ntinuous audio recording inting out architectural and

historical highlights of the for- mer meat-packing district. The tour is to begin at the lofty Karla Cooper Gallery on West 20th Street at 9:00 am sharp on Saturday the 20th. Lunch will be served in several of the colorful local culinary establishments, and members of the walking tour will receive discount coupons for soft drinks and souvenirs. Transportation will be provided by bus to and from the Chelsea area. Photographing the barren spaces is strictly prohibited. There are, however, several illus- trated guide books with interior photos and blueprints, which can be purchased beforehand by interested parties.

INDIANAPOLIS, Page 8

82. **Vik Muniz**. *Hey! Never Mind Content— Look at the Context* from the series "Personal Articles." 2000. One from a series of sixty-four photolithographs printed in black, comp. and sheet: 10 13/16 x 4 13/16" (27.5 x 12.3 cm) (irreg.)

all but fourteen names from a telephone-book page that included listings for people with the Spanish surname "Muñoz." By highlighting the row of "Marías" that were not erased, Orozco disrupts both the relative anonymity that accrues from a randomly chosen telephone-book page and the confusing duplication of common (for a Spanish speaker) first and last names like "María" and "Muñoz." Orozco manipulates a universally familiar format—the telephone-book listing—to create a situation in which the Spanish-speaking viewer seems to be the ideal audience. At the same time, he playfully alludes to the neutrality usually associated with series and repetition in Minimalist art, then negates it through the obsessive focus on the word "María." Paradoxically drawing through the act of erasure, Orozco poetically calls on the viewer to contemplate the particular features of the individual "Marías" that blend into one another in their fleeting appearance on the printed page.

Miriam Basilio

1 Fernando Bryce, quoted in Christoff Tannert and Jorge Villacorta, *Fernando Bryce* (Berlin: Verlag Thumm & Kolbe, 2003), p. 3.

83. **Gabriel Orozco**. *Maria, Maria, Maria*. 1992. Erased telephone-book page, 11 x 9 1/8" (27.9 x 23.2 cm)

ENRIQUE CHAGOYA'S *The Illuminated Cannibal*

Like his predecessors Diego Rivera, José Clemente Orozco, and David Alfaro Siquieros, Enrique Chagoya left Mexico to work as an artist in the United States. Unlike them and parallel to millions of Mexicans who have become residents and workers in this country, he has stayed here, becoming a permanent resident of San Francisco and an important figure in the art community there and nationally. His art reflects this compound and contemporary identity, in which historical, cultural, and geographical references mix and ricochet against each other. Absurdity and insight, surrealist imaginings and social chronicle, buttress his distinct vision of today's hybrid state of affairs.

Although he works in many different media, Chagoya has devised a distinctive means to symbolize and narrate a consciousness of disjunctive and often irreconcilable feelings and understandings. Using joined sheets of handmade bark paper, called "amate," as did his pre-Columbian ancestors, he has adapted the codex, a form by which ancient Meso-American cultures recorded their histories.[1] For these unfolding narratives Chagoya decided "to invent my own account of the many possible stories—from Cortez to the border patrol—in my own visual language. I mix pre-Columbian mythology with Catholic icons, American comics and images of ethnic stereotypes."[2] He thus attempts both to "reclaim" lost voices and to question the veracity of all historical narratives. Technically Chagoya's codices also straddle traditional distinctions among media, often combining drawing, collage, and printmaking. Stylistically, Chagoya has looked to the early-nineteenth-century prints of the Spanish artist Francisco de Goya and to the early-twentieth-century prints of the Mexican José Guadalupe Posada (whose work is extremely well represented in The Museum of Modern Art's collection), both of whom are noted for their social satire.

Altogether, Chagoya has completed twenty-two codices. Among the most recent, *The Illuminated Cannibal* charts the transformation of an indigenous American into a Chicano consumer. Reading from right to left, it incorporates images from "high" art, popular culture, and pre-Columbian, Spanish, and English symbols and language. Each of the ten joined sheets are marked in the upper right corner by the Aztec counting system. Across cultures and histories, characters scrutinize and encounter, watch and confront each other, images slipping one over the other, transforming and obliterating meaning and logic. One of the most poignant, powerful, and humorous images appears in a central sheet in which Aztecs, seen from a Western point of view, pour molten gold down the throat of Mickey Mouse. While referring to the famous incident in which Aztecs killed several of the conquering Cortez's soldiers in this manner, Chagoya turns an image originally intended to underscore Aztec barbarism into one of empowerment, while nodding to the ubiquity of Disney cartoons permeating and mediating contemporary global culture.

The Spanish conquest of what is now called Mexico disrupted centuries-old cultures, setting off a chain of political and cultural events and transformations that continue unabated, even if domesticated, through to the present. Despite the violence of that conquest, Chagoya has noted that perhaps the most violent century in the history of humanity has been the twentieth, in which "cultures are transformed and often completely destroyed by conquering ones. Countries are endlessly remapped and renamed in recurrent holocausts. 'World orders' come and go in the middle of ideological frenzy. . . . This is the raw material for my art."[3] While Chagoya's references and images are specific, the meaning and significance of his work are not confined to any one culture or historical period; his attempt to reflect on humanity's dilemmas remains rooted in the present as much as in the past, and shows a constant hope for creation and rebirth.

Gary Garrels

84. **Enrique Chagoya**. *The Illuminated Cannibal*. 2002. Transfer drawing, cut-and-pasted painted papers, ink, and synthetic polymer paint on pieced *amate* paper, sheet: 8" x 10' (20.3 x 304.8 cm). Details

1. During their conquest of Mexico, Spanish soldiers and priests burned every library they encounter, including that of the Aztec ruler and poet Netzahualcoyotl, considered one of the largest in the ancient world, and including medical, astronomical, religious, and historical texts. Thus the Spanish effectively destroyed almost the complete written record of this civilization. Only about sixteen pre-Columbian codices survived the European conquests, most of them now housed in European libraries. See *Utopian Cannibal: Adventures in Reverse Anthropology. Recent Work by Enrique Chagoya* (Saint Louis: Forum for Contemporary Art, 2001), p. 17.

2. "Enrique Chagoya, Statement 2002." Artists' Files, Department of Drawings, The Museum of Modern Art Archives, New York.

3. Ibid.

CHECKLIST OF THE EXHIBITION

All works are in the Collection of The Museum of Modern Art, New York. Checklist is organized alphabetically by name. Titles, whether in English, Spanish or Portuguese, appear as they are entered in the MoMA database. Parentheses around dates indicate that it does not appear on the work itself. In the dimensions, height precedes width precedes depth.

Adál (Puerto Rican, born 1947)
El Puerto Rican Passport
(with manifesto by Reverend Pedro Pietri), 1995
Lithograph
Overall and page 5 x 3 7/16" (12.7 x 8.8 cm)
The Museum of Modern Art Library
A.B. A2586 A12p
(page 134)

José R. Alicea (Puerto Rican, born 1928)
Collar and Zemi, c. 1962–66
Woodcut, printed in color
Comp. 12 11/16 x 18 5/16" (32.2 x 46.6 cm) (irreg.)
Sheet 17 7/16 x 25 15/16" (44.3 x 66 cm)
Publisher and printer: the artist probably at El Taller de Artes
Gráficas del Instituto de Cultura Puertorriqueña, San Juan
Edition: 15
Gift of the San Juan Racing Association
190.1967
(page 78, bottom)

Carlos Alonso (Argentine, born 1929)
Van Gogh, 1966
Pen and ink on paper
13 3/4 x 19 5/8" (34.8 x 49.8 cm)
Inter-American Fund
176.1967
(page 46, bottom)

Artur Barrio (Artur Alípio Barrio de Sousa)
(Brazilian, born Portugal, 1945)
Fac-símile, 1979
Photolithograph
Overall and page 8 1/16 x 7" (20.5 x 17.8 cm)
The Museum of Modern Art / Franklin Furnace Artists'
Books Collection
A.B. L663 A12f

Alvaro Barrios (Colombian, born 1945)
*Alvaro Barrios as Marcel Duchamp as
Rrose Selavy as L.H.O.O.Q.*, 1970–82
Photolithograph
Overall 5 9/16 x 4 9/16" (14.1 x 11.6 cm)
The Museum of Modern Art /
Franklin Furnace Artists' Books Collection
A.B. B27517 A12a

Hércules Barsotti (Brazilian, born 1914)
Untitled, 1960
Folded photolithograph in Plexiglas mount
Comp. (with mount) 10 1/2 x 10 1/2 x 2 1/2"
(26.7 x 26.6 x 6.4 cm)
Comp. (without mount) 6 11/16 x 6 11/16" (17 x 17 cm)
Publisher: the artist
Printer: unknown
Edition: 10
Gift of Sylvio Nery da Fonseca Escritório de Arte, Ltda.
1438.2001
(page 51, bottom)

Jean-Michel Basquiat (American, 1960–1988)
Untitled, (1985)
Cut-and-pasted paper and oilstick with
acrylic gel medium on paper
Sheet 41 1/2 x 29 1/2" (105.4 x 75 cm)
Acquired in memory of Kevin W. Robbins through funds
provided by his family and friends and by the
Committee on Drawings
194.1993
(page 145)

Roberto Berdecio (Bolivian, born 1913)
The Cube and the Perspective, 1935
Enamel airbrushed on steel panel mounted on wood
30 x 26" (76.2 x 66 cm)
Gift of Leigh Athearn
315.1941
(page 96)

Antonio Berni (Argentine, 1905-1981)
New Chicago Athletic Club, (1937)
Oil on canvas
6' 3/4" x 9' 10 1/4" (184.8 x 300.4 cm)
Inter-American Fund
645.1942
(page 98)

Antonio Berni (Argentine, 1905–1981)
Seated Boy, 1942
Oil on canvas
37 x 22 3/4" (94 x 57.8 cm)
Inter-American Fund
SC646.1942
(page 27)

Fernando Botero (Colombian, born 1932)
The Presidential Family, 1967
Oil on canvas
6' 8 1/2" x 6' 5 1/4" (203.5 x 196.2 cm)
Gift of Warren D. Benedek
2667.1967
(page 123)

Fernando Bryce (Peruvian, born 1965)
"South of the Border," 2002
Black ink on paper
.1-.8 = 16 1/2 x 11 3/4"(41.9 x 29.9 cm); .9-.28 = 11 5/8 x 8
1/4" (29.5 x 21 cm); .29 = 16 5/8 x 11 5/8 (42.2 x 29.5 cm)
Purchase
141.2003.a-cc
(page 160)

Waltércio Caldas (Brazilian, born 1946)
Mirror of Light, (1974)
Mirror with painted wood frame and electric
light in metal fixture
6' 1 7/8" x 6' 1 7/8" (187.6 x 187.6 cm)
Gift of Manuel Francisco do Nascimento Brito,
Beatriz Pimenta Camargo, Gilberto Chateaubriand,
Joachim Esteve, José Mindlin, and
Maria de Lourdes Egydio Villela
152.1998
(page 137)

Enrique Chagoya (Mexican, born 1953)
The Illuminated Cannibal, 2002
Transfer drawing, cut-and-pasted painted papers,
ink and synthetic polymer paint on pieced amate paper
Sheet 8" x 10' (20.3 x 304.8 cm)
Purchase
299.2002
(page 165)

Jean Charlot (American, 1898–1979. To Mexico 1921.)
Metropolis: Bolshevik Superpoem in 5 Cantos
by Manuel Maples Arce, 1924
Illustrated book with 7 woodcuts, 6 printed in black, and 1
(front cover), printed in color
Page 9 1/8 x 6 11/16" (23 x 17 cm)
Publisher and printer: Andrés Botas e Hijo, Sucr., Mexico City
Edition: 500
Gift of Mrs. René d'Harnoncourt
72.1984.1-7

José Chávez Morado (Mexican, 1909–2002)
Ballad of the Streetcars from the series *The Illustrated
Educational Broadsheet*, 1939, published 1944
Photolithographic reproduction of a linoleum cut,
printed in black
Comp. 6 x 10 1/8" (19.3 x 25.8 cm) (irreg.)
Sheet 17 1/8 x 13 3/16" (43.5 x 33.5 cm)
Publisher and printer: Taller de Gráfica Popular, Mexico City
Edition: unknown
Inter-American Fund
156.1944.18

Carlos Cruz-Diez (Venezuelan, born 1923)
Physichromie, 114, 1964
Synthetic polymer paint on wood panel and on parallel
cardboard strips interleaved with projecting plastic strips
(or blades)
28 x 56 1/4" (71.1 x 142.8 cm)
Inter-American Fund
284.1965
(page 48)

Augusto de Campos (Brazilian, born 1931) and
Julio Plaza (Spanish, born 1938)
Black Box, 1975
Lithograph and photolithograph
Dimensions variable. Dimensions closed 12 x 9 3/8"
(30.5 x 23.8 cm)
The Museum of Modern Art Library
Spec. Coll P5582 C26c

Willys de Castro (Brazilian, 1926–1988)
Abstract, 1957/58
Ink on buff paper
2 1/4 x 1 1/8" (5.8 x 2.9 cm)
Gift of Hércules Rubens Barsotti, São Paulo
1153.2001
(page 51, top)

Willys de Castro (Brazilian, 1926-1988)
Abstract, 1957/58
Ink on buff paper
3 3/8 x 5 1/4" (8.6 x 13.3 cm)
Gift of Hércules Rubens Barsotti, São Paulo
1154.2001

Jorge de la Vega (Argentine, 1930–1971)
Try, Try, Try Again, 1967
Series of three etchings with sugarlift aquatint, printed in color
Comp. (each) 11 x 11" (28 x 28 cm) (irreg.)
Sheet (each) 14 3/16 x 14 3/16" (36 x 36 cm) (irreg.)
Publisher: unknown
Printer: New York Graphic Workshop, New York
Edition: 50
Inter-American Fund
255.1967.1-3

Jorge de la Vega (Argentine, 1930–1971)
Documentary, 1966
Pen, brush, and ink on paper
14 x 16 3/4" (35.5 x 42.5 cm)
Given anonymously
814.1969
(page 76)

Jorge de la Vega (Argentine, 1930–1971)
Parenthesis, 1967
Pen, brush, and ink on paper
11 x 13 5/8" (27.9 x 34.6 cm)
Inter-American Fund
815.1969

Ernesto Deira (Argentine, 1928–1986)
Untitled, (1963)
Ink on paper
12 5/8 x 18 7/8" (32 x 47.9 cm)
Inter-American Fund
9.1965
(page 46, top)

Antonio Dias (Brazilian, born 1944)
Untitled, 1967
Brush, pen and colored ink on paper
18 1/2 x 12 5/8" (46.9 x 31.9 cm)
Inter-American Fund
817.1969
(page 77, left)

Antonio Dias (Brazilian, born 1944)
Untitled, 1967
Brush, pen and colored ink on paper
18 1/2 x 12 5/8" (47.0 x 31.9 cm)
Inter-American Fund
818.1969
(page 77, right)

Gonzalo Díaz (Chilean, born 1947)
Untitled, 1991
Screenprint, printed in color
Comp. 42 1/8 x 29 15/16" (107 x 76 cm)
Sheet 43 5/16 x 30 3/8" (110 x 77.2cm)
Publisher and printer: unknown
Edition: artist's proof (edition unknown)
Gift of Waldo Rasmussen
145.1994
(page 79)

Eugenio Dittborn (Chilean, born 1943)
*The Present Work is a Re-Edition of
Two Earlier Publications*, 1981
Lithograph and electrostatic prints
Page 12 11/16 x 8 1/4" (32.2 x 21 cm)
The Museum of Modern Art /
Franklin Furnace Artists' Books Collection
A.B. D494 A12p

Eugenio Dittborn (Chilean, born 1943)
*We: a text / by Eugenio Dittborn on occasion
of the XII Paris Biennale*, 1982
Pencil on paper
68 1/2 x 56 1/2" (174 x 143.5 cm)
The Museum of Modern Art /
Franklin Furnace Artists' Books Collection
A.B. D494 A12w

Iran do Espírito Santo (Brazilian, born 1963)
Butterfly Prussian Blue, 1998
Gouache on paper
Sheet 11 x 13 7/8" (27.9 x 35.2 cm)
Purchase
2407.2001
(page 80)

Iran do Espírito Santo (Brazilian, born 1963)
Red Cross Like, 1998
Gouache and graphite on paper
Sheet 13 7/8 x 11" (35.2 x 27.9 cm)
Purchase
2409.2001

Iran do Espírito Santo (Brazilian, born 1963)
Dual Ellipsis, 1998
Gouache and graphite on paper
Sheet 13 7/8 x 11" (35.2 x 27.9 cm)
Purchase
2410.2001

Iran do Espírito Santo (Brazilian, born 1963)
Green Block, 1999
Gouache and graphite on paper
Sheet 13 7/8 x 11" (35.2 x 27.9 cm)
Purchase
2414.2001

León Ferrari (Argentine, born 1920)
Untitled, 1962
Ink on paper
39 3/8 x 26 5/8" (100 x 67.6 cm)
Purchase
380.2003

León Ferrari (Argentine, born 1920)
Labyrinth, 1980
Electrostatic prints
Overall closed 6 7/8 x 4" (17.5 x 10.2 cm)
The Museum of Modern Art /
Franklin Furnace Artists' Books Collection
A.B. F382 A12L

León Ferrari (Argentine, born 1920)
Re-reading of the Bible, 1988
Chromogenic photographs and electrostatic prints
Page 13 x 9 3/4" (33 x 22.9 cm)
The Museum of Modern Art /
Franklin Furnace Artists' Books Collection
A.B. F382 A12r

Rafael Ferrer (Puerto Rican, born 1933)
50 Cakes of Ice, 1970
Gelatin silver prints
9 7/8 x 13 5/8" (24.9 x 34.6 cm) (each)
Overall 9 7/8 x 41" (24.9 x 104.1 cm)
Gift of M. E. Thelen Gallery
42.1971.a-c
(page 133)

Pedro Figari (Uruguayan, 1861–1938)
Creole Dance, (c. 1925?)
Oil on cardboard
20 1/2 x 32" (52.1 x 81.3 cm)
Gift of the Honorable and Mrs. Robert Woods Bliss
8.1943
(page 26)

Antonio Frasconi (Uruguayan, born Argentina, 1919)
VIET NAM!, 1967
Illustrated book with 13 woodcuts, printed in black, and
7 relief halftones, 5 printed in black and 2 printed in color
Page 21 1/16 x 13 15/16" (53 x 35.4 cm) (irreg.)
Publisher and printer: the artist, South Norwalk, Connecticut
Edition: 5
Walter Bareiss Fund and Gift of Leo Auerbach (by exchange)
351.1987.1-20
(page 126)

Gego (Gertrude Goldschmidt)
(Venezuelan, born Germany, 1912–1994)
Sphere, (1959)
Welded brass and steel, painted black
22" (55.7 cm) diam., 8 5/8 x 7 1/2 x 7 1/8"
(21.8 x 19 x 18 cm) on 3 points spaced apart
Inter-American Fund
115.1960
(page 108)

Gego (Gertrude Goldschmidt)
(Venezuelan, born Germany, 1912–1994)
Balance, 1960
Etching, printed in black
Plate 9 3/4 x 8 11/16" (24.7 x 22.0 cm)
Sheet 15 x 11 1/8" (38.0 x 28.3 cm)
Publisher: possibly David Herbert and
Betty Parsons, New York
Printer: probably either Threitel-Gratz Co. Craftsmen in
Metal, New York or The Engraving Workshop, New York
Edition: 10
Inter-American Fund
223.1967

Gego (Gertrude Goldschmidt)
(Venezuelan, born Germany, 1912–1994)
Untitled, 1963
Ink on paper
Sheet 30 x 22" (76.2 x 55.9 cm)
Purchase
2416.2001
(page 109)

Gego (Gertrude Goldschmidt)
(Venezuelan, born Germany, 1912–1994)
Untitled, (December 12–14) 1966
Lithograph, printed in black
Comp. 32 1/16 x 23 1/8" (81.5 x 58.8 cm)
Sheet 32 1/16 x 23 1/8" (81.5 x 58.8 cm)
Publisher and printer: Tamarind Lithography Workshop, Inc.,
Los Angeles
Edition: publisher's proof (10 plus 9 publisher's proofs)
Gift of Kleiner, Bell & Co.
1910.1967

Gego (Gertrude Goldschmidt)
(Venezuelan, born Germany, 1912–1994)
Untitled, (December 8–12) 1966
Lithograph, printed in black
Comp. 22 1/8 x 22 3/16" (56.2 x 56.4 cm)
Sheet 22 3/16 x 22 3/16" (56.3 x 56.4 cm)
Publisher and printer: Tamarind Lithography Workshop,
Inc., Los Angeles
Edition: publisher's proof (20 plus 9 publisher's proofs)
Gift of Kleiner, Bell & Co.
1915.1967

Gego (Gertrude Goldschmidt)
(Venezuelan, born Germany, 1912–1994)
Untitled, (December 12-19) 1966
Lithograph, printed in color
Comp. 22 1/16 x 22 1/16" (56.1 x 56.1 cm)
Sheet 22 1/16 x 22 1/16" (56.1 x 56.1 cm)
Publisher and printer: Tamarind Lithography Workshop,
Inc., Los Angeles
Edition: publisher's proof (20 plus 9 publisher's proofs)
Gift of Kleiner, Bell & Co.
1916.1967
(page 110)

Gego (Gertrude Goldschmidt)
(Venezuelan, born Germany, 1912–1994)
Untitled, 1969
Ink and pencil on paper
Sheet 25 3/4 x 19 3/4" (65.4 x 50.2 cm)
Purchase
2417.2001

Gego (Gertrude Goldschmidt)
(Venezuelan, born Germany, 1912–1994)
Untitled, 1970
Colored ink on paper
Sheet 25 3/4 x 19 3/4" (65.4 x 50.2 cm)
Gift of Patricia Phelps de Cisneros in memory
of Warren Lowry
2418.2001
(page 111)

Anna Bella Geiger (Brazilian, born 1933)
Our Daily Bread, 1979
Photolithograph and letterpress
Postcards 4 5/8 x 6 5/8" (11.7 x 16.8 cm)
Overall bag 17 x 5 1/2" (43.2 x 14 cm)
The Museum of Modern Art /
Franklin Furnace Artists' Books Collection
A.B. G348 A12o

Mathias Goeritz (German, 1915–1990. To Mexico 1949)
Message Number 7B, Ecclesiastes VII, 1959
Construction of nails, metal foils, oil and iron on wood panel
17 7/8 x 13 5/8 x 3 3/8" (45.1 x 34.5 x 8.4 cm)
Gift of Philip Johnson
779.1969
(page 118)

Sergio Gonzalez-Tornero (Chilean, born 1927)
"UB," 1961
Engraving with scraper, printed in black
Plate 15 1/2 x 13 5/8" (39.4 x 34.6 cm)
Sheet 25 5/8 x 19 5/8" (65.1 x 49.9 cm)
Publisher, printer, and edition: unknown
Felipe Cossio del Pomar Fund
260.1963

Felix Gonzalez-Torres (American, born Cuba, 1957–1996)
"Untitled" (Perfect Lovers), 1991
Clocks, paint on wall
Overall 14 x 28 x 2 3/4" (35.6 x 71.2 x 7 cm)
Gift of the Dannheisser Foundation
177.1996.a-b
(page 142)

Alberto da Veiga Guignard (Brazilian, 1895–1962)
Ouro Preto: St. John's Eve, 1942
Oil on plywood
31 1/2 x 23 5/8" (80 x 60 cm)
Commissioned through the Inter-American Fund
10.1943

Arturo Herrera (Venezuelan, born 1959)
A Knock, 2000
Cut-and-pasted printed papers
70 x 60" (177.8 x 152.4 cm)
Purchase
401.2002
(page 81)

Lorenzo Homar (Puerto Rican, born 1913)
La Cancora, 1963
Wood engraving, printed in black
Comp. 2 9/16 x 3 1/8" (6.5 x 8 cm)
Sheet 10 3/16 x 8" (25.9 x 20.3 cm)
Publisher: probably Galeria Colibri, San Juan
Printer: possibly the artist at El Taller de Artes Gráficas del
Instituto de Cultura Puertorriqueña, San Juan, Puerto Rico
Edition: 30
Felipe Cossio del Pomar Fund
131.1964

Carlos Irizarry (Puerto Rican, born 1938)
My Son, the Soldier (Parts I-II), 1970
Two screenprints, printed in color
Comp. 22 13/16 x 60 9/16" (58 x 153.8 cm)
Sheet 25 1/8 x 62 3/16" (63.8 x 158 cm)
Publisher and printer: unknown
Edition: artist's proof (edition unknown)
Gift of San Juan Racing Association
176.1970.1-2

Alfredo Jaar (Chilean, born 1956)
Two or Three Things I Imagine About Them, 1992
Photolithograph and embossed metal foil
Overall 8 x 4 1/2" (20.3 x 11.4 cm)
The Museum of Modern Art /
Franklin Furnace Artists' Books Collection
A.B. J14 xL66

Frida Kahlo (Mexican, 1907–1954)
Self-Portrait with Cropped Hair, 1940
Oil on canvas
15 3/4 x 11" (40 x 27.9 cm)
Gift of Edgar Kaufmann, Jr.
3.1943
(page 22)

Leandro Katz (Argentine, born 1938)
Ñ, 1971
Photolithograph
Overall 11 x 8 3/8" (27.9 x 21.3 cm)
The Museum of Modern Art /
Franklin Furnace Artists' Books Collection
ABK279A12n

Kcho (Alexis Leyva Machado) (Cuban, born 1970)
In the Eyes of History, 1992–95
Watercolor and charcoal on paper
Sheet 60 x 49 1/4" (152.4 x 125.1 cm)
Purchased with funds given by Patricia and Morris Orden
82.1996
(page 156)

Guillermo Kuitca (Argentine, born 1961)
Lincoln Center Triptych, 2002
Color digital ink printed on glossy photographic paper, solvent
Sheet 16 7/8 x 10 7/8" (42.9 x 27.7 cm) (each)
Purchase
7.2003.a-c

Wifredo Lam (Cuban, 1902–1982)
Satan, 1942
Gouache on paper
41 7/8 x 34" (106.4 x 86.4 cm)
Inter-American Fund
710.1942
(page 105)

Wifredo Lam (Cuban, 1902–1982)
The Jungle, 1943
Gouache on paper mounted on canvas
Sheet 7' 10 1/4" x 7' 6 1/2" (239.4 x 229.9cm)
Inter-American Fund
140.1945
(page 104)

Julio Le Parc (Argentine, born 1928)
Instability Through Movement of the Spectator, 1962
Synthetic polymer paint on wood and polished aluminum
in painted wood box
28 5/8 x 57 1/8 x 36 1/2" (72.6 x 145 x 92.8 cm)
Inter-American Fund
110.1965
(page 49)

José Leonilson (Brazilian, 1953–1994)
Desire is a Blue Lake, 1989
Watercolor and ink
Sheet 12 1/2 x 9 3/8" (31.9 x 24 cm)
Gift of the Friends of Contemporary Drawing
135.1999

José Leonilson (Brazilian, 1953–1994)
Sunset, Earthquake, Loneliness, 1990
Ink and metallic color
Sheet 11 7/8 x 8 7/8" (30.4 x 22.7 cm)
Gift of the Artist's Estate
138.1999

José Leonilson (Brazilian, 1953–1994)
34 with Scars, 1991
Synthetic polymer paint, embroidery thread and plastic
tacks on voile
16 1/8 x 12 3/16" (41 x 31 cm)
Gift of Carmen Bezerra Dias in memory of
Theodorino Torquato Dias
1144.2001
(page 153)

José Leonilson (Brazilian, 1953–1994)
I Am Your Man, 1992
Watercolor and ink
Sheet 9 x 12" (22.8 x 30.5 cm)
Gift of the Friends of Contemporary Drawing
139.1999

Los Carpinteros (Cuban)
Coal Oven, 1998
Watercolor, pencil and colored pencil on paper
Sheet 7' 2 1/4" x 51 1/4" (219.1 x 130.2 cm)
Gift of Dean Valentine and Amy Adelson
439.2002
(page 157)

Anna Maria Maiolino (Brazilian, born Italy, 1942)
Black Hole from the series *Holes/Drawing Objects*, 1974
Paper and Styrofoam in wooden box
Sheet 27 x 27" (68.6 x 68.6 cm)
Purchase
2421.2001.a-e
(page 50)

Fabian Marcaccio (Argentine, born 1963)
*560 Conjectures for a New Paint
Management, 1989–98*, 1999
Ink jet print mounted on polystyrene with a lamination
Comp. 30 1/4 x 23 3/16" (76.9 x 58.9 cm)
Sheet 30 1/4 x 23 3/16" (76 x 58.9 cm)
Publisher and printer: Muse X Editions, Los Angeles
Edition: 25
Gift of the Young Print Collectors of the Department of
Prints and Illustrated Books
429.1999

Marisol (Marisol Escobar) (Venezuelan, born France, 1930)
Love, 1962
Plaster and glass (Coca-Cola bottle)
6 1/4 x 4 1/8 x 8 1/8" (15.8 x 10.5 x 20.6 cm)
Gift of Claire and Tom Wesselmann
1405.1974
(page 74)

Marisol (Marisol Escobar) (Venezuelan, born France, 1930)
LBJ, (1967)
Synthetic polymer paint and pencil on wood construction
6' 8" x 27 7/8 x 24 5/8" (203.1 x 70.9 x 62.4 cm)
Gift of Mr. and Mrs. Lester Avnet
776.1968.a-c
(page 124)

Maria (Maria Martins) (Brazilian, 1910–1973)
The Impossible, III, 1946
Bronze
31 1/2 x 32 1/2 x 21" (80 x 82.5 x 53.3 cm)
Purchase
138.1946

Antonio Martorell (Puerto Rican, born 1939)
ABC of Puerto Rico by Rubén del Rosario and
Isabel Freire de Matos, 1968
Illustrated book with 36 photolithographic reproductions
after woodcuts, printed in color and in black
Page 9 1/2 x 8 5/16" (24.1 x 21.1 cm)
Publisher: Troutman Press, Sharon, Connecticut
Printer: probably Troutman Press, Sharon, Connecticut
Edition: 6000
Gift of Mrs. Ketty Rodriguez
1645.1968
(page 78, top)

Antonio Martorell (Puerto Rican, born 1939)
Untitled illustration from *Ode to the Lizard* by Pablo Neruda
(Neftali Ricardo Reyes), 1973
Woodcut, printed in color
Comp. 5 1/2 x 4" (14 x 10.2 cm) (irreg.)
Sheet 17 x 12 1/4" (43.1 x 31.1 cm)
Publisher: the artist, Canovanas, Puerto Rico
Printer: the artist with the assistance of Eric Lluch and Victor
Maldonado, Barrio Campo Rico, Canovanas, Puerto Rico
Edition: 150
Given anonymously
281.1974.5

Matta (Roberto Sebastián Antonio Matta Echaurren)
(Chilean, 1911–2002)
Condors and Carrion, (1941)
Pencil and crayon on paper
23 x 29" (58.4 x 73.7 cm)
Inter-American Fund
32.1942
(page 107, top)

Matta (Roberto Sebastián Antonio Matta Echaurren)
(Chilean, 1911–2002)
Listen to Living, 1941
Oil on canvas
29 1/2 x 37 7/8" (74.9 x 94.9 cm)
Inter-American Fund
33.1942
(page 107, bottom)

Almir Mavignier (Brazilian, born 1925)
Untitled, 1961
Screenprint, printed in color
Comp. 13 13/16 x 9 13/16" (35.1 x 25 cm)
Sheet 15 3/4 x 11 11/16" (40 x 29.7 cm)
Publisher and printer: unknown
Edition: 16
Brazil Fund
37.1965.8

Almir Mavignier (Brazilian, born 1925)
Untitled, 1961
Screenprint, printed in color
Comp. 13 13/16 x 9 13/16" (35.1 x 25 cm)
Sheet 15 11/16 x 11 11/16" (39.9 x 29.7 cm)
Publisher and printer: unknown
Edition: 50
Brazil Fund
37.1965.9

Almir Mavignier (Brazilian, born 1925)
Untitled, 1962
Screenprint, printed in black
Comp. 9 13/16 x 13 3/4" (25 x 35 cm)
Sheet 11 5/8 x 15 5/8" (29 x 39.7 cm)
Publisher, printer, and edition: unknown
Brazil Fund
190.1965

Cildo Meireles (Brazilian, born 1948)
Insertions into Ideological Circuits, 1970
Rubber stamp, printed on both sides of a Brazilian
one cruzeiro bill
Comp. and sheet 2 9/16 x 5 13/16" (6.5 x 14.7 cm)
Publisher and edition: unknown
Gift of Paulo Herkenhoff
SC113.1993
(page 129, top)

Cildo Meireles (Brazilian, born 1948)
Insertions into Ideological Circuits, (c. 1970)
Rubber stamp, printed on both sides of a Brazilian
fifty cruzados novos bill
Comp. and sheet 2 1/2 x 5 1/2" (6.4 x 14 cm)
Publisher and edition: unknown
Gift of Paulo Herkenhoff
SC114.1993
(page 129, middle)

Cildo Meireles (Brazilian, born 1948)
Insertions into Ideological Circuits, (c. 1975)
Rubber stamp, printed on both sides of a Brazilian
five-hundred cruzados novos bill
Comp. and sheet 2 1/2 x 5 1/2" (6.4 x 14 cm)
Publisher and edition: unknown
Gift of Paulo Herkenhoff
SC115.1993
(page 129, bottom)

Cildo Meireles (Brazilian, born 1948)
Zero Cruzeiro, 1978
Photolithograph, printed on both sides
Comp. and sheet 2 3/4 x 6 1/8" (7.1 x 15.6 cm)
Publisher, printer, and edition: unknown
Gift of Paulo Herkenhoff
SC116.1993
(page 130, top)

Cildo Meireles (Brazilian, born 1948)
Zero Cruzeiro, 1978
Photolithograph, printed on both sides
Comp. and sheet 2 3/4 x 6 1/8" (7.1 x 15.6 cm)
Publisher, printer, and edition: unknown
Gift of Paulo Herkenhoff
SC117.1993

Cildo Meireles (Brazilian, born 1948)
Zero Dollar, 1984
Photolithograph, printed on both sides
Comp. and sheet 2 11/16 x 5 13/16" (6.8 x 14.7 cm)
Publisher, printer, and edition: unknown
Gift of Paulo Herkenhoff
SC118.1993
(page 130, bottom)

Cildo Meireles (Brazilian, born 1948)
Zero Dollar, 1984
Photolithograph, printed on both sides
Comp. and sheet 2 11/16 x 5 13/16" (6.8 x 14.7 cm)
Publisher, printer, and edition: unknown
Gift of Paulo Herkenhoff
SC119.1993

Cildo Meireles (Brazilian, born 1948)
Thread, 1990–95
48 bales of hay, 1 18-carat gold needle,
58 meters of gold thread
Dimensions variable 7' 1" x 6' 1 1/16" x 72"
(215.9 x 185.5 x 182.9 cm) (approx.)
Fractional and promised gift of Patricia Phelps de Cisneros
1175.2001.a-c
(page 136)

Leopoldo Méndez (Mexican, 1902–1969)
Deportation into Death, 1942
Linoleum cut, printed in black
Block 13 3/4 x 19 5/8" (35 x 49.8 cm)
Sheet 17 5/16 x 24" (44 x 61 cm)
Publisher and printer: Taller de Gráfica Popular, Mexico City
Edition: unknown
Inter-American Fund
152.1944

Leopoldo Méndez (Mexican, 1902–1969)
Fascism (2) from the portfolio *25 Prints of Leopoldo Méndez*, 1945
Wood engraving, printed in black
Comp. 5 1/2 x 4 3/4" (14 x 12 cm)
Sheet 9 5/8 x 7 11/16" (24.5 x 19.8 cm)
Publisher and printer: La Estampa Mexicana, Mexico City
Edition: 100
Transferred from the Museum Library, 1949
594.1949

Ana Mendieta (American, born Cuba, 1948–1985)
Nile Born, (1984)
Sand and binder on wood
2 3/4 x 19 1/4 x 61 1/2" (7 x 48.9 x 156.2 cm)
Gift of Agnes Gund
167.1992
(page 150)

Carlos Mérida (Guatemalan, 1891–1984)
Tempo in Red Major, 1942
Colored crayons on paper
17 7/8 x 24" (45.4 x 61.0 cm)
Inter-American Fund
738.1942
(page 20)

Beatriz Milhazes (Brazilian, born 1960)
Succulent Eggplants, 1996
Synthetic polymer paint on canvas
6' 2 3/4" x 8' 1/2" (189.9 x 245.1 cm)
Gift of Agnes Gund and Nina and Gordon Bunshaft
Bequest Fund
161.2002
(page 11)

Rafael Montañez Ortiz (Puerto Rican, born United States, 1934)
Archeological Find, 3, (1961)
Burnt mattress
6' 2 7/8" x 41 1/4" x 9 3/8" (190 x 104.5 x 23.7 cm)
Gift of Constance Kane
76.1963
(page 119)

Roberto Montenegro (Mexican, 1885–1968)
Maya Women, 1926
Oil on canvas
31 1/2 x 27 1/2" (80 x 69.8 cm)
Gift of Nelson A. Rockefeller
560.1941
(page 19)

Vik Muniz (Brazilian, born 1961)
Elephant Woman from the series "Personal Articles," 2000
Photolithograph, printed in black
Comp. and sheet 9 13/16 x 6 1/2" (25 x 16.5 cm) (irreg.)
Publisher: the artist, New York
Printer: Chinese newspaper printer
Edition: 6
Frances Keech Fund
1355.2000.1

Vik Muniz (Brazilian, born 1961)
Hundreds Die by Own Hand from the series "Personal Articles," 2000
Photolithograph, printed in black
Comp. And sheet 12 13/16 x 5 1/4" (32.5 x 13.3 cm) (irreg.)
Publisher: the artist, New York
Printer: Chinese newspaper printer
Edition: 6
Frances Keech Fund
1355.2000.3

Vik Muniz (Brazilian, born 1961)
Never Before Released Cassavetes Thriller Is a Joy Ride from the series "Personal Articles," 2000
Photolithograph, printed in black
Comp. and sheet 13 7/16 x 6 1/2" (34.2 x 16.5 cm) (irreg.)
Publisher: the artist, New York
Printer: Chinese newspaper printer
Edition: 6
Frances Keech Fund
1355.2000.4

Vik Muniz (Brazilian, born 1961)
New Lascaux Amusement Park to Bring Renewed Wealth and Lots of Excitement to Vazere Valley from the series "Personal Articles," 2000
Photolithograph, printed in black
Comp. and sheet 11 x 7 1/2" (28 x 19 cm) (irreg.)
Publisher: the artist, New York
Printer: Chinese newspaper printer
Edition: 6
Frances Keech Fund
1355.2000.5

Vik Muniz (Brazilian, born 1961)
Hey! Never Mind Content— Look at the Context from the series "Personal Articles," 2000
Photolithograph, printed in black
Comp. and sheet 10 13/16 x 4 13/16" (27.5 x 12.3 cm) (irreg.)
Publisher: the artist, New York
Printer: Chinese newspaper printer
Edition: 6
Frances Keech Fund
1355.2000.7
(page 161)

Ernesto Neto (Brazilian, born 1964)
Self Jazz Eu, 1999
Ink and silver marker on paper
Sheet 37 1/2 x 25 3/4" (95.3 x 65.4 cm)
Purchase
314.2002

Juan O'Gorman (Mexican, 1905–1982)
The Sand Mines of Tetelpa, 1942
Tempera on composition board
22 1/4 x 18" (56.5 x 45.7 cm)
Gift of Edgar Kaufmann, Jr.
751.1942

Miguel Ocampo (Argentine, born 1922)
Number 172, 1957
Oil on canvas
21 1/4 x 31 7/8" (54 x 81 cm)
Inter-American Fund
89.1958
(page 44)

Hélio Oiticica (Brazilian, 1937–1980)
Untitled No. 4066, 1958
Gouache on cardboard
Sheet 22 7/8 x 21" (58.1 x 53.3 cm)
Gift of the Oiticica Family
175.1997
(page 114)

Hélio Oiticica (Brazilian, 1937–1980)
Untitled No. 348, 1958
Gouache on cardboard
18 1/8 x 22 3/4" (46 x 58 cm)
Purchased with funds given by Maria de Lourdes Egydio Villela
10.1998
(page 116)

Hélio Oiticica (Brazilian, 1937–1980)
Untitled, 1959
Gouache on cardboard
19 7/8 x 26 3/4" (50.5 x 68 cm)
Purchased with funds given by Patricia Phelps de Cisneros in honor of Paulo Herkenhoff
176.1997
(page 115)

Hélio Oiticica (Brazilian, 1937–1980)
Homage to My Father (H.O. Project), 1972
Screenprint, printed in color
Comp. 15 7/8 x 17 15/16" (40.4 x 45.6 cm)
Sheet 17 15/16 x 23 15/16" (45 x 60.9 cm)
Publisher, printer, and edition: unknown
Gift of the Oiticica Family
434.1999

Hélio Oiticica (Brazilian, 1937–1980)
Homage to My Father (H.O. Project), 1972
Screenprint, printed in color
Comp. and sheet 17 11/16 x 15 11/16" (45 x 39.9 cm)
Publisher, printer, and edition: unknown
Gift of the Oiticica Family
146.2000

Gabriel Orozco (Mexican, born 1962)
Maria, Maria, Maria, 1992
Erased phone book page
11 x 9 1/8" (27.9 x 23.2 cm)
Gift of Patricia Phelps de Cisneros and the David Rockefeller Latin American Fund
201.1995
(page 163)

Gabriel Orozco (Mexican, born 1962)
Horses Running Endlessly, 1995
Wood
3 3/8 x 34 3/8 x 34 3/8" (8.7 x 87.5 x 87.5 cm)
Gift of Agnes Gund and Lewis B. Cullman in honor of Chess in the Schools
1147.2001
(page 75)

José Clemente Orozco (Mexican, 1883–1949)
The Subway, (1928)
Oil on canvas
16 1/8 x 22 1/8" (41 x 56.2 cm)
Gift of Abby Aldrich Rockefeller
203.1935
(page 89)

José Clemente Orozco (Mexican, 1883–1949)
Vaudeville in Harlem, 1928
Lithograph, printed in black
Comp. 11 15/16 x 15 7/8" (30.3 x 40.4 cm)
Sheet 13 13/16 x 17 13/16" (35 x 45.2 cm)
Publisher: E. Weyhe, New York
Printer: George C. Miller, New York
Edition: 30
Gift of Abby Aldrich Rockefeller
1545.1940

José Clemente Orozco (Mexican, 1883–1949)
Zapatistas, 1931
Oil on canvas
45 x 55" (114.3 x 139.7 cm)
Given anonymously
470.1937
(page 17)

José Clemente Orozco (Mexican, 1883–1949)
Hanging Negroes, (c. 1933-34)
Lithograph, printed in black
Comp. 12 11/16 x 8 15/16" (32.3 x 22.7 cm)
Sheet 15 13/16 x 11 1/2" (40 x 29.2 cm)
Publisher: unknown
Printer: George C. Miller, New York
Edition: 100
Gift of Abby Aldrich Rockefeller
652.1940.6
(page 90)

José Clemente Orozco (Mexican, 1883–1949)
Self-Portrait, 1940
Tempera on cardboard, mounted on composition board
20 1/4 x 23 3/4" (51.4 x 60.3 cm)
Inter-American Fund
605.1942
(page 92)

Lygia Pape (Brazilian, born 1937)
Untitled, 1959
Woodcut, printed in black
Comp. and sheet 19 11/16 x 19 11/16" (50 x 50 cm)
Publisher and printer: probably the artist
Edition: unknown
Gift of Patricia Phelps de Cisneros in memory of
Marco Antonio Vilaça
147.2000
(page 113)

Lygia Pape (Brazilian, born 1937)
Book of Creation, 1959–60
Goauche on cardboard
Each 12 x 12" (30.5 x 30.5 cm)
Fractional and promised gift of Patricia Phelps de Cisneros
1349.2001.a-r
(page 112)

Amelia Peláez del Casal (Cuban, 1896–1968)
Card Game, 1936
Pencil on buff paper
25 3/8 x 26 3/8" (64.4 x 67 cm)
Inter-American Fund
767.1942
(page 21)

Claudio Perna (Venezuelan, 1938–1997)
Autocurriculum, 1975–80
Felt-tip pen, color pencil, and rubber stamp on
electrostatic prints
Page 10 15/16 x 8 1/8" (27.8 x 20.6 cm)
The Museum of Modern Art /
Franklin Furnace Artists' Books Collection
P3725 A13

Liliana Porter (American, born Argentina, 1941)
The Human Condition I from the series *Magritte*, 1976
Photoetching and aquatint, printed in black,
with hand additions
Plate 12 3/4 x 8 7/8" (32.4 x 22.5 cm)
Sheet 23 5/8 x 18 1/2" (60 x 47 cm)
Publisher: the artist, Locust Valley, New York
Printer: Studio Camnitzer-Porter, Locust Valley, New York
Edition: 30 planned
Purchase
47.1977

Cândido Portinari (Brazilian, 1903–1962)
Hill, 1933
Oil on canvas
44 7/8 x 57 3/8" (114 x 145.7 cm)
Abby Aldrich Rockefeller Fund
663.1939
(page 25, bottom)

Eduardo Ramírez Villamizar (Colombian, born 1922)
Black and White, 1956
Gouache and graphite on grey paper
25 7/8 x 32 5/8" (65.6 x 82.9 cm)
Inter-American Fund
580.1956

Diego Rivera (Mexican, 1886–1957)
May Day, Moscow, 1928
Watercolor and pencil on graph paper
6 3/8 x 4 1/8" (16.2 x 10.5 cm)
Gift of Abby Aldrich Rockefeller
137.1935.3
(page 83)

Diego Rivera (Mexican, 1886–1957)
May Day, Moscow, 1928
Watercolor and pencil on graph paper
6 3/8 x 4 1/8" (16.2 x 10.5 cm)
Gift of Abby Aldrich Rockefeller
137.1935.10

Diego Rivera (Mexican, 1886–1957)
May Day, Moscow, 1928
Watercolor and crayon on graph paper
6 3/8 x 4 1/8" (16.2 x 10.5 cm)
Gift of Abby Aldrich Rockefeller
137.1935.13

Diego Rivera (Mexican, 1886–1957)
May Day, Moscow, 1928
Watercolor and pencil on graph paper
4 1/8 x 6 3/8" (10.5 x 16.2 cm)
Gift of Abby Aldrich Rockefeller
137.1935.17
(page 84, top)

Diego Rivera (Mexican, 1886–1957)
May Day, Moscow, 1928
Watercolor and pencil on graph paper
4 1/8 x 6 5/16" (10.5 x 16.1 cm)
Gift of Abby Aldrich Rockefeller
137.1935.18

Diego Rivera (Mexican, 1886–1957)
May Day, Moscow, 1928
Watercolor and crayon on graph paper
4 1/8 x 6 3/8" (10.5 x 16.2 cm)
Gift of Abby Aldrich Rockefeller
137.1935.20

Diego Rivera (Mexican, 1886–1957)
May Day, Moscow, 1928
Watercolor and crayon on graph paper
4 1/8 x 6 3/8" (10.5 x 16.2 cm)
Gift of Abby Aldrich Rockefeller
137.1935.21

Diego Rivera (Mexican, 1886–1957)
May Day, Moscow, 1928
Watercolor and pencil on graph paper
4 1/8 x 6 3/8" (10.5 x 16.2 cm)
Gift of Abby Aldrich Rockefeller
137.1935.24

Diego Rivera (Mexican, 1886–1957)
May Day, Moscow, 1928
Watercolor and pencil on graph paper
6 3/8 x 4 1/8" (16.2 x 10.5 cm)
Gift of Abby Aldrich Rockefeller
137.1935.25

Diego Rivera (Mexican, 1886–1957)
May Day, Moscow, 1928
Watercolor and crayon on graph paper
4 1/8 x 6 3/8" (10.5 x 16.2 cm)
Gift of Abby Aldrich Rockefeller
137.1935.28
(page 84, middle)

Diego Rivera (Mexican, 1886–1957)
May Day, Moscow, 1928
Watercolor and pencil on graph paper
4 1/8 x 6 3/8" (10.5 x 16.2 cm)
Gift of Abby Aldrich Rockefeller
137.1935.30

Diego Rivera (Mexican, 1886–1957)
May Day, Moscow, 1928
Watercolor and crayon on graph paper
4 1/8 x 6 3/8" (10.5 x 16.2 cm)
Gift of Abby Aldrich Rockefeller
137.1935.32

Diego Rivera (Mexican, 1886–1957)
May Day, Moscow, 1928
Watercolor and pencil on graph paper
4 1/8 x 6 3/8" (10.5 x 16.2 cm)
Gift of Abby Aldrich Rockefeller
137.1935.34

Diego Rivera (Mexican, 1886–1957)
May Day, Moscow, 1928
Watercolor and crayon on graph paper
4 1/8 x 6 3/8" (10.5 x 16.2 cm)
Gift of Abby Aldrich Rockefeller
137.1935.38

Diego Rivera (Mexican, 1886–1957)
May Day, Moscow, 1928
Watercolor and crayon on graph paper
4 1/8 x 6 3/8" (10.5 x 16.2 cm)
Gift of Abby Aldrich Rockefeller
137.1935.41

Diego Rivera (Mexican, 1886–1957)
May Day, Moscow, 1928
Watercolor and crayon on graph paper
4 1/8 x 6 3/8" (10.5 x 16.2 cm)
Gift of Abby Aldrich Rockefeller
137.1935.45

Diego Rivera (Mexican, 1886–1957)
Flower Festival: Feast of Santa Anita, 1931
Encaustic on canvas
6' 6 1/2" x 64" (199.3 x 162.5 cm)
Gift of Abby Aldrich Rockefeller
23.1936
(page 18)

Diego Rivera (Mexican, 1886–1957)
Angeline Beloff, December, 1917
Pencil on paper
13 1/4 x 10" (33.7 x 25.4 cm)
Gift of Mrs. Wolfgang Schoenborn in honor
of René d'Harnoncourt
36.1975

Antonio Ruiz (Mexican, 1897–1964)
The New Rich, 1941
Oil on canvas
12 5/8 x 16 5/8" (32.1 x 42.2 cm)
Inter-American Fund
6.1943
(page 24)

José Sabogal (Peruvian, 1888–1956)
The Veil, 1942
Duco on wood
10 5/8 x 6" (27 x 15.2 cm)
Gift of the artist
SC616.1942

Doris Salcedo (Colombian, born 1958)
Untitled, (1995)
Wood, cement, steel, cloth, and leather
7' 9" x 41" x 19" (236.2 x 104.1 x 48.2 cm)
The Norman and Rosita Winston Foundation, Inc. Fund
and purchase
4.1996
(page 149)

Juan Sánchez (Puerto Rican, born United States, 1954)
For Don Pedro, 1992
Lithograph and photolithograph, printed in color,
with oil stick additions and collage
Comp. and sheet 22 3/16 x 30" (56.4 x 76.2 cm)
Publisher and printer: Tamarind Institute,
Albuquerque, New Mexico
Edition: 22
The Ralph E. Shikes Fund
690.1993

Mira Schendel (Brazilian, born Switzerland, 1919–1988)
Untitled (red), (1964)
Monotype
Sheet 18 1/2 x 9" (47 x 22.9 cm)
Gift of Luisa Strina in memory of Lydia and Ferdinando Strina
2453.2001
(page 47, right)

Mira Schendel (Brazilian, born Switzerland, 1919–1988)
Untitled, 1964
Monotype
Sheet 18 1/4 x 9" (46.4 x 22.9 cm)
Gift of Luisa Strina in memory of Lydia and Ferdinando Strina
2454.2001
(page 47, left)

Lasar Segall (Brazilian, born Lithuania,1891–1957)
Shantytown in Rio de Janeiro, 1930
Drypoint, printed in black
Plate 9 3/8 x 11 3/4" (23.8 x 29.8 cm)
Sheet 12 15/16 x 20 3/16" (32.9 x 51.3 cm)
Publisher and printer: unknown
Edition: 30
Inter-American Fund
1390.1968
(page 25, top)

Lasar Segall (Brazilian, born Lithuania, 1891–1957)
Mangue by Jorge de Lima, Mário de Andrade, and
Mário Bandeira, 1941, published 1943
Illustrated book with 3 woodcuts, printed in black;
1 lithograph, printed in color, with crayon additions; and
42 line block and relief halftone reproductions of drawings
Page 13 5/8 x 9 3/4" (34 x 24.7 cm)
Publisher: Revista Acadêmica Editora, Rio de Janeiro, Brazil
Printer: unknown
Edition: 135
Purchase
607.1949.1-4

Antonio Seguí (Argentine, born 1934)
(Untitled), 1967
Gouache, wash, wax crayon, pastel and pencil
Sheet 19 5/8 x 25 1/2" (49.8 x 64.7 cm)
Inter-American Fund
843.1969

Regina Silveira (Brazilian, born 1939)
Topography, 1978
Lithograph
Overall closed 4 1/4 x 6 5/16" (10.8 x 16 cm)
The Museum of Modern Art /
Franklin Furnace Artists' Books Collection
A.B. S4575 A12t

David Alfaro Siqueiros (Mexican, 1896–1974)
Collective Suicide, 1936
Enamel on wood with applied sections
49" x 6' (124.5 x 182.9 cm)
Gift of Dr. Gregory Zilboorg
208.1937
(page 16)

David Alfaro Siqueiros (Mexican, 1896–1974)
Echo of a Scream, 1937
Enamel on wood
48 x 36" (121.9 x 91.4 cm)
Gift of Edward M. M. Warburg
633.1939
(page 101)

Jesús Rafael Soto (Venezuelan, born 1923)
(Untitled), 1959
Tempera on wood panel with painted wire composition
9 1/2 x 7 1/2 x 5 5/8" (24 x 19 x 14.1 cm)
Gift of Philip Johnson
796.1969
(page 45)

Jesús Rafael Soto (Venezuelan, born 1923)
Olive and Black, 1966
Flexible mobile, metal strips suspended in front of two
plywood panels painted with synthetic polymer paint
and mounted on composition board
61 1/2 x 42 1/4 x 12 1/2" (156.1 x 107.1 x 31.7 cm)
Inter-American Fund
574.1967
(page 120)

Rufino Tamayo (Mexican, 1899–1991)
Animals, 1941
Oil on canvas
30 1/8 x 40" (76.5 x 101.6 cm)
Inter-American Fund
165.1942
(page 23)

Joaquín Torres-García (Uruguayan, 1874–1949)
Guitar, 1924
Painted wood relief
12 1/2 x 4 x 3 1/8" (37.7 x 10 x 7.7 cm)
Abby Aldrich Rockefeller Fund
433.1981

Joaquín Torres-García (Uruguayan, 1874–1949)
Composition, 1932
Oil on canvas
28 1/4 x 19 3/4" (71.8 x 50.2 cm)
Gift of Dr. Román Fresnedo Siri
611.1942
(page 95)

Rafael Tufiño (Puerto Rican, born United States, 1922)
Fire, Fire, Fire from the portfolio *Plenas*, 1953–55
Linoleum cut
Comp. 11 1/4 x 17 13/16" (28.5 x 45.2 cm) (irreg.)
Sheet 13 x 20 13/16" (33 x 45.3 cm)
Publisher and printer: Editorial Caribe, San Juan, Puerto Rico
Edition: 850
The Louis E. Stern Collection
1109.1964.24

Mario Urteaga (Mario Urteaga Alvarado)
(Peruvian, 1875–1957)
Burial of an Illustrious Man, 1936
Oil on canvas
23 x 32 1/2" (58.4 x 82.5 cm)
Inter-American Fund
806.1942
(page 13)

Edgardo Antonio Vigo (Argentine, 1927–1997)
Poetic Analysis of 1 Meter of Thread, 1970
Letterpress and die-cut board with string and
metal grommets
Overall closed 9 5/16 x 4" (23.7 x 10.2 cm). String 39 1/4"
(99.7 cm)
The Museum of Modern Art /
Franklin Furnace Artists' Books Collection
A.B. V4412 A12ai

FOR FURTHER READING

This concise bibliography contains many of the important texts written on Latin American art since 1980. It is meant as a general introduction to the recent available scholarship. These books and exhibition catalogues were also chosen in light of the specific artists and art movements found in *MoMA at El Museo*. For a more comprehensive bibliography of Latin American art, please visit the "Latin American Modern and Contemporary Art Online Bibliography" Website, at http://momaapps.moma.org/shtmlpgs/lab/Home.html, published by The Museum of Modern Art in 2003.
Donald L. Woodward

Ades, Dawn. *Art in Latin America: The Modern Era, 1820–1980*. Exh. cat. New Haven and London: Yale University Press, 1989.

Amaral, Aracy A. *Arte para quê?: a preocupação social na arte brasileira, 1930–1970*. 2nd rev. ed. São Paulo: Nobel, 1987.

———. *Arts in the Week of '22*. Rev. ed. São Paulo: Câmara Brasileira do Livro, 1992.

Amaral, Aracy A., and Paulo Herkenhoff. *Ultramodern: The Art of Contemporary Brazil*. Exh. cat. Washington, D.C.: National Museum of Women in the Arts, 1993.

Armstrong, Elizabeth, and Victor Zamudio-Taylor. *Ultrabaroque: Aspects of Post–Latin American Art*. Exh. cat. La Jolla: Museum of Contemporary Art, San Diego, 2000.

Baddeley, Oriana, and Valerie Fraser. *Drawing the Line: Art and Cultural Identity in Contemporary Latin America*. London and New York: Verso, 1989.

Báez, Myrna, and José A. Torres Martinó. *Puerto Rico: arte e identidad*. San Juan: Editorial de la Universidad de Puerto Rico, 1998.

Barnitz, Jacqueline. *Twentieth-Century Art of Latin America*. Austin: University of Texas Press, 2001.

Bayón, Damián, and Roberto Pontual. *La Peinture de l'Amérique latine au XXe siècle*. Paris: Mengès, 1990.

Bois, Yve-Alain, et al. *Geometric Abstraction: Latin American Art from the Patricia Phelps de Cisneros Collection/Abstracción Geométrica: arte Latinoamericano en la Colección Patricia Phelps de Cisneros*. Exh. cat. Cambridge: Harvard University Art Museums, 2001.

Borràs, Maria Lluïsa, ed. *Arte Madí*. Exh. cat. Madrid: Museo Nacional Centro de Arte Reina Sofía, 1997.

Borràs, Maria Lluïsa, et al. *Cuba siglo XX: modernidad y sincretismo*. Exh. cat. Las Palmas de Gran Canaria: Centro Atlántico de Arte Moderno, 1996.

Boulton, Alfredo. *La pintura en Venezuela*. Caracas: Ediciones Macanao, 1987.

Brasil: de la antropofagia a Brasilia, 1920–1950. Exh. cat. Valenciá: Institut Valencia d'Art Modern, 2000.

Camnitzer, Luis. *New Art of Cuba*. 2nd rev. ed. Austin: University of Texas Press, 2003.

Cancel, Luis R., et al. *The Latin American Spirit: Art and Artists in the United States, 1920–1970*. Exh. cat. New York: Bronx Museum of the Arts and Harry N. Abrams, 1988.

Castrillón Vizcarra, Alfonso. *Los Independientes: distancias y antagonismos en la plástica peruana de los años 37 al 47*. Lima: Instituto Cultural Peruano Norteamericano, 2001.

Chile: 100 años artes visuales. Exh. cat. 3 vols. Santiago: Museo Nacional de Bellas Artes, 2000.

Craven, David. *Art and Revolution in Latin America, 1910–1990*. New Haven and London: Yale University Press, 2002.

Day, Holliday T., and Hollister Sturges. *Art of the Fantastic: Latin America, 1920–1987*. Exh. cat. Indianapolis: Indianapolis Museum of Art, 1987.

Fernández, Justino. *Arte moderno y contemporáneo de México*. 2 vols. Mexico City: Universidad Nacional Autónoma de México, 1993.

Fletcher, Valerie. *Crosscurrents of Modernism: Four Latin American Pioneers—Diego Rivera, Joaquín Torres-García, Wifredo Lam, Matta.* Exh. cat. Washington, D.C.: Hirshhorn Museum and Sculpture Garden and Smithsonian Institution Press, 1992.

Folgarait, Leonard. *Mural Painting and Social Revolution in Mexico, 1920–1940: Art of the New Order.* Cambridge and New York: Cambridge University Press, 1998.

Fuentes-Perez, Ileana, et al. *Outside Cuba: Contemporary Cuban Visual Artists/Fuera de Cuba: artistas cubanos contemporáneos.* Exh. cat. New Brunswick: Office of Hispanic Arts, Mason Gross School of the Arts, Rutgers State University of New Jersey, and Miami: Research Institute for Cuban Studies, University of Miami, 1989.

Fusco, Coco. *English Is Broken Here: Notes on Cultural Fusion in the Americas.* New York: New Press, 1995.

García Canclini, Néstor. *Hybrid Cultures: Strategies for Entering and Leaving Modernity.* Trans. Christopher L. Chiappari and Silvia L. López. Minneapolis: University of Minnesota Press, 1995. Originally published as *Culturas híbridas: estrategias para entrar y salir de la modernidad.* Mexico City: Grijalbo, 1989.

Giunta, Andrea. *Vanguardia, internacionalismo y política: arte argentino en los años sesenta.* Buenos Aires: Paidós, 2001.

Glusberg, Jorge. *Del Pop-Art a la Nueva Imagen.* Buenos Aires: Ediciones de Arte Gaglianone, 1985.

Goldman, Shifra M. *Contemporary Mexican Painting in a Time of Change.* Austin and London: University of Texas Press, 1981.

———. *Dimensions of the Americas: Art and Social Change in Latin America and the United States.* Chicago and London: University of Chicago Press, 1994.

Gradowczyk, Mario H., and Nelly Perazzo. *Abstract Art from the Río de la Plata: Buenos Aires and Montevideo, 1933–1953.* Exh. cat. New York: The Americas Society, 2001.

Griswold del Castillo, Richard, Teresa McKenna, and Yvonne Yarbro Bejaraneo, eds. *Chicano Art: Resistance and Affirmation, 1965–1985.* Exh. cat. Los Angeles: Wright Art Gallery, University of California, 1992.

Hurlburt, Laurance P. *The Mexican Muralists in the United States.* Albuquerque: University of New Mexico Press, 1989.

Jiménez, Ariel. *Paralelos: arte brasileira da segunda metade do século XX em contexto. Colección Cisneros.* Exh. cat. São Paulo: Museu de Arte Moderna de São Paulo, 2002.

Kalenberg, Ángel. *Artes visuales del Uruguay: de la piedra a la computadora/Visual Arts of Uruguay: From the Stone to the Computer.* 2 vols. Montevideo: Testoni Studio and Galería Latina, 2001.

López Anaya, Jorge. *Historia del arte argentino.* Buenos Aires: Emecé, 1997.

Lucie-Smith, Edward. *Latin American Art of the 20th Century.* London: Thames & Hudson, 1993.

Martin, Susan, and Alma Ruiz, eds. *The Experimental Exercise of Freedom: Lygia Clark, Gego, Mathias Goeritz, Hélio Oiticica and Mira Schendel.* Exh. cat. Los Angeles: The Museum of Contemporary Art, 1999.

Martínez, Juan A. *Cuban Art and National Identity: The Vanguardia Painters, 1927–1950.* Gainesville: University Press of Florida, 1994.

Memoria. Congreso Internacional de Muralismo. San Ildefonso, cuna del Muralismo Mexicano: reflexiones historiográficas y artísticas. Mexico City: Antiguo Colegio de San Ildefonso, 1999.

Mesquita, Ivo, and Adriano Pedrosa. *F[r]icciones.* Exh. cat. Madrid: Museo Nacional Centro de Arte Reina Sofía, 2000.

Milliet, Maria Alice. *Espelho Selvagem: arte moderna no Brasil da primeira metade do século XX: Coleção Nemirovsky.* Exh. cat. São Paulo: Museu de Arte Moderna de São Paulo, 2002.

Modernidad y postmodernidad: espacios y tiempos dentro del arte latinoamericano. Caracas: Museo Alejandro Otero, 2000.

Mosquera, Gerardo. *Contracandela: ensayos sobre kitsch, identidad, arte abstracto y otros temas calientes.* Caracas: Monte Avila Editores Latinoamericana and Galería de Arte Nacional, 1993.

Mosquera, Gerardo, ed. *Beyond the Fantastic: Contemporary Art Criticism from Latin America.* London: Institute of International Visual Arts, 1995.

Pacheco, Marcelo E., ed. *MALBA: Colección Costantini. Museo de arte latinoamericano de Buenos Aires.* Mexico City: Landucci, 2001.

Paz, Octavio. *Essays on Mexican Art.* Trans. Helen Lane. New York: Harcourt & Company, 1993.

Pedrosa, Mario. *Textos escolhidos.* 4 vols. Ed. Otília Beatriz Fiori Arantes. São Paulo: Edusp, 1995–2000.

Pérez-Oramas, Luis. *Mirar furtivo.* Caracas: Consejo Nacional de la Cultura, 1997.

Pini, Ivonne. *En busca de lo propio. Inicios de la modernidad en el arte de Cuba, México, Uruguay y Colombia, 1920–1930.* Bogotá: Universidad Nacional de Colombia, 2000.

Pintura latinoamericano: breve panorama de la modernidad figurativa en la primera mitad del siglo XX. Buenos Aires: Banco Velox, 1999.

Pontual, Roberto. *Entre dois séculos: arte brasileira do século XX. Coleção Gilberto Chateaubriand.* Rio de Janeiro: Editora JB, 1987.

Poupeye, Veerle. *Caribbean Art.* London: Thames & Hudson, 1998.

Ramírez, Mari Carmen, ed. *El Taller Torres-García: The School of the South and Its Legacy.* Exh. cat. Austin: University of Texas Press for the Archer M. Huntington Art Gallery, 1992.

———. *Re-Aligning Vision: Alternative Currents in South American Drawing.* Exh. cat. Austin: Archer M. Huntington Art Gallery, The University of Texas at Austin, 1997.

Ramírez, Mari Carmen, and Héctor Olea. *Heterotopías: medio siglo sin-lugar, 1918–1968.* Exh. cat. Madrid: Museo Nacional Centro de Arte Reina Sofía, 2000.

Rasmussen, Waldo, Fatima Bercht, and Elizabeth Ferrer, eds. *Latin American Artists of the Twentieth Century.* Exh. cat. New York: The Museum of Modern Art, 1993.

Rochfort, Desmond. *Mexican Muralists: Orozco, Rivera, Siqueiros.* London: Laurence King, 1993.

Rodríguez, Bélgica. *Arte centroamericano.* San José: EDUCA, 1998.

Romero Brest, Jorge. *Arte visual en el Di Tella: aventura memorable en los años 60.* Buenos Aires: Emecé, 1992.

Rubiano Caballero, Germán. *Arte de América Latina, 1981–2000.* Washington, D.C.: Banco Interamericano de Desarrollo, 2001.

Serrano, Eduardo. *Cien años del arte colombiano, 1886–1986.* Bogotá: Museo de Arte Moderno, 1985.

60 años de TGP: Taller Gráfica Popular. Mexico City: Consejo Nacional para la Cultural y las Artes, Instituto Nacional de Bellas Artes, 1997.

Stofflet, Mary, et al. *Latin American Drawings Today.* Exh. cat. San Diego: San Diego Museum of Art, 1991.

Sullivan, Edward J. *Aspects of Contemporary Mexican Painting.* Exh. cat. New York: The Americas Society, 1990.

Sullivan, Edward J., ed. *Latin America Art in the Twentieth Century.* London: Phaidon, 1996.

———. *Brazil: Body and Soul.* Exh. cat. New York: Solomon R. Guggenheim Museum, 2001.

Traba, Marta. *Art of Latin America, 1900–1980.* Washington, D.C.: Inter-American Development Bank, 1994.

U-ABC. Painting, Sculptures, Photography from Uruguay, Argentina, Brazil and Chile. Exh. cat. Amsterdam: Stedelijk Museum, 1989.

Veigas, José, et al. *Memoria: Cuban Art of the 20th Century*. Los Angeles: California/International Arts Foundation, 2002.

Voces de ultramar: arte en América Latina y Canarias, 1910–1960. Exh. cat. Las Palmas de Gran Canaria: Centro Atlántico de Arte Moderno, 1992.

Weinberg Staber, Margit, Nelly Perazzo, and Tomás Maldonado. *Arte concreto invencón, arte madí*. Basel: Galerie Von Bartha, 1991.

Wifredo Lam and His Contemporaries, 1938–1952. Exh. cat. New York: Studio Museum in Harlem, 1992.

Wood, Yolanda. *De la plástica cubana y caribeña*. Havana: Editorial Letras Cubanas, 1990.

Woodward, Donald L. *Latin American Modern and Contemporary Art Online Bibliography*. New York: The Museum of Modern Art, 2003. http://momaapps.moma.org/shtmlpgs/lab/Home.html

Zanini, Walter, ed. *História geral da arte no Brasil*. 2 vols. São Paulo: Instituto Walther Moreira Salles and Fundação Djalma Guimarães, 1983.

Zeitlin, Marilyn A., ed. *Contemporary Art from Cuba: Irony and Survival on the Utopian Island/Arte contemporáneo de Cuba: ironía y sobrevivencia en la isla utópica*. Exh. cat. Tempe: Arizona State University Art Museum, and New York: Delano Greenidge, 1999.

183

PHOTOGRAPHY CREDITS

All photographs, listed by plate number below, have been provided by The Museum of Modern Art's Department of Imaging Services, photographers Kelly Benjamin, Thomas Griesel, Erik Landsberg, Paige Knight, and John Wronn unless otherwise noted.

Front cover (detail): © 2004 Artists Rights Society (ARS), New York / VEGAP, Madrid

Back cover: © The Felix Gonzalez-Torres Foundation, courtesy of Andrea Rosen Gallery, New York

Frontspiece (detail): © Iran do Espírito Santo, courtesy of the artist and Sean Kelly Gallery, New York

Plate 1: © 2004 Beatriz Milhazes

Plate 2: © Estate of David Alfaro Siqueiros/Licensed by VAGA, New York, NY/Reproducción autorizada por el Instituto Nacional de Bellas Artes y Literatura

Plate 3: © Clemente Orozco V. Reproducción autorizada por el Instituto Nacional de Bellas Artes y Literatura

Plate 4: © 2004 Banco de México, Diego Rivera & Frida Kahlo Museums Trust. Av. Cinco de Mayo No. 2, Col. Centro, Del. Cuauhtémoc 06059, México, D.F. Reproducción autorizada por el Instituto Nacional de Bellas Artes y Literatura

Plate 5: © Roberto Montenegro

Plate 6: © Estate of Carlos Mérida/Licensed by VAGA, New York, NY.

Plate 7: © The Amelia Peláez Foundation, Inc., Leonardtown, MD

Plate 8: © 2004 Banco de México, Diego Rivera & Frida Kahlo Museums Trust. Av. Cinco de Mayo No. 2, Col. Centro, Del. Cuauhtémoc 06059, México, D.F. Reproducción autorizada por el Instituto Nacional de Bellas Artes y Literatura

Plate 9: © Herederos de Rufino Tamayo

Plate10: © Antonio Ruiz

Plate 11: © Associação Cultural de Amigos do Museu Lasar Segall

Plate 12: © 2004 Cândido Portinari, courtesy Projeto Portinari

Plate 13: © 2004 Mario Urteaga, courtesy of Cesar Urteaga

Plate 14: © Pedro Figari, courtesy descendants of Pedro Figari

Plate 15: © Courtesy of family of Antonio Berni

Plate 16: © 2004 Miguel Ocampo, courtesy of Galería Niko Gulland

Plate 17: © Jesús Soto, courtesy Riva Yares Gallery

Plate 18: © 2004 Ernesto Deira, courtesy of family of the artist

Plate 19: © 2004 Carlos Alonso

Plates 20, 21: © Mira Schendel, courtesy of Galería André Millan

Plate 22: © 2004 Artists Rights Society (ARS), New York /ADAGP, Paris

Plate 23: © Julio Le Parc

Plate 24: © 2004 Anna Maria Maiolino, courtesy of Gabinete de Arte Raquel Arnaud

Plate 25: © 2004 Willys de Castro, courtesy of Gabinete de Arte Raquel Arnaud

Plate 26: © 2004 Hércules Barsotti, courtesy of Gabinete de Arte Raquel Arnaud

Plate 27: Art © Marisol/Licensed by VAGA, New York, NY

Plate 28: © Gabriel Orozco, courtesy Marian Goodman Gallery, New York

Plate 29: © Courtesy R. de la Vega-R. Benzacar Galería de Arte

Plates 30, 31 © 2004 Antonio Dias, courtesy of Galería Luisa Strina

Plate 32: © 2004 Antonio Martorell

Plate 33: © 2004 José Alicea

Plate 34: © 2004 Gonzalo Díaz

Plate 35: © Iran do Espírito Santo, courtesy of the artist and Sean Kelly Gallery, New York

Plate 36: © Arturo Herrera, courtesy of Brent Sikkema NYC. Image courtesy of Brent Sikkema NYC

Plates 37, 38: © 2004 Banco de México, Diego Rivera & Frida Kahlo Museums Trust. Av. Cinco de Mayo No. 2, Col. Centro, Del. Cuauhtémoc 06059, México, D.F. Reproducción autorizada por el Instituto Nacional de Bellas Artes y Literatura

Plates 39–41: © Clemente Orozco V. Reproducción autorizada por el Instituto Nacional de Bellas Artes y Literatura

Plate 42: © 2004 Artists Rights Society (ARS), New York / VEGAP, Madrid

Plate 43: © Roberto Berdecio

Plate 44: © Courtesy of family of Antonio Berni

Plate 45: © Estate of David Alfaro Siqueiros/Licensed by VAGA, New York, NY. Reproducción autorizada por el Instituto Nacional de Bellas Artes y Literatura

Plates 46, 47: © 2004 Artists Rights Society (ARS), New York / ADAGP, Paris

Plates 48, 49: © 2004 Artists Rights Society (ARS), New York / ADAGP, Paris

Plates 50–53: © Courtesy Colección Fundación Gego

Plate 54: © 2004 Lygia Pape. Image courtesy Colección Patricia Phelps de Cisneros

Plate 55: © 2004 Lygia Pape

Plates 56–58: © Hélio Oiticica, courtesy Projeto Hélio Oiticica

Plate 59: © 2004 Mathias Goeritz, courtesy of family of the artist

Plate 60: © 2004 Raphael Montañez Ortiz

Plate 61: © Jesús Soto, courtesy Riva Yares Gallery

Plate 62: © Fernando Botero, courtesy Marlborough Gallery, New York

Plate 63: Art © Marisol/Licensed by VAGA, New York, NY

Plate 64: © 2004 Antonio Frasconi

Plates 65–69: © 2004 Cildo Meireles, courtesy of Galería Luisa Strina

Plate 70: © 2004 Rafael Ferrer

Plate 71: © Adál 1994. Image courtesy of the artist

Plate 72: © 2004 Cildo Meireles, courtesy of Galería Luisa Strina Image courtesy Colección Patricia Phelps de Cisneros

Plate 73: © 2004 Waltércio Caldas, courtesy of Gabinete de Arte Raquel Arnaud

Plate 74: © The Felix Gonzalez-Torres Foundation, courtesy of Andrea Rosen Gallery, New York

Plate 75: © 2004 Artists Rights Society (ARS), New York / ADAGP, Paris

Plate 76: © Doris Salcedo

Plate 77: © Courtesy of the Estate of Ana Mendieta and Galerie Lelong, New York

Plate 78: © Courtesy Sociedade Amigos do Projeto Leonilson

Plate 79: © 2004 Kcho, courtesy Gallery 106

Plate 80: © 2004 Los Carpinteros

Plates 81: © Fernando Bryce, courtesy of Galerie Barbara Thumm. Image courtesy Galerie Barbara Thumm

Plate 82: © Vik Muniz/Licensed by VAGA, New York, NY

Plate 83: © Gabriel Orozco, courtesy Marian Goodman Gallery, New York

Plate 84: © 2004 Enrique Chagoya